DRAGON TATTOOS

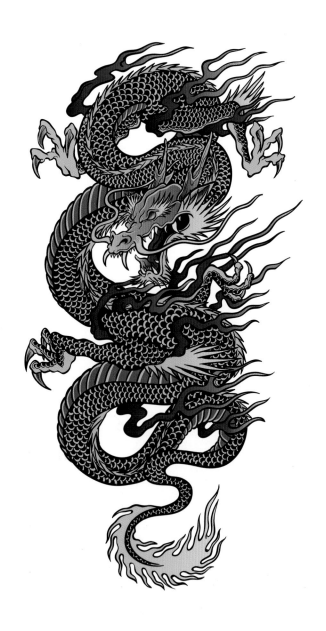

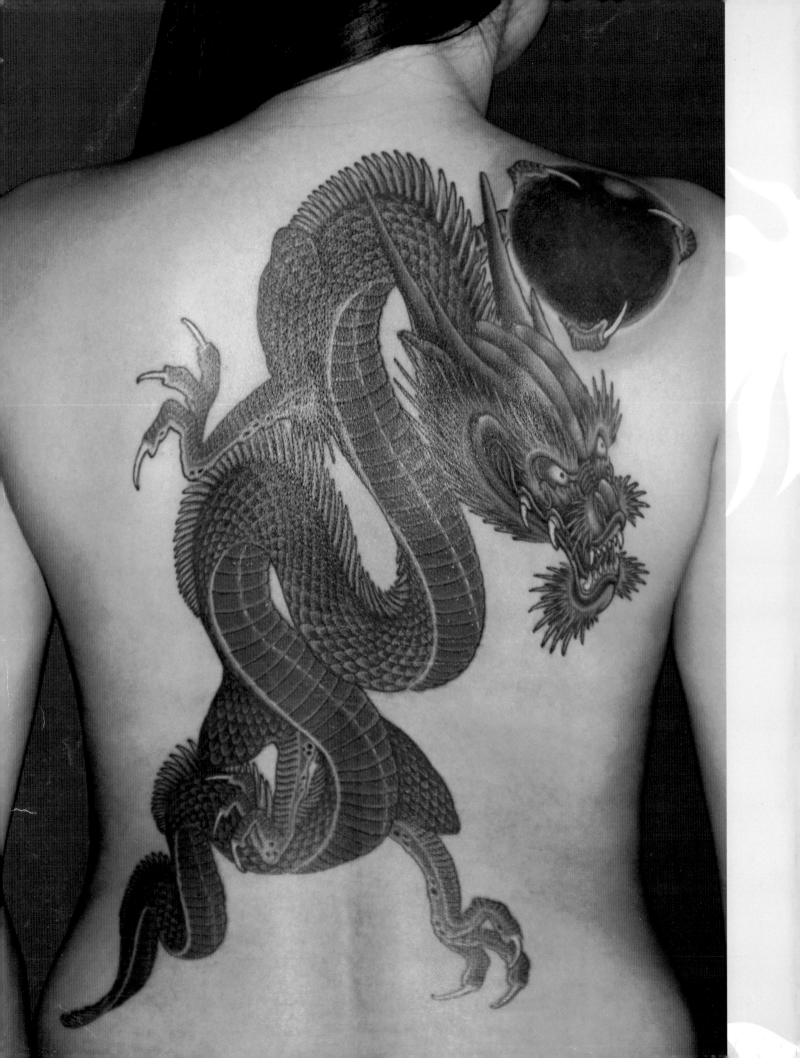

CONTENTS

INTRODUCTION

Movies, tattoos, fairy tales, manga, religious icons, political thrillers, role-playing games, fantasy artwork and TV shows . . . images of dragons are everywhere and have been for so long that you could be forgiven for believing they are not mythical, but real. Their longevity poses an interesting question: how does a creature that has never been proven to exist maintain such a hold on our collective imagination?

We will examine this, but first – what does a typical dragon look like? Dragons are widely regarded as having the appearance of a massive winged reptile, an enormous flying lizard that exhales fire and smoke. Interestingly, different cultures have variations on this basic appearance; some dragons are more snake-like than lizard-like, for example. Most dragons are an amalgamation of two or more animals, and as such they are the best-known example of a chimera, a monstrous creature with parts from multiple

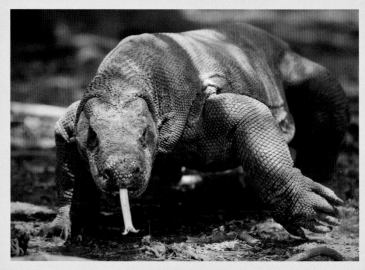

ABOVE: The Komodo dragon is probably the closest living relative to the dragon of myth.

animals. Other chimeric beings include griffins, sphinxes, unicorns and so on, which we'll discuss later in this book.

The origin of dragons

The dragon's enduring appeal as an icon and symbol of supernatural power has been strengthened by the mystery surrounding it. Many people have a deep desire to connect with myth and the idea that such a remarkable creature might have walked the Earth feeds this need. So is there any evidence that dragons ever existed? They do bear a striking resemblance to the pterosaur, a flying reptile that has been extinct for the last 65 million years. A descendant of the pterosaur, the ropen, is said to live in Papua New Guinea, although sightings are rare. The ropen is a cryptid, which means its existence is alleged but not confirmed, unlike the Komodo dragon, the large monitor lizard found on certain Indonesian islands. Undisturbed by predators and unchanged in size for the last 900,000 years, the Komodo dragon is as close as we get to a living relative of the legendary dragon.

LEFT: An intimidating statue typical of European dragons. Originating in France, carved stone gargoyles representing mythical dragon-like creatures were used on churches and sacred buildings as waterspouts to throw off the rain.

Centuries of storytelling have resulted in numerous adaptations of these creatures and their elevation to magical status. Dragons are present in many creation myths from different cultures, so they certainly play a significant role in the human subconscious.

If we accept that dragons are indeed the result of the human imagination we need to look at the qualities we seek to invest in them. These are usually present in the animals that make up the dragon chimera (in China dragons are composed of nine animals, while in Europe they are hybrids of several animals, but not necessarily nine).

Dragon creation myths

The dragon appears in creation myths the world over, from Babylon's Tiamat to India's Nāga serpent deities, and including the Bunyip of Australian Aborigines, North America's Piasa, the Aztec god Quetzalcoatl and West Africa's Aido Hwedo, also known as the Rainbow Serpent, who embodied both genders in one supernatural body.

In Babylon, the cradle of civilization, a goddess called Tiamat (tellingly, a female creature who embodied primordial chaos) was in turn represented as a sea monster and a dragon. Tiamat was the inspiration for one of the villains in the game 'Dungeons and Dragons', where she is represented as a five-headed dragon. She was closely linked to another monstrous sea creature, Lotan, a giant seven-headed serpent, probably an early incarnation of the Hydra. Lotan is believed to have evolved into what we know as the Leviathan, which dates from the time when the Israelites came into contact with these earlier myths and assimilated them into their own.

The Leviathan, present in the Old Testament Book of Job, is a monstrous sea creature whose power and strength highlight man's weaknesses. Today, the word Leviathan is used to describe any enormous sea creature or structure, but in Biblical times it was a metaphor for the Egyptians, powerful enemies of the Israelites, who the latter saw as an invincible opponent. Centuries later, in the Middle Ages, the Leviathan became associated with Satan and was regarded as the incarnation of demonic qualities.

Greek mythology is full of serpents and dragons, especially the multi-headed variety. Several of these, including the Hydra, Scylla, Chimæra and Medea's chariot dragons, were present in Theoi mythology. The noun 'dragon', from the ancient Greek drakōn (δράκων), means 'large reptile'.

In China, where emperors were believed to be descended from dragons, the creature was used as a symbol of power and its divine status was especially celebrated. However, long before the dragon was taken to represent imperial power, Nü-Kua, a goddess who was half-woman and half-dragon, had created men and women out of clay and breathed life into them.

Dragon qualities

There are some striking differences in the characteristics of Eastern and Western dragons. Eastern dragons are generally positive, benevolent figures which represent aspirational qualities. In the case of Western dragons, medieval myths and earlier tales identified them with evil and Satan and they became a prized rival and trophy for knights in search of glory. In Ancient Egypt, the sun god Ra was said to fight his arch-enemy, the infernal dragon Apophis, god of chaos and darkness, every day as the sun gave way to night. Again this tale gave rise to the conviction that dragons were diabolical beings.

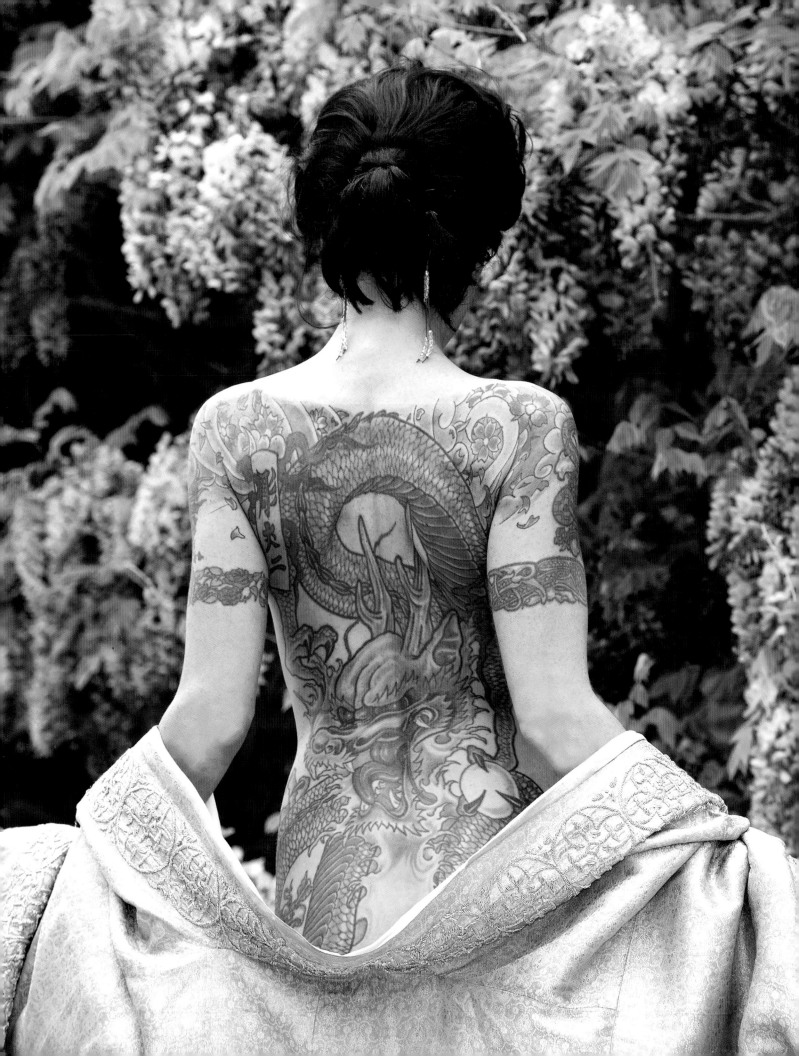

EASTERN DRAGONS

There are dozens of different types and representations of Eastern dragons in existence, all of them linked to local folklore. Here we explore the most popular examples, which have been successfully transferred to skin art. The fact that these images have been widely reproduced on paper over the centuries almost certainly contributes to their easy adaptation as tattoos.

The three main types of Eastern dragon are Chinese, Korean and Japanese. While their meanings and significance vary, their most noticeable shared characteristic is their lack of wings. This feature clearly differentiates Eastern from European dragons. The Eastern dragon has a snake-like body and appears to move elegantly and swiftly through water or air. Eastern dragons are closely linked with the element of water: they control rain by causing pressure on the clouds. This contrasts strongly with European dragons' close relationship with fire. In the East, dragons dispense water and life, in the West, fire and destruction. Eastern dragons are also symbols of power, wisdom and good fortune.

LEFT: An elaborate back piece depicting a dragon clutching a sacred pearl

CHINESE DRAGONS

China's fascination with dragons dates back several thousand years BCE. While the Chinese dragon (also called lung or long) is a creature without wings, it is nevertheless capable of flying. It appears to be a mixture of nine different animals, nine being considered a special and sacred number as it is the largest single digit. Recurring throughout Chinese and North-East Asian cultural symbolism, it is represented in myths and good-luck charms as a base figure or versions of its own multiple, and appears in the Burmese currency in denominations of 18, 27 and so on.

The animals composing the Chinese dragon are said to stem from the totemic animals of the different ethnic tribes which form the Chinese nation and its great diasporadic influences. In Chinese legends from various periods we find dragons made up from a serpent's body, a camel's head, a carp's scales, a deer's horns, an eagle's talons, a tiger's paws, a rabbit's eyes, a frog's belly and a bull's ears.

The Power of Nine

The number of scales on a dragon is also a multiple of nine: it has a total of 117, made up of 81 (9 x 9) yang and 36 (9 x 4) yin scales. Only the emperor and his highest-ranking officials wore robes decorated with nine dragons.

Dragons were believed to lay only nine eggs at a time, with each of the offspring invested with different facets of personality, mystical powers and wisdom. The Chinese reproduce these dragons in nine ways as befits their personalities: they appear on bridges (for their love of water), carved on stone tablets (because they love literature), on Buddha's throne (as they like to rest) and so on. A traditional Chinese structure, the Nine Dragons Wall, depicts them colourfully on glazed tiles. A few of these walls still exist, typically near imperial palaces and parks, the most imposing one being near the Forbidden City in Beijing.

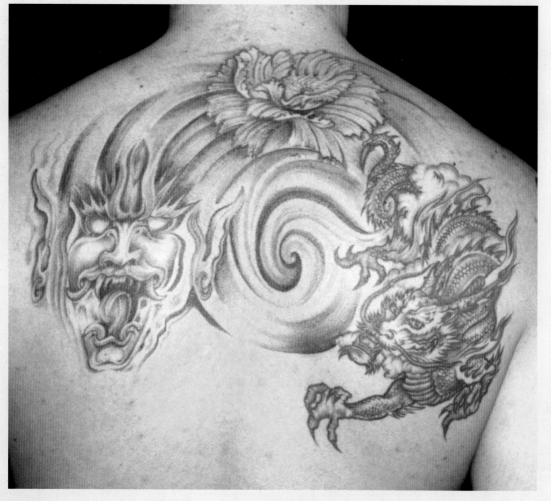

LEFT: A demon and a four-clawed dragon joined by swirls of air adorn this piece. Tattoo by Silvia Tattoo Studio, Italy

ABOVE: The Chinese Zodiac symbol for the dragon (for those born in the years 1916, 1928, 1940, 1952, 1964, 1976, 1988, 2000 and 2012)

OPPOSITE: A horned red dragon emerges dramatically from big splashes of water. Tattoo by Lutz Lehmann, Artcore Ink, Finsterwalde, Germany

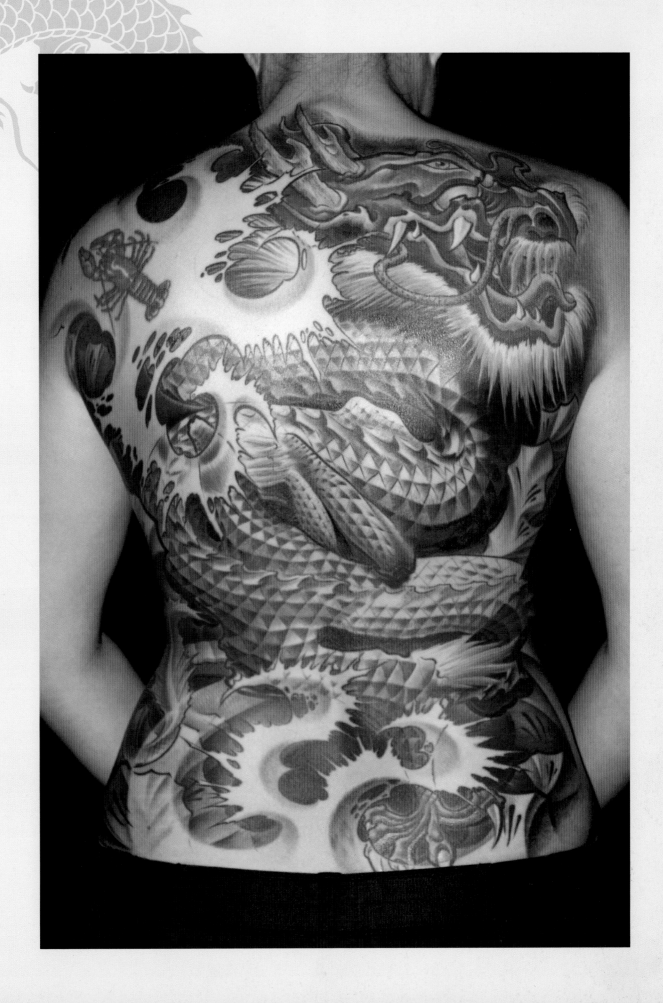

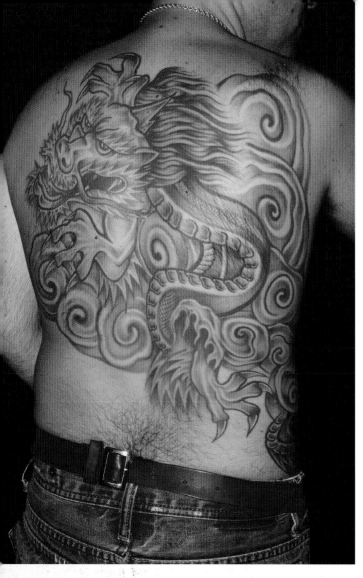

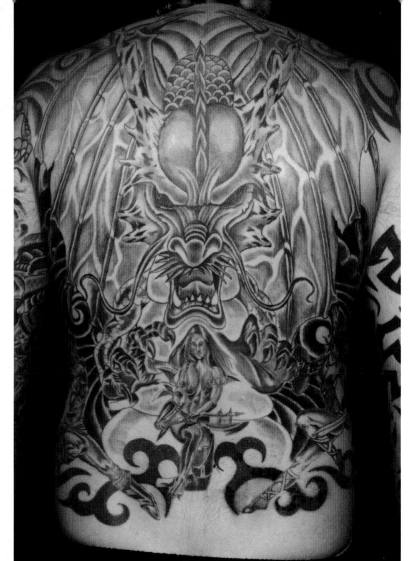

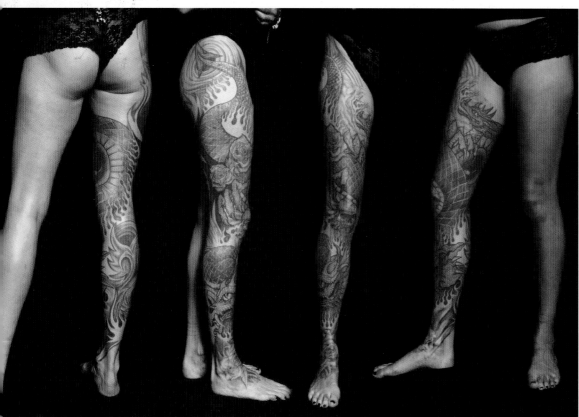

ABOVE LEFT: An ornate four-clawed dragon. Tattoo by Jorge Riera, Alicante, Spain

ABOVE RIGHT: A large winged dragon takes centre stage behind a female warrior. Tattoo by Alex McKay, The Studio, Wareham, UK

LEFT: Black and grey dragons dominate this beautiful leg tattoo by Brendan Roberts, Think Tattoos, Bolton, UK

OPPOSITE

TOP: Colourful and striking, the tattoos on these legs depict an intricate underwater scene and a red dragon ascending to the skies. Tattoo by English Rose Tattoo Studio, Peterborough, UK

BOTTOM RIGHT: A five-clawed imperial Chinese dragon coils around a bellybutton. Tattoo by Filip Leu, Sainte-Croix, Switzerland

BOTTOM CENTRE AND LEFT: An old horned dragon in black and grey wraps itself around this man's torso. Tattoo by Tattoo Mania, Mestre, Italy

The dragon's claws

There are traditional and national variations in the appearance of dragons, according to different cultures. What was originally a five-clawed dragon in Chinese mythology became a four-clawed beast in Korea, and a three-clawed creature in Japan. The Chinese claim the dragon lost a digit with each move eastwards. However, the Japanese say the dragon gained one claw as it moved westwards and the Koreans contend that their four-clawed creature gained an extra digit when moving west and lost one when travelling east.

The golden five-fingered Chinese dragon represented the emperor and it was considered treason for anyone to reproduce it. Despite the mythological imperative, Chinese dragons have also been portrayed with three and four claws, depending on the dominant dynasty. It is thought that the number of the dragon's claws may have represented the different strata of Chinese society. The five-clawed dragons have always been linked to the aristocracy or directly to the emperor. During the Qing dynasty, the five-clawed dragon was even represented on the national flag, a position it held until the establishment of the Republic of China in 1911.

Today, the majority of tattoo representations show Japanese dragons, identifiable by their three toes. Their dominance of the tattoo world increases as the influence of Japanese tattoo ink masters extends geographically, while Chinese tattoo masters are still inking only within China mostly, which means that their skin designs are less widely shared with the rest of the world.

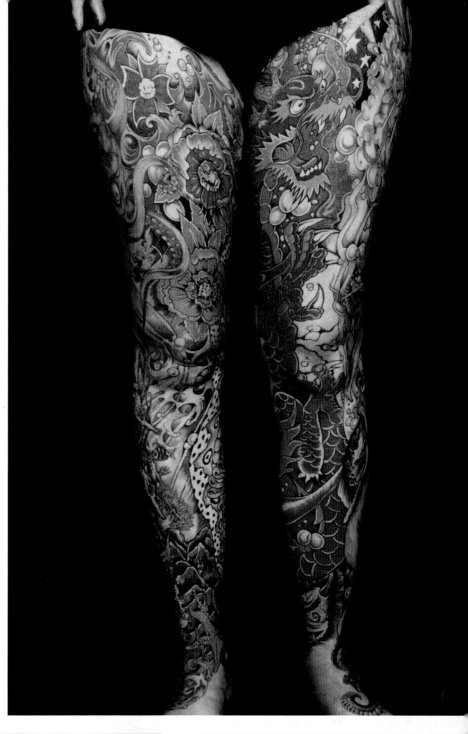

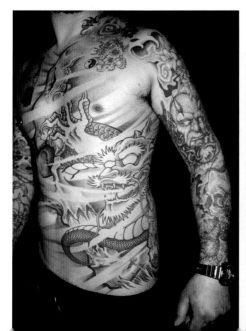

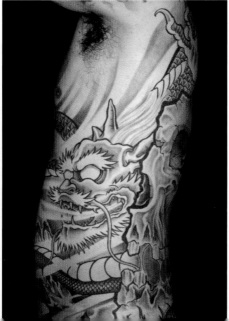

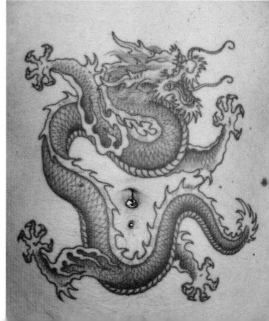

JAPANESE DRAGONS

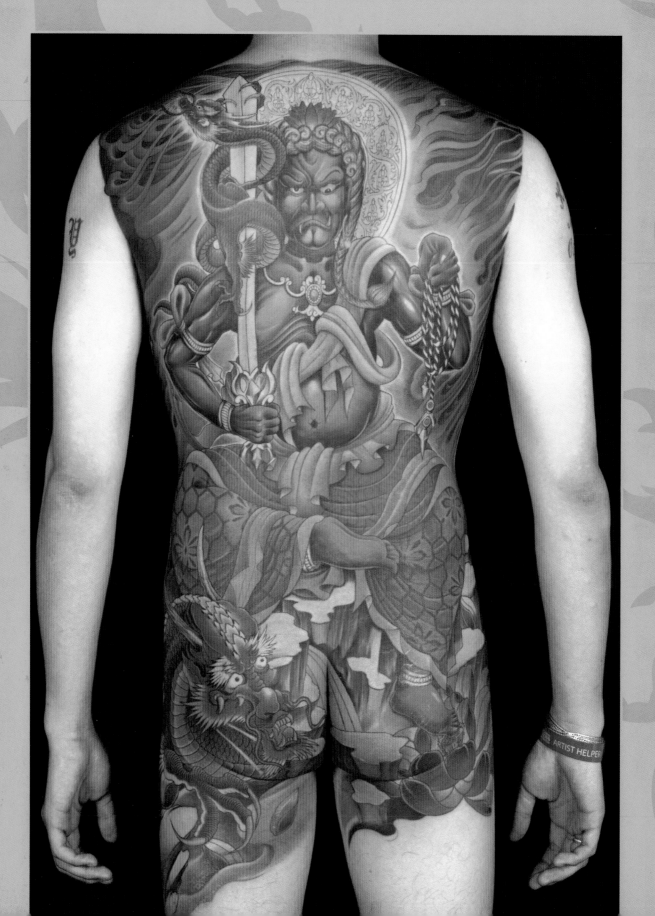

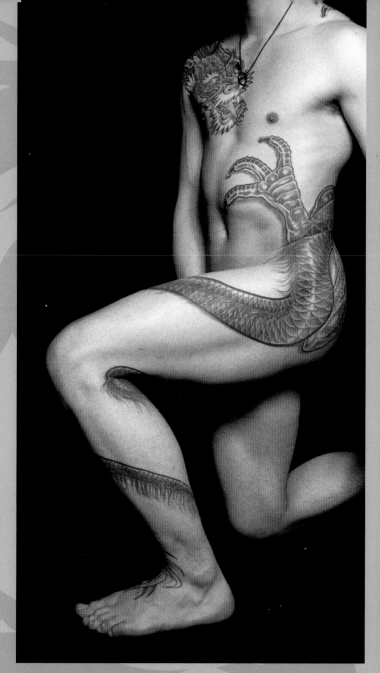

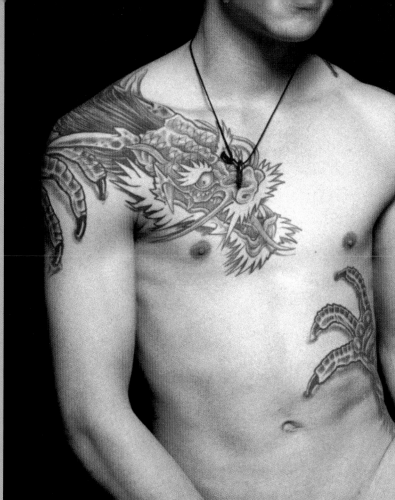

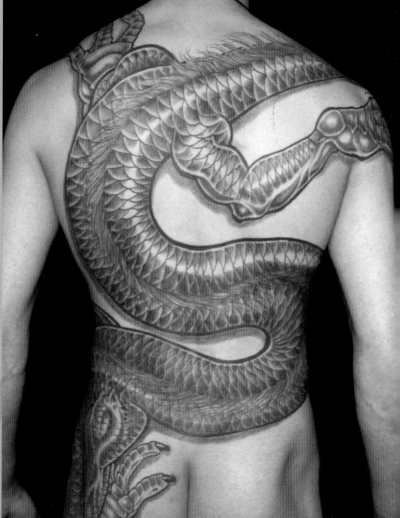

OPPOSITE: Two dragons appear in this back piece which represents Fudō Myō–ō (or Ācala in Sanskrit), the best-known of the Myō-ō deities, the Five Wisdom Kings notorious for their wrath and venerated in Japanese esoteric Buddhism. The flames all around him signify the purification of earthly desires, while his frightening appearance is supposed to scare men into salvation through self-control. The dragon wrapped around his sword is supposed to be himself in dragon manifestation as Dragon King Kurikara. Tattoo by Tang Ping, Beijing, China

THIS PAGE: A great example of a dragon bodysuit which covers most of the back and continues over the chest and legs in a dynamic and organic manner. Tattoo by Bob Hoyle, Garghoyle Tattoo Studio, Elland, UK

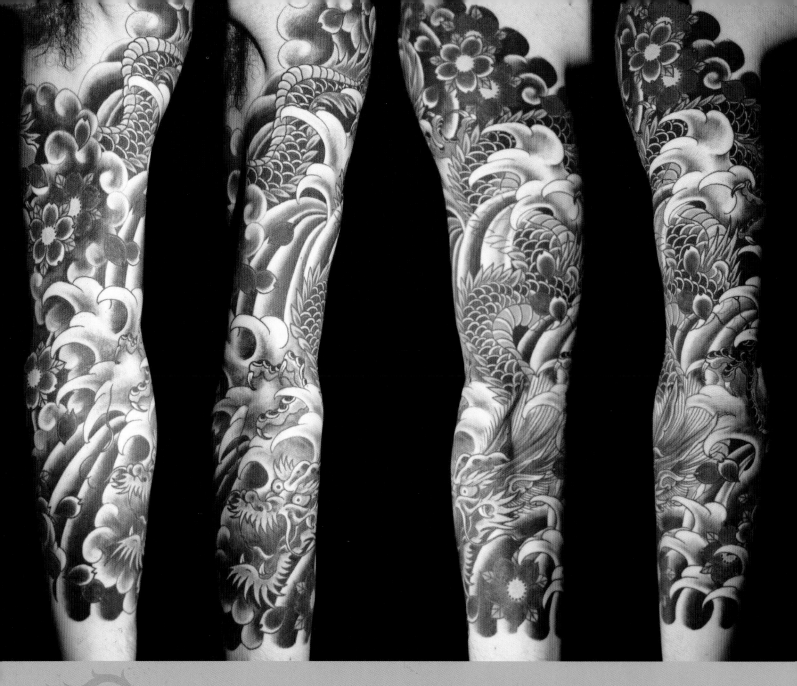

In Japan, four animals are considered sacred: the azure dragon (or Seiryu), the phoenix (or Suzaku, meaning red bird), the kirin (or Byakku, a white tiger or unicorn) and the black turtle (or Genbu). Known collectively as Shishin, these animals represent and protect the four cardinal directions of the compass. Each of them has individual traits and preferences, each is associated with a season and a specific colour, and each is assigned a sector of the night sky containing seven constellations. These four sacred animals appear throughout Far Eastern cultures, recurring in Vietnamese, Korean and Chinese imagery.

The Japanese dragon appears to have been derived from the Chinese dragon both in origin and appearance, although it only has three claws. The Indian Naga legends have also been influential on the Japanese dragon. Most of the Naga iconography arrived in Japan via China, which explains the obvious similarities between Chinese and Japanese dragons. As in China, Japan's rulers claimed to be

directly related to these divine creatures: for example, Emperor Hirohito stated that he was a descendant of Princess Fruitful Jewel, daughter of the Dragon King of the Sea.

The myths surrounding the Japanese dragon are also influenced by stories that originated in other Asian countries. These tales have been reinterpreted and assimilated into Japanese folklore, with the dragon becoming a fundamental part of many Japanese stories. A discussion of all the different dragons that exist in Japanese mythology would involve making a long list, noting the different characteristics of each creature and the meaning it embodies in its own particular tale. Each dragon has its own distinctive story which defines its significance through its interactions with other characters and explains its personality by placing the dragon in a specific narrative context. Instead of embarking on this complex process, here we look at the influence of Japanese dragon imagery and its popularity as a source of tattoo motifs.

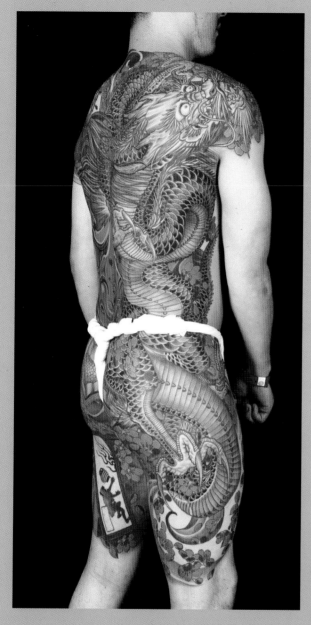

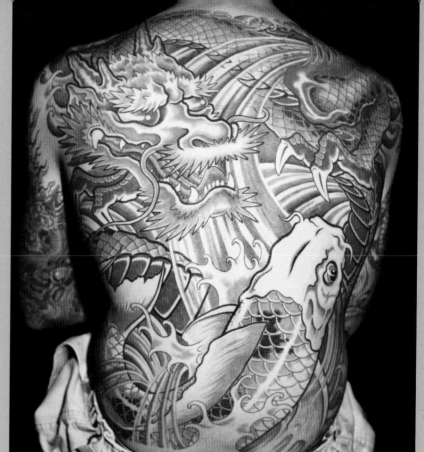

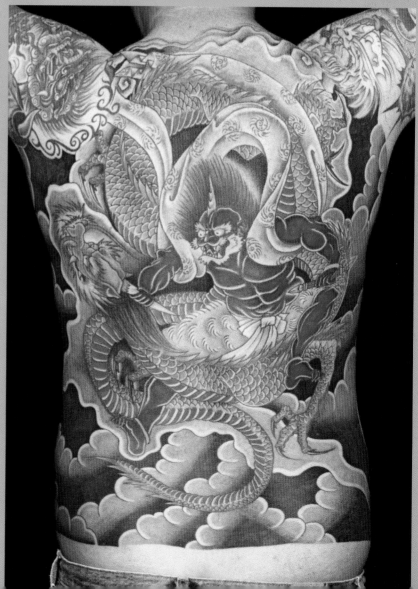

OPPOSITE: A dragon is engulfed in wild stylized waters and splashes of colour provided by red blossoms. Tattoo by Jamie Ruth, Good Times Tattoo, London, UK

ABOVE: A full back piece consisting of a large dragon going upwards and filling the back with its muscular frame, with cherry blossom all around it. Tattoo by Jess Yen, My Tattoo, Alhambra, California, USA

TOP RIGHT: A dragon and a carp together, both symbols of power and perseverance (in an ancient Chinese myth, a carp is turned into a dragon as a reward at the end of a particularly tough ordeal). Tattoo by Darren Stares, Unique Tattoo, Portsmouth, UK

RIGHT: A green dragon in a scene surrounded by vapour and what appears to be a red demon. Tattoo by Troy Bond, Phill Bonds Tattoo Studio, Torquay, UK

Dragon folklore

In Japan, the dragon goes by different names influenced by other cultures, but it is best known as ryu (also ryuu or ryo, derived from Chinese etymology) or tatsu. Ryo-Wo is the Japanese dragon king, considered to be the sea god and responsible for controlling water.

The close relationship with other Eastern civilizations such as those of India and China has heavily influenced Japanese myths and legends. Recurring images in Japanese iconography include the portrayal of dragons and pearls together. This motif also appears in Chinese art and probably originated in India. However, in Japan, an island that for centuries has depended heavily on the ocean for its sustenance, the pearl often features in sea-related narratives. The pearl is also associated with the Chintamani, a stone of alleged extra-terrestrial origin and equivalent of the Philosopher's Stone, which could turn base metal into gold, grant wishes and bestow god-like status on a human being. Appearing on Tibetan prayer flags and depicted in Hindu and Buddhist texts thousands of years before Christianity adopted the concept of the Holy Grail, the Chintamani embodies wisdom.

While water serpents and multi-headed dragons already existed in local Japanese myths, as the influx of foreign influences increased the tales assimilated other dragon types as well. Japanese dragons are often portrayed in splashing water or clouds of vapour to show their connection with the water element. They are also depicted with Buddha figures, underlining their role as protector of the Buddhist faith and its temples. Dragons are believed to live in streams or lakes near to Buddhist temples and Shinto shrines, and this conviction is often reflected in the names of Buddhist temples dedicated to specific dragons. A strand of the Shinto faith called 'Ryujin shinko' is associated with the worship of the dragon as a water spirit. It is closely connected to agriculture and fishing, with believers praying for rain for their harvests or for calm seas and a good catch.

BELOW: A colourful dragon half sleeve rendered mostly with warm colours. Tattoo by Lars, Art of Paint, Oranienburg, Germany
OPPOSITE: A wonderful piece with the dragon's serpentine body filling the whole torso, by Japanese tattoo master Horitsune II, Osaka, Japan

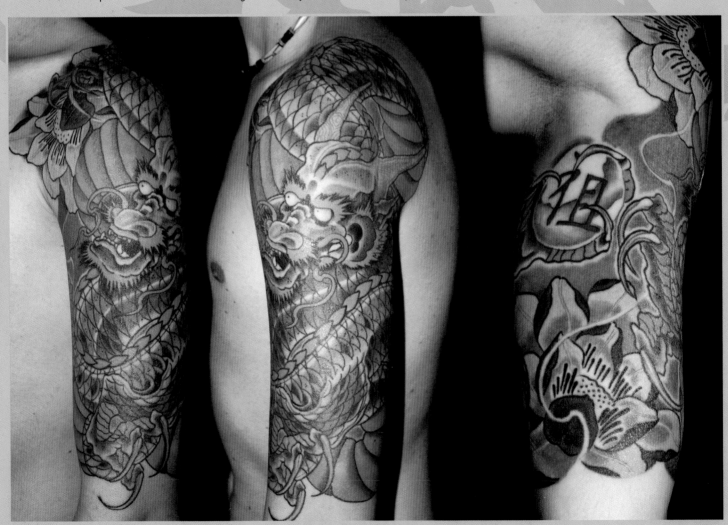

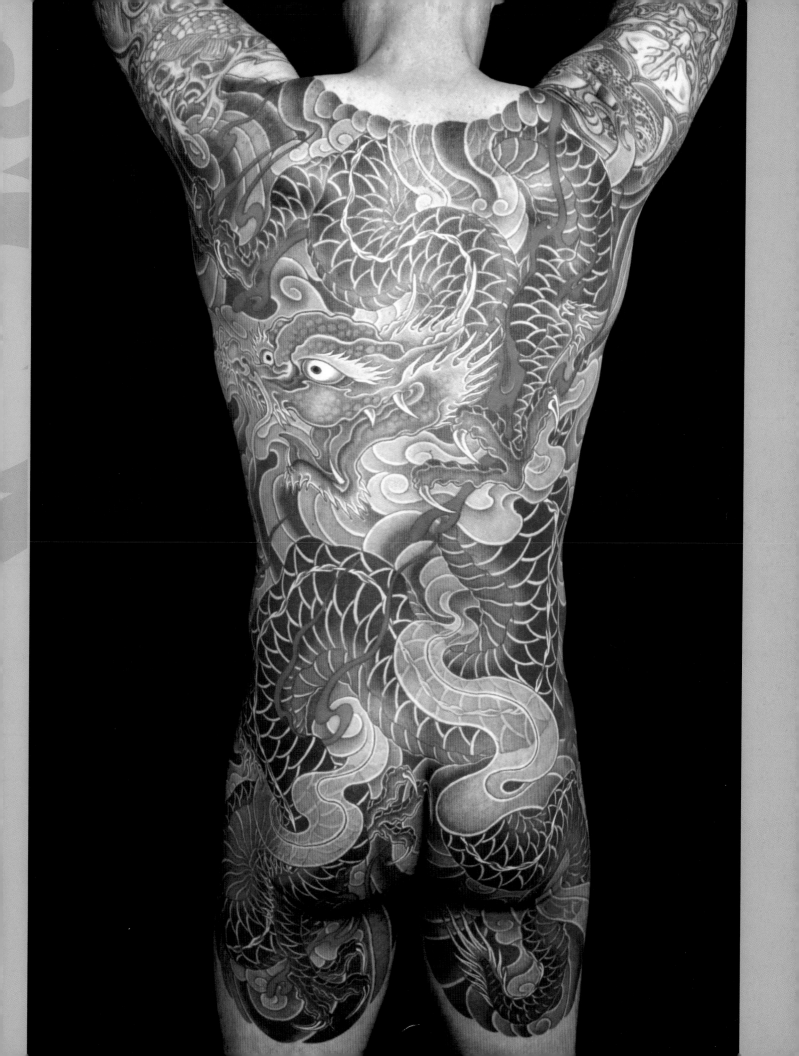

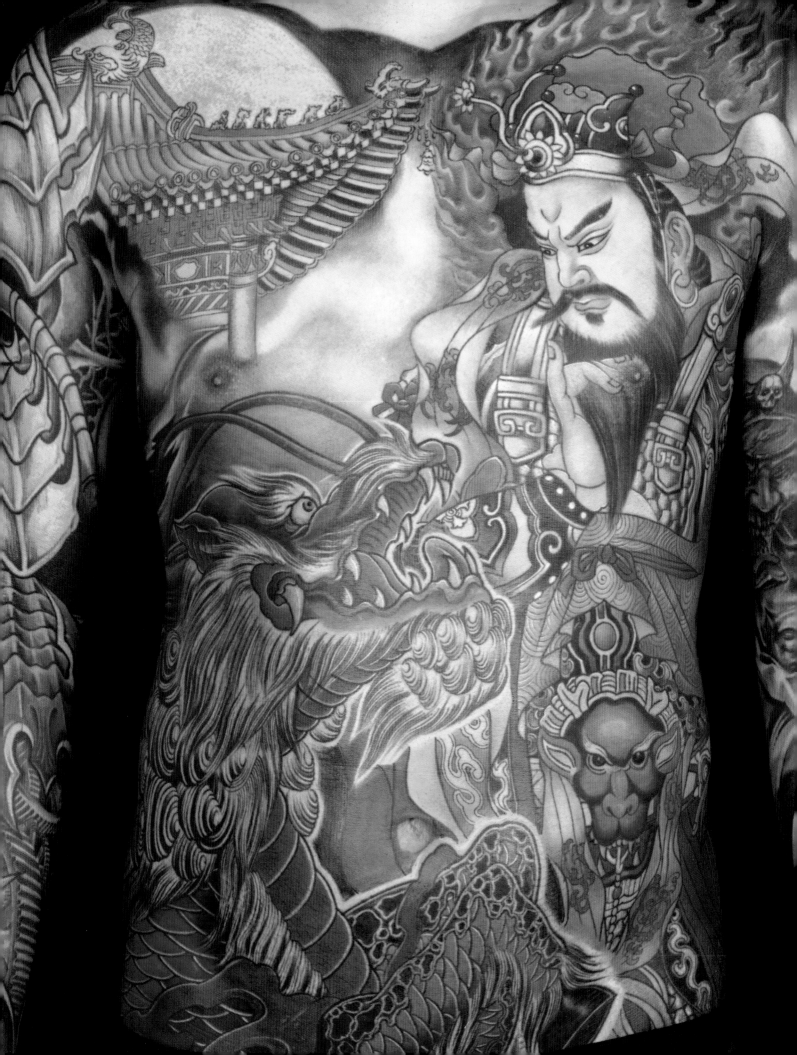

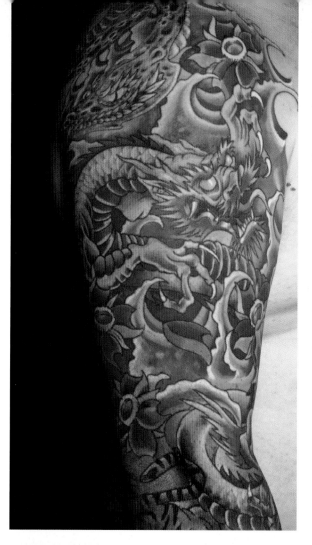

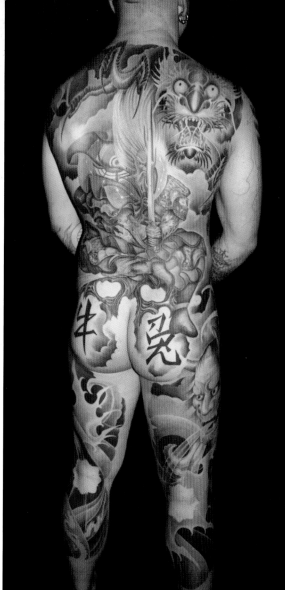

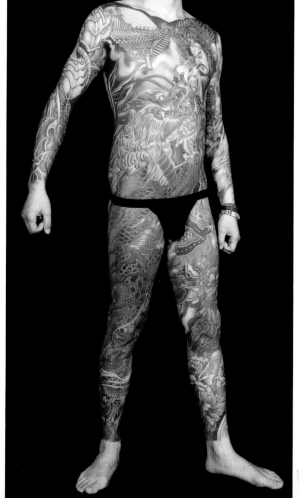

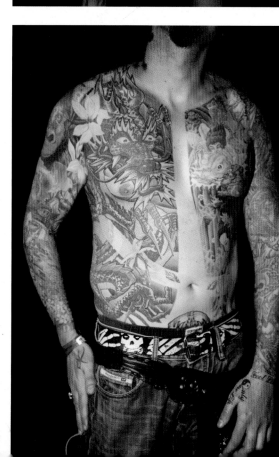

OPPOSITE AND BOTTOM LEFT: Imperial references are plentiful with dragons, from whom imperial power was supposed to have derived. The gold colour associated with emperors underlines the regal theme. Tattoo by Tang Ping, Beijing, China

TOP LEFT: A dragon in its element, water: two subjects often portrayed together. Tattoo by Matt Lapping, Inkwerx, Hull, UK

TOP RIGHT: A beautifully nuanced black and grey body suit which sees an old samurai warrior and a dragon framing the tattoo at the top. Tattoo by Sid Siamese I, Karlstad, Sweden

BOTTOM RIGHT: A striking red dragon stands out from the right side of the man's chest and abdomen. Tattoo by Tom Hanke, Tättoowier, Germany

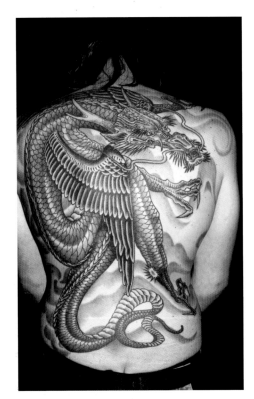

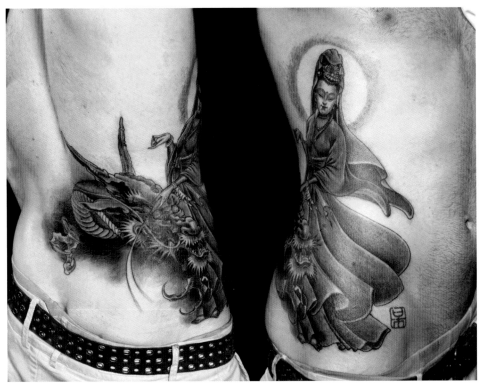

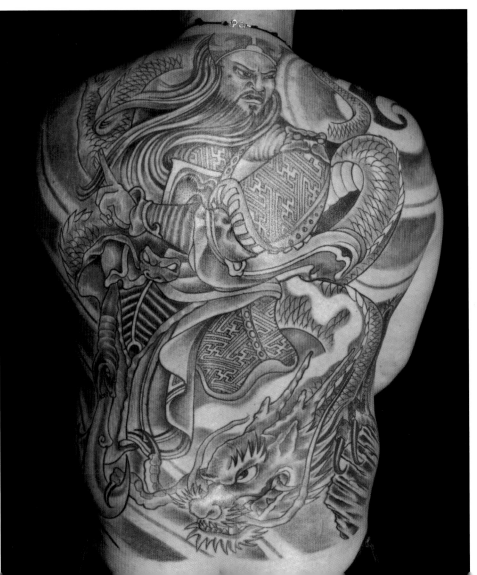

ABOVE LEFT: An unusual sight – a winged Eastern dragon. It is probably Ying-Lung (or Yinglong), a rain deity in Chinese mythology and the only dragon said to have wings. Tattoo by Neil Bass, Tattoo FX, Burgess Hill, UK

ABOVE RIGHT: A freshly tattooed piece (hence the redness) by Yang, East Tattoo, Kaohsiung, Taiwan

RIGHT: Two popular Japanese icons, the samurai and the dragon. Highly detailed and full of movement, this tattoo is by Paul Saunders, Voodoo Tattoo, Warrington, UK

OPPOSITE: Two dragons come face to face with each other in this beautifully executed back piece by George Bone, London, UK

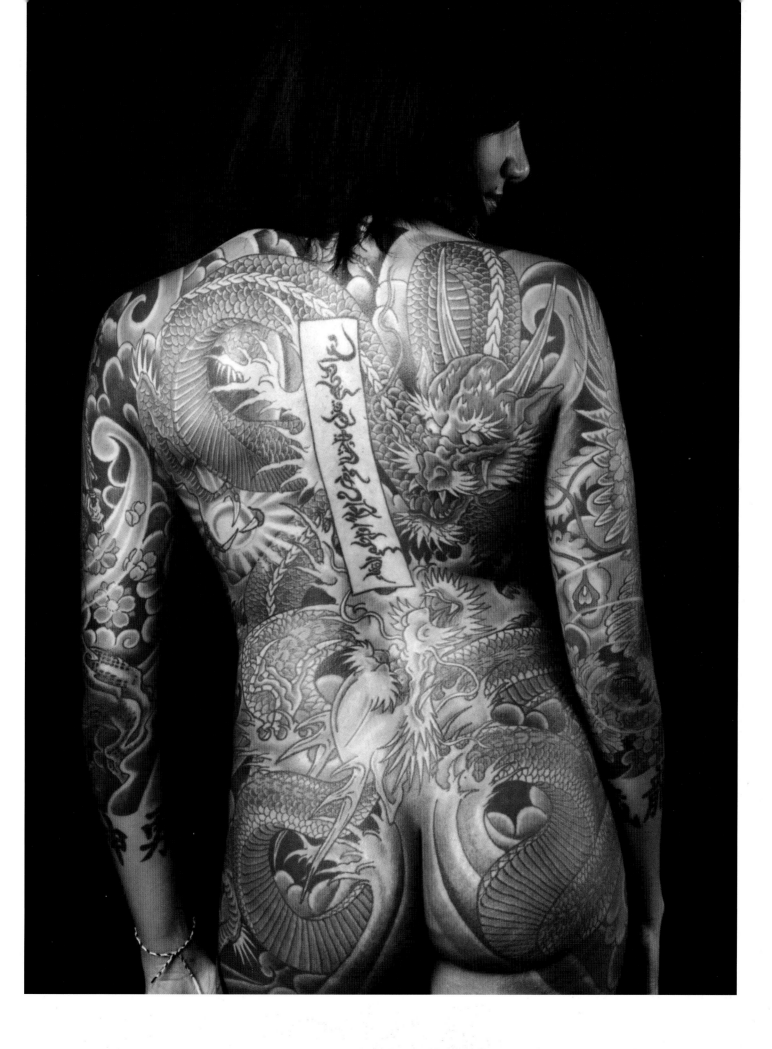

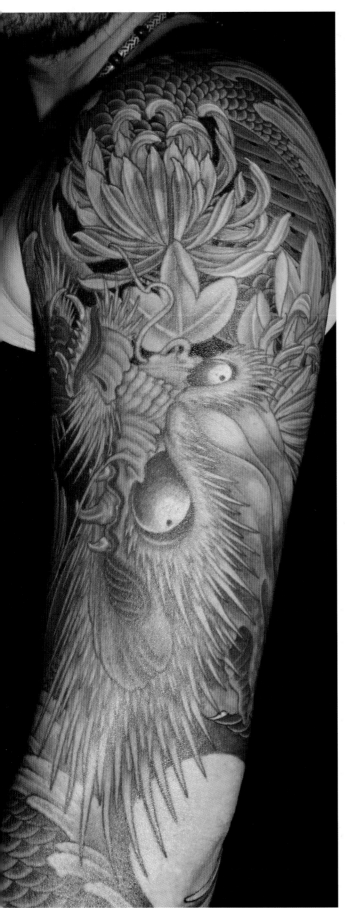

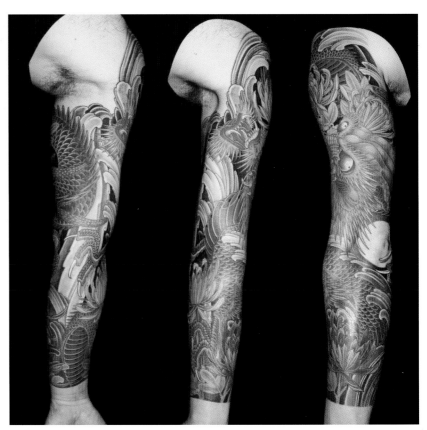

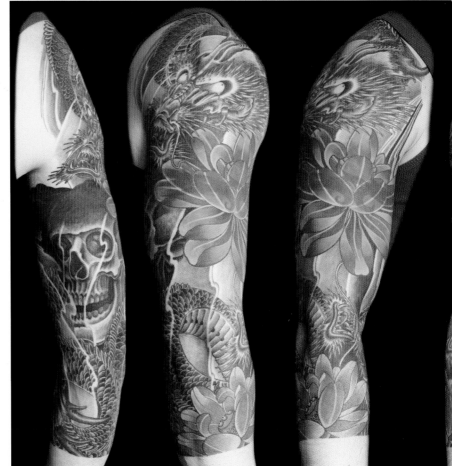

OPPOSITE FAR LEFT AND TOP RIGHT:
A bold sleeve design where a green dragon wraps around the arm. Tattoo by Noi Siamese 3, 1969 Tattoo, Oslo, Norway

BOTTOM: Dragons, a skull and colourful flowers – another sleek and bold design by Noi Siamese 3, 1969 Tattoo, Oslo, Norway

RIGHT: A striking dragon engulfed in splashes of water, its face and claw taking up most of the man's back. Tattoo by Rodrigo Souto, Black Garden Tattoo Studio, London, UK

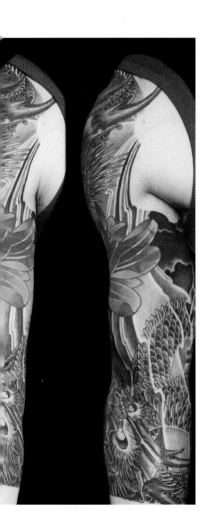

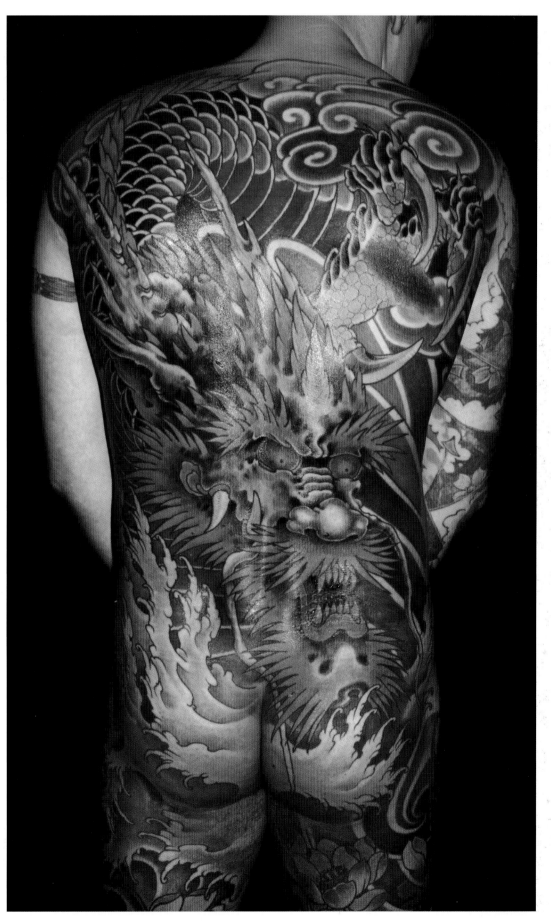

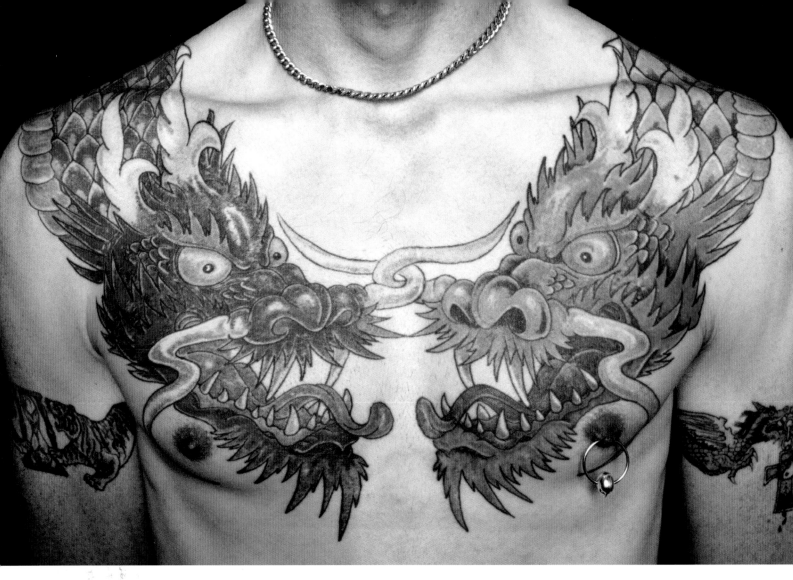

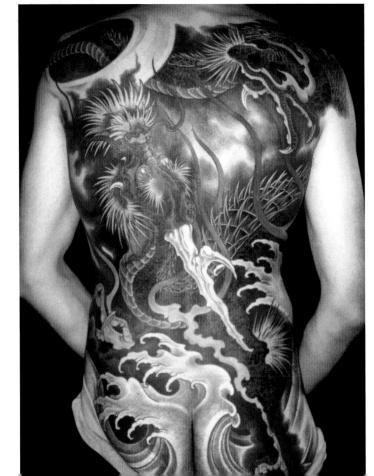 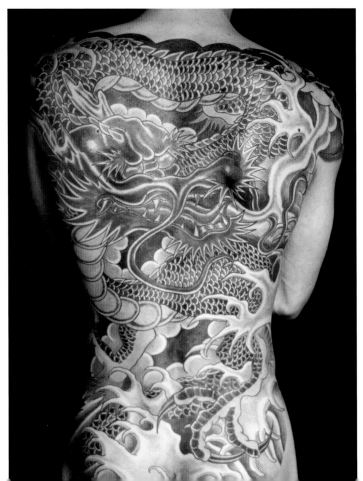

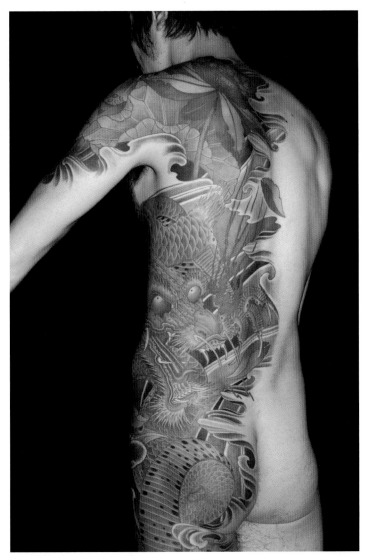

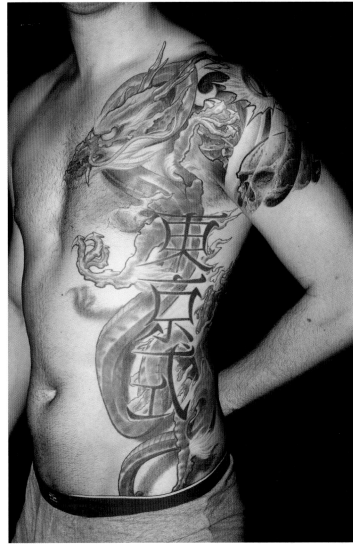

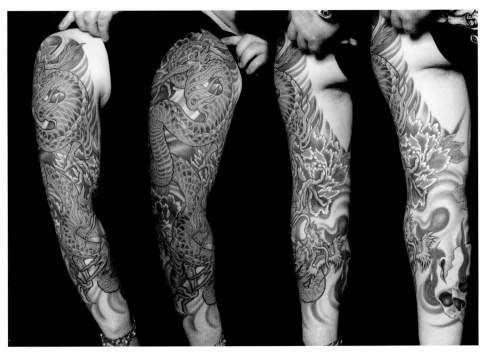

OPPOSITE TOP: Two dragons face each other and their whiskers entwine. Tattoo by Dick Want, UK

OPPOSITE LEFT: An ascending dragon in a dramatic scene with strong colours and crashing waves. Tattoo by Filip Leu, Sainte-Croix, Switzerland

OPPOSITE RIGHT: A red dragon with a yellow underbelly covers this back with its body and its claws amid Japanese-style splashes of water. Tattoo by Marco Bratt, Noordwijk, The Netherlands

TOP LEFT: A powerful green dragon takes up a whole side of this man's body in this striking design by Noi Siamese 3, 1969 Tattoo, Oslo, Norway

TOP RIGHT: An old dragon (note the long whiskers) rises from the fire. Tattoo by Lutz Lehman, Artcore Ink, Finsterwalde, Germany

LEFT: Flames, skulls, flowers and a mighty dragon: a bold tattoo wrapped around an arm by Rob Ratcliffe, Border Rose Tattoo, Littleborough, UK

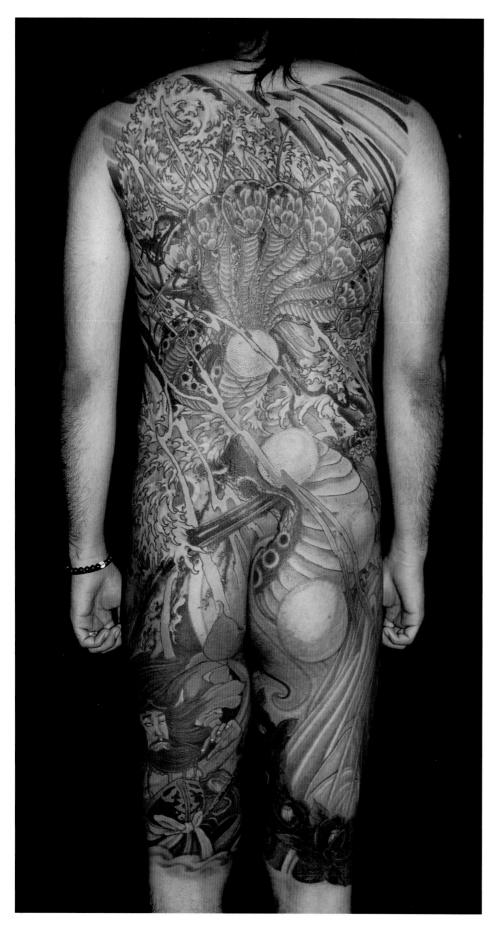

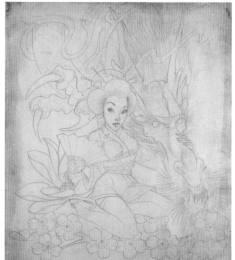

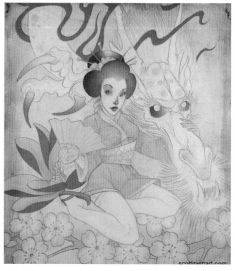

TOP AND ABOVE: A pretty geisha and a pet dragon, delicately outlined (top) and the finished product (above), illustrations by Scott Irwin aka Coolaid, One More Tattoo, Luxembourg

LEFT: According to Japanese legend, Yamata no Orochi was the name of the dragon slain by Susanoo, the disgraced brother of the sun goddess who had banished him from heaven. Susanoo intervened against the eight-headed dragon who had demanded that a local family sacrifice one of their daughters every seven years. He succeeded by getting the beast drunk on sake and then killing it. Tattoo by Takami, Knock Over Decorate Tattoo, Yonago, Japan

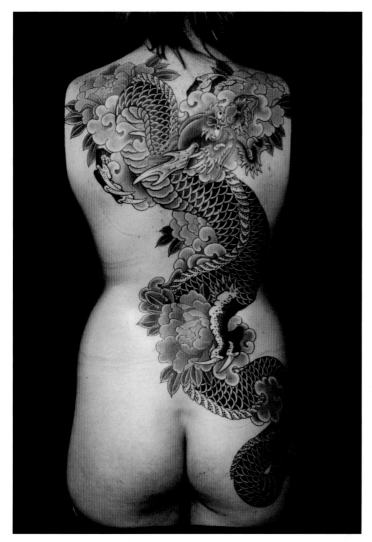

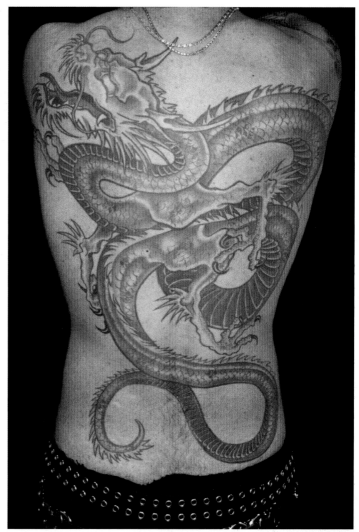

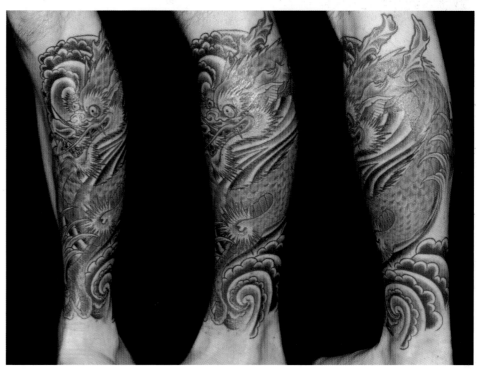

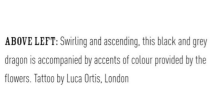

ABOVE LEFT: Swirling and ascending, this black and grey dragon is accompanied by accents of colour provided by the flowers. Tattoo by Luca Ortis, London

ABOVE RIGHT: Serpent-like movements propel the dragon through the air. A dynamic piece by Vladi Tattoo, Lecce, Italy

RIGHT: Swirls of vapour surround this blue dragon. Tattoo by Stewart, Angelic Hell, Brighton, UK

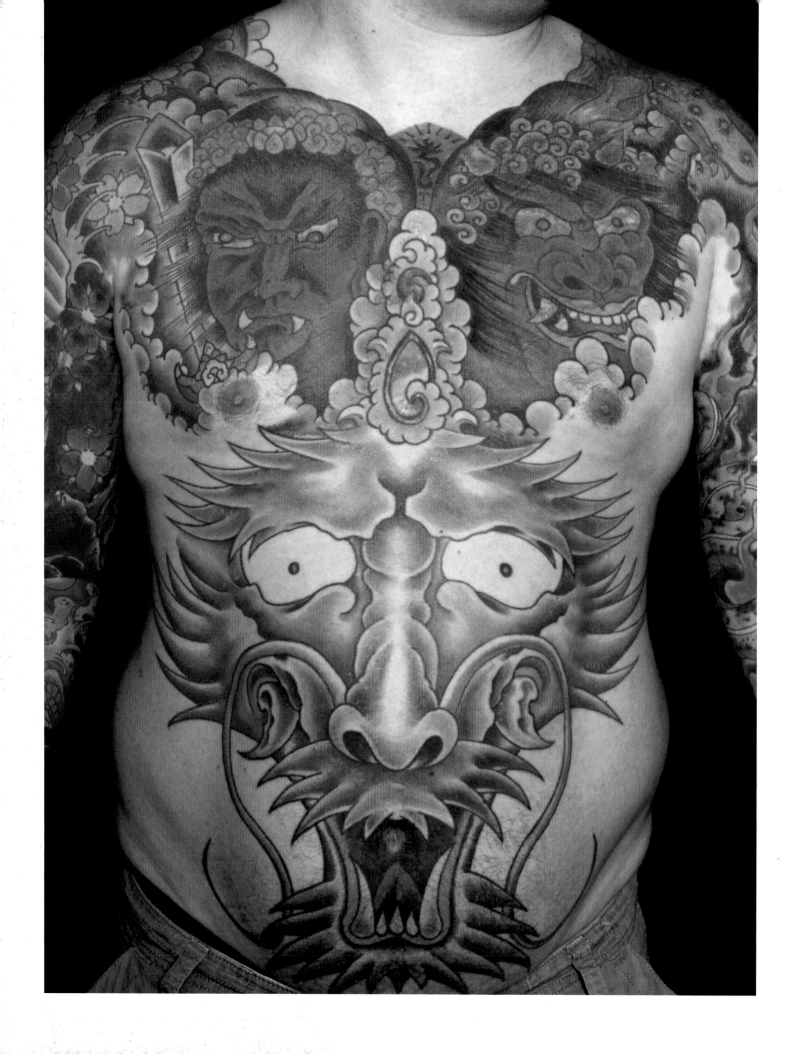

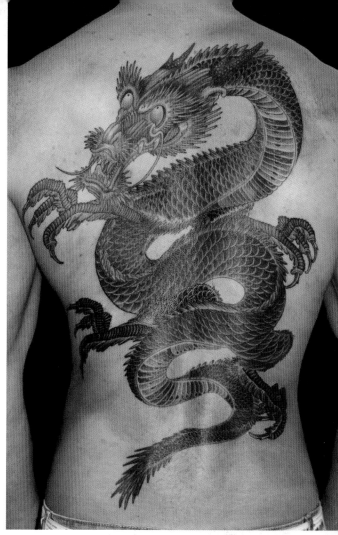

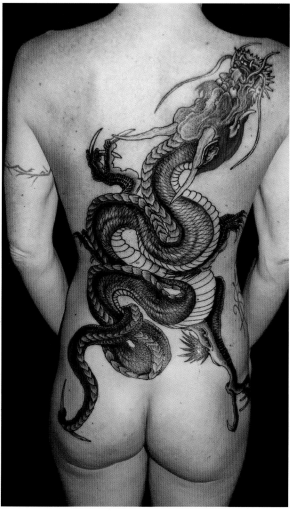

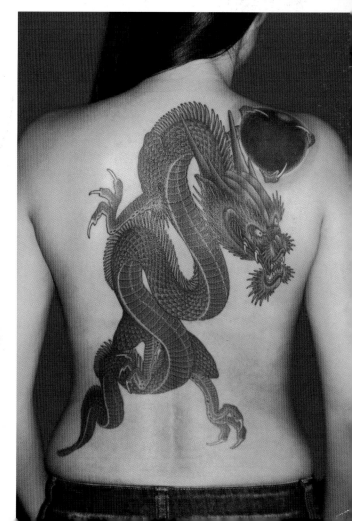

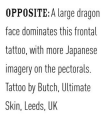

OPPOSITE: A large dragon face dominates this frontal tattoo, with more Japanese imagery on the pectorals. Tattoo by Butch, Ultimate Skin, Leeds, UK

TOP LEFT: The movement in this tattoo provides the perfect composition for this black and grey piece by Skin Fantasy, Cleethorpes, UK

TOP RIGHT: A bold design rendering the reptilian appearance of the dragon in black and grey. Tattoo by Noi Siamese 3, 1969 Tattoo, Oslo, Norway

BOTTOM RIGHT: Rising high through the skies clutching a large black pearl, this dragon is by Noi Siamese 3, 1969 Tattoo, Oslo, Norway

BOTTOM LEFT: An ascending dragon, in strong contrasting tones of black and red. Tattoo by Takami at Knock Over Decorate Tattoo, Yonago, Japan

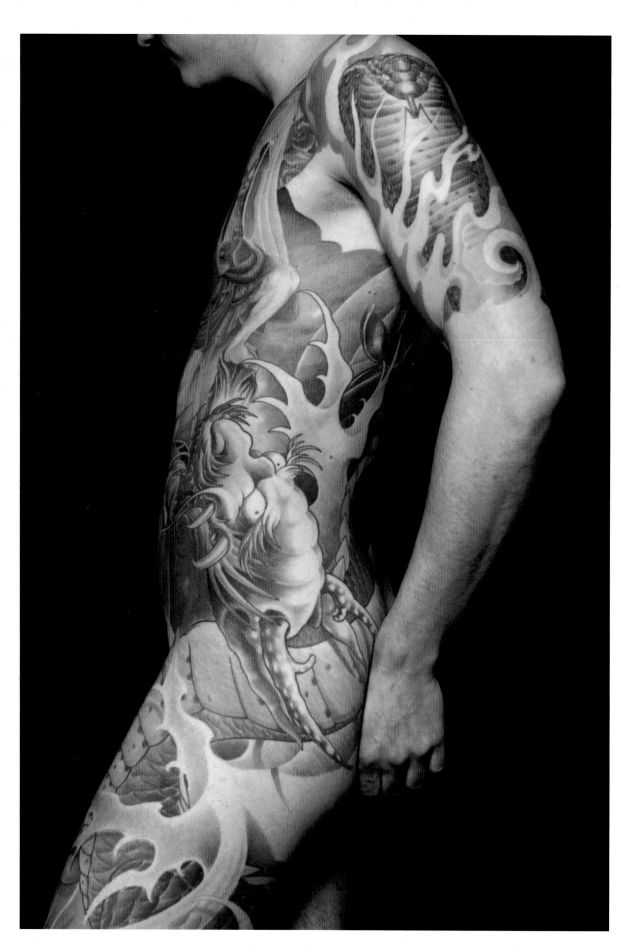

LEFT: A beautifully woven work with a delicately nuanced black and grey dragon who rises from the ocean waves. The cobra at the top of the arm also suggests the serpentine connection. Tattoo by Sid Siamese I, Karlstad, Sweden

OPPOSITE TOP LEFT: There are strong lines and subtle shading in this tattoo by Neil Bass, Tattoo FX, Burgess Hill, UK

OPPOSITE TOP RIGHT: A popular choice of placement on the body: the dragon wraps itself around the arm and its face adorns the chest area. Tattoo by Ray Hunt, Diablo Tattoo, Rochester, UK

OPPOSITE BOTTOM: A black and grey dragon that wraps itself around the man's torso starting from the top of the shoulders. Tattoo by Robert Hernandez, Spain

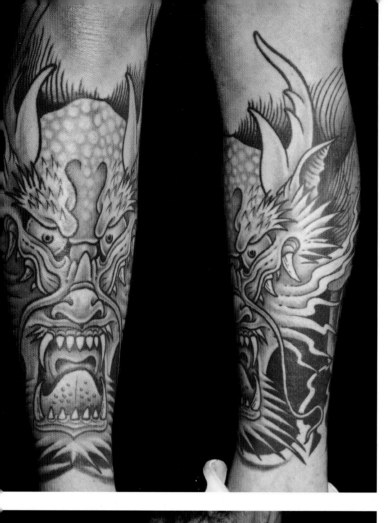
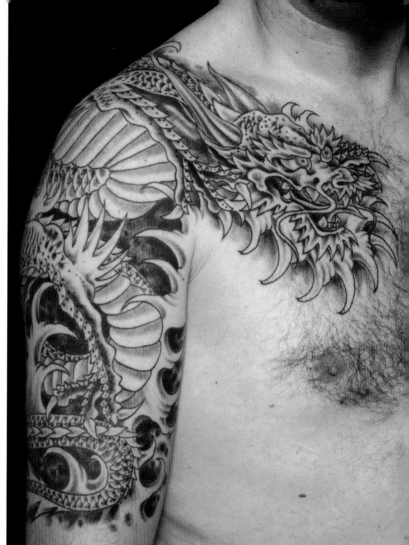
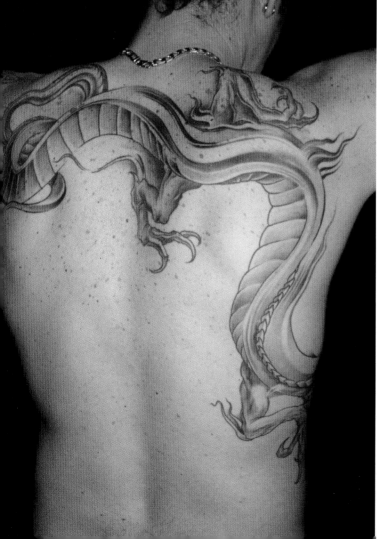
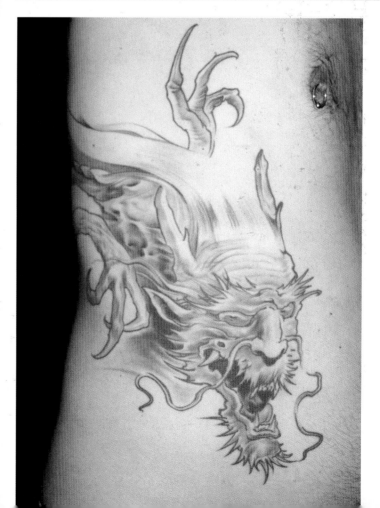

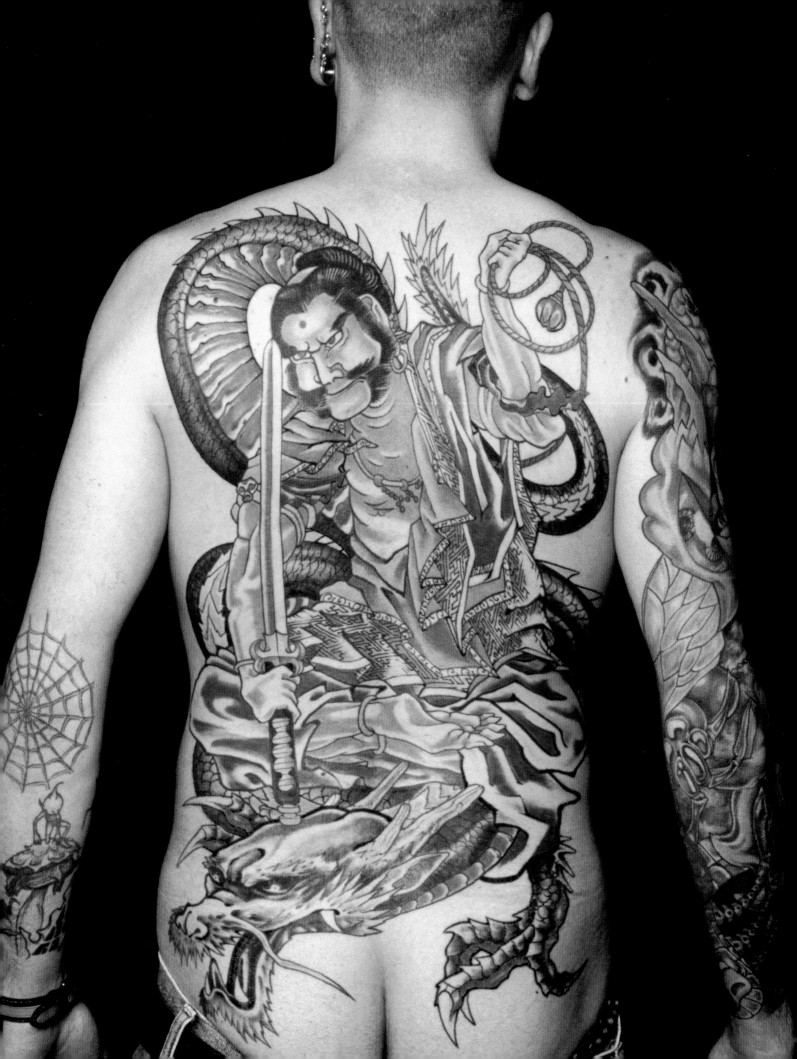

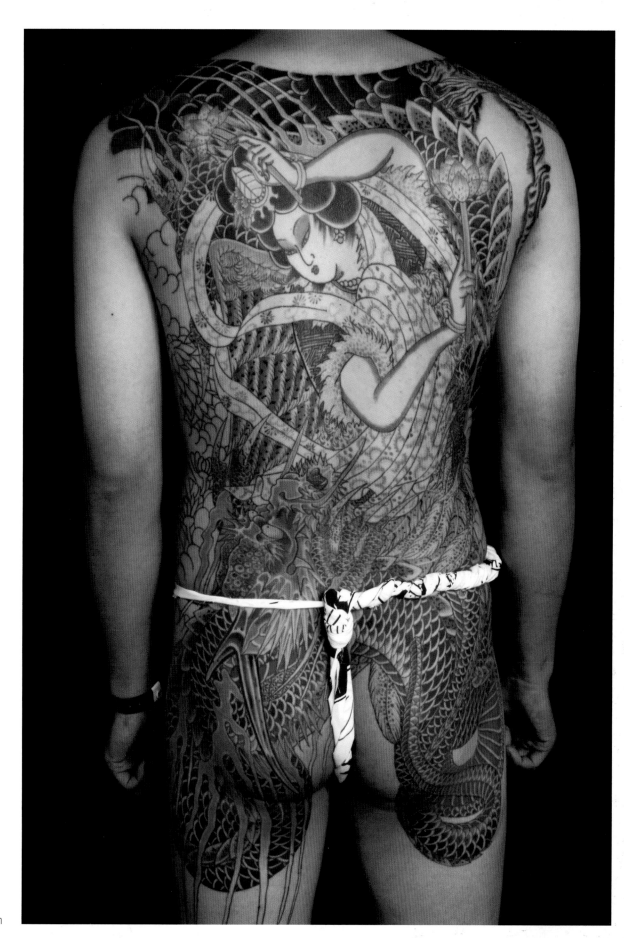

OPPOSITE: A samurai warrior and a dragon, two strong symbols in Japanese imagery. Tattoo by Claudio Pittan, Claudio Pittan Tattoo, Milan, Italy

RIGHT: The flowing robe of the lotus-holding geisha and the coils of the dragon create a dynamic and colourful back piece. Tattoo by Horikoi, Japan

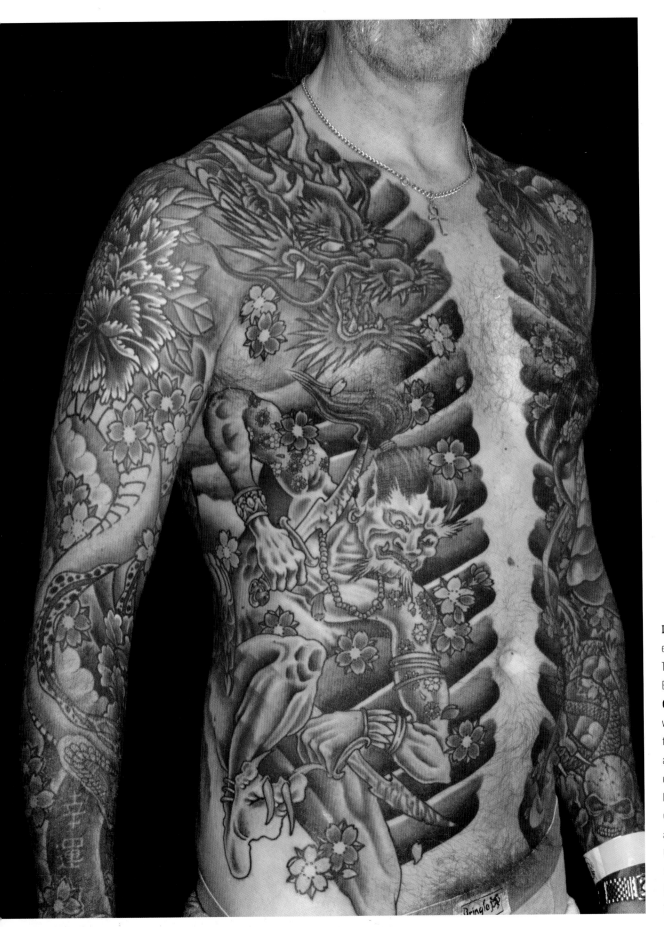

LEFT: A blue four-toed oni escapes a dragon chasing it. Tattoo by Neil Bass, Tattoo FX, Burgess Hill, UK

OPPOSITE TOP: Coiling its way through water and fire, this dragon wraps around the arm and shoulder and ends on the chest. Tattoo by Andy Bowler, Monki Do, Belper, UK

OPPOSITE BOTTOM: Bold and highly stylized in striking black and grey, this tattoo is made up of a large dragon head, a demon and a koi. Tattoo by Ichie, Austria

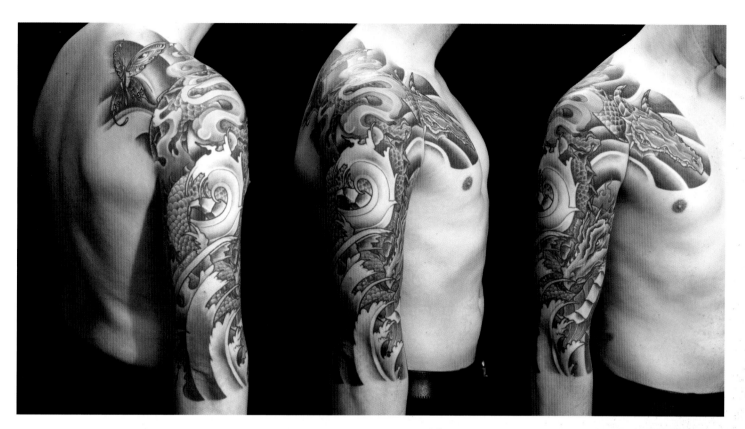

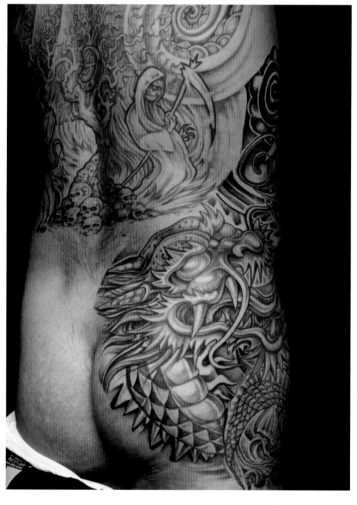

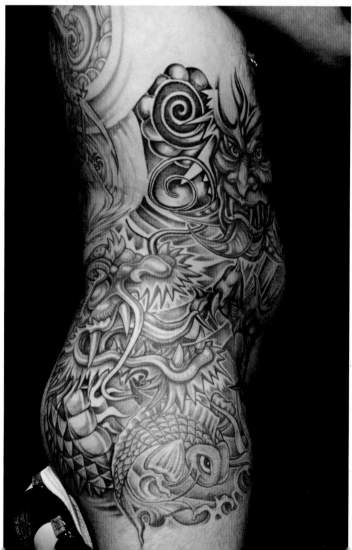

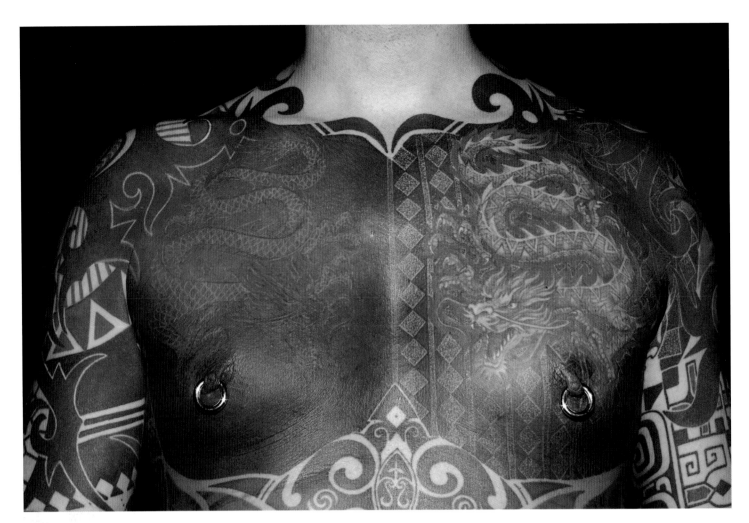

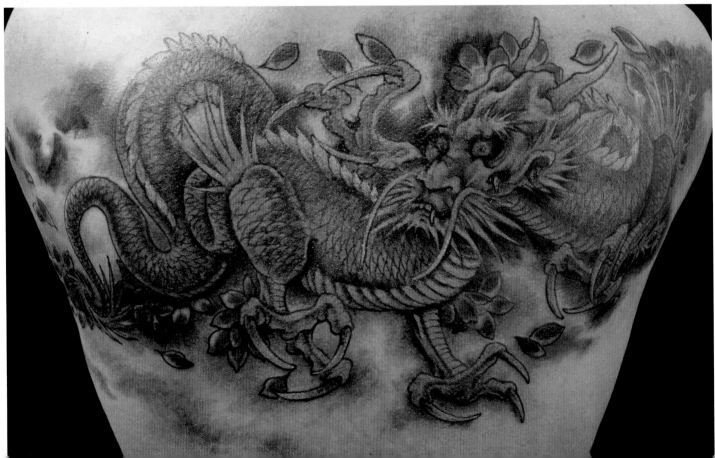

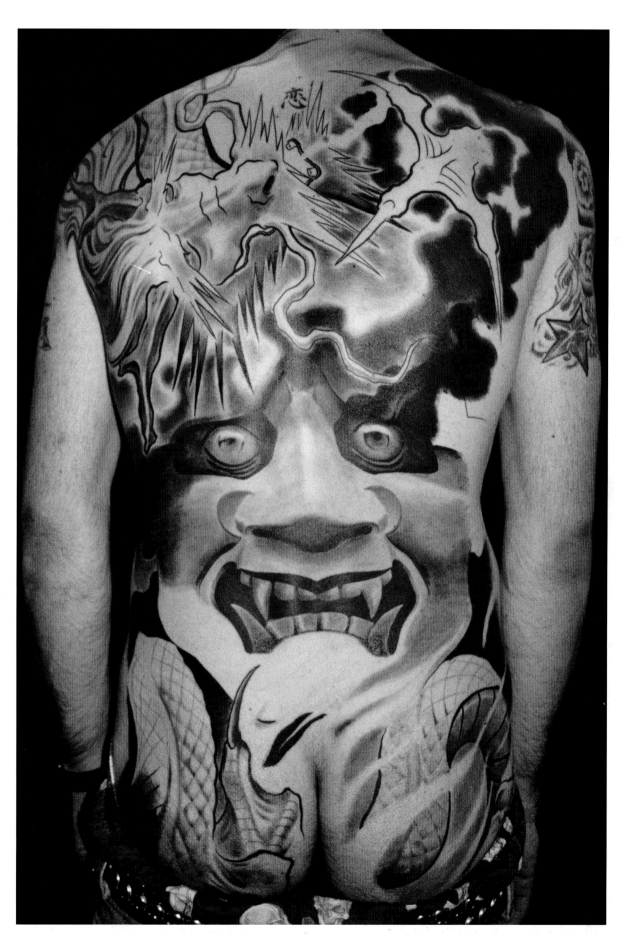

OPPOSITE TOP: Two dragons embedded in a larger design, both surrounded by tight patterns and strong dark colours. Tattoo by Yvonne, Blut & Eisen, Berlin, Germany

OPPOSITE BOTTOM: Covering the top of a back, this Japanese ryu in a cloud of vapour manages to be dynamic yet light. Tattoo by Takami at Knock Over Decorate Tattoo in Yonago, Japan

RIGHT: A large-scale tattoo with bold designs. A demon's face dominates the back, and a dragon coils around it. Tattoo by Cristian Benvenuto, Buenos Aires, Argentina

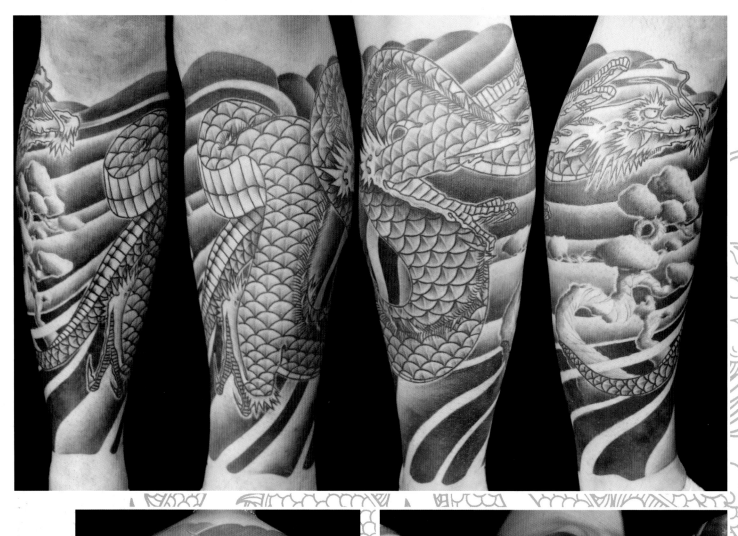

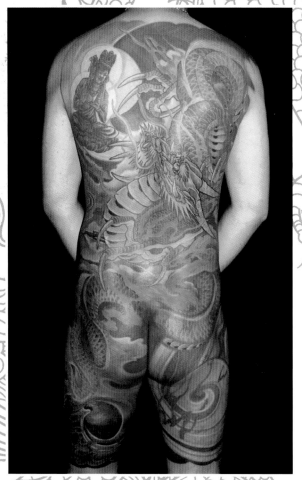

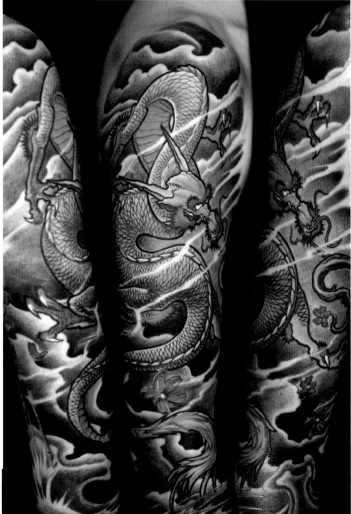

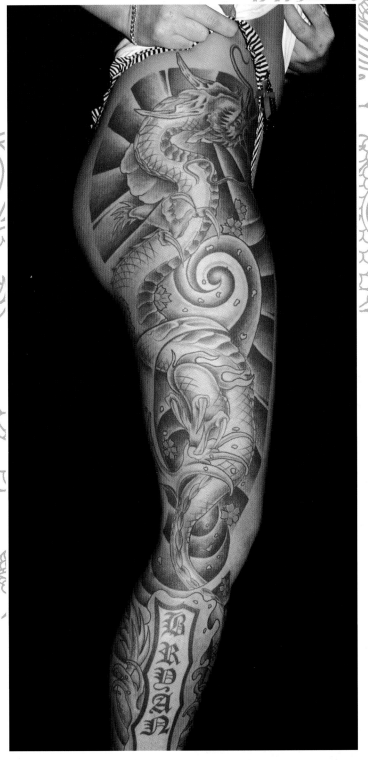

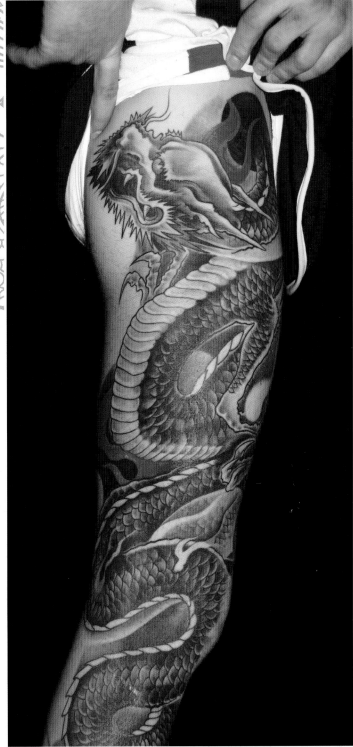

OPPOSITE TOP: Using serpentine moves to ascend quickly through the clouds, a dragon leg design by Mark Gibson, Monki Do, Belper, UK

OPPOSITE BOTTOM LEFT: A spiritual piece which features a large ascending dragon rising through coloured fumes. Tattoo by Takami at Knock Over Decorate Tattoo in Yonago, Japan

OPPOSITE BOTTOM RIGHT: Very bright and colourful, this blue dragon seems surrounded by adverse elements. Tattoo by Robert Kornaijser, One More Tattoo, Luxembourg

LEFT: Ascending through the skies on a stylized background, the dragon curls around the leg. Tattoo by Matt Oschersleben, Germany

RIGHT: A bold black and grey dragon design fills the leg with accents of red. Tattoo by Sebastian, Tattoo Gonzo, Poland

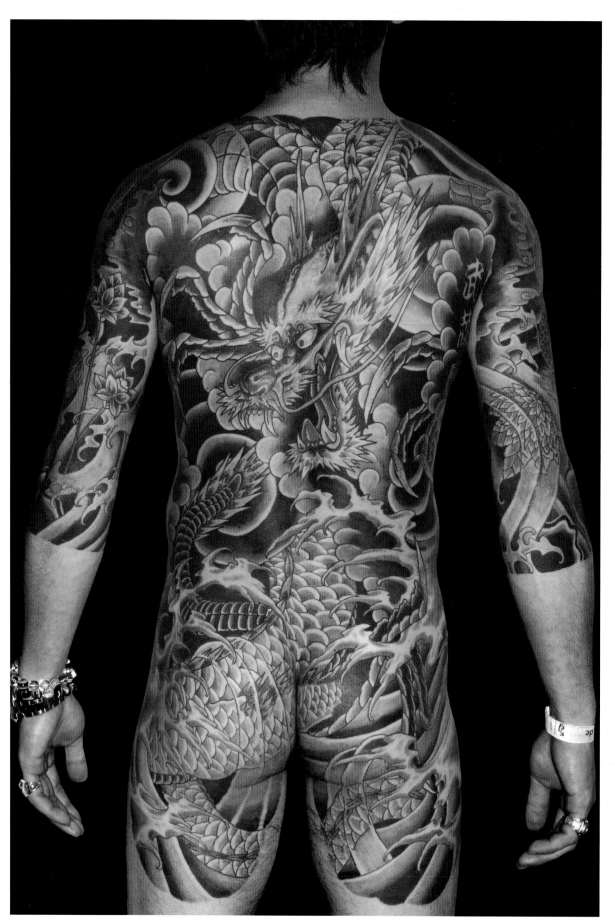

LEFT: A wonderful back piece dedicated to one dragon shows its powerful serpentine body rising from the waters to the skies. Tattoo by Musashi, Supertattoo, Osaka, Japan

OPPOSITE TOP: A beautiful blue dragon with a flower motif adorns these shoulders. Tattoo by Sacha, Primitive Abstract, Oslo, Norway

OPPOSITE BOTTOM LEFT: A bold, bright green dragon makes up a half sleeve. Tattoo by Eun Sen Sin, One More Tattoo, Luxembourg

OPPOSITE BOTTOM RIGHT: A beautiful organic piece with bold designs and plenty of movement. Tattoo by Richard Sorensen, One More Tattoo, Luxembourg

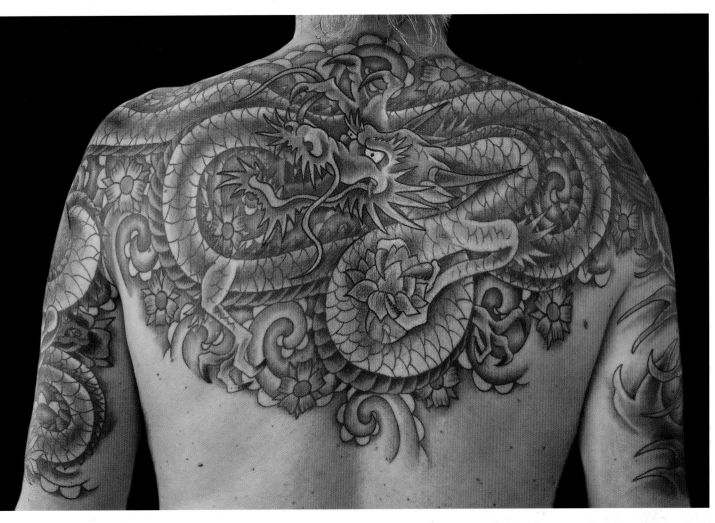

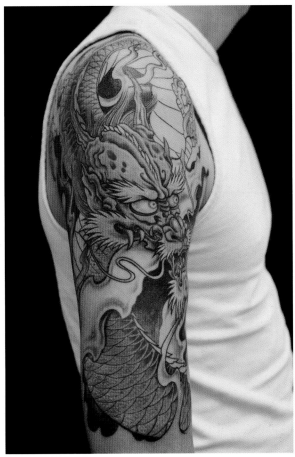

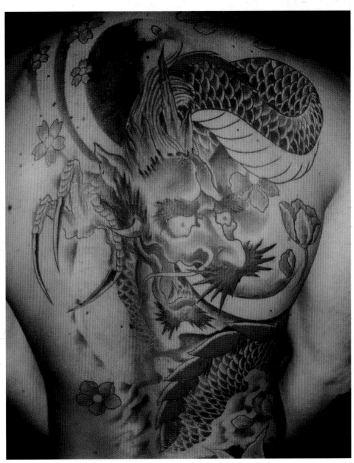

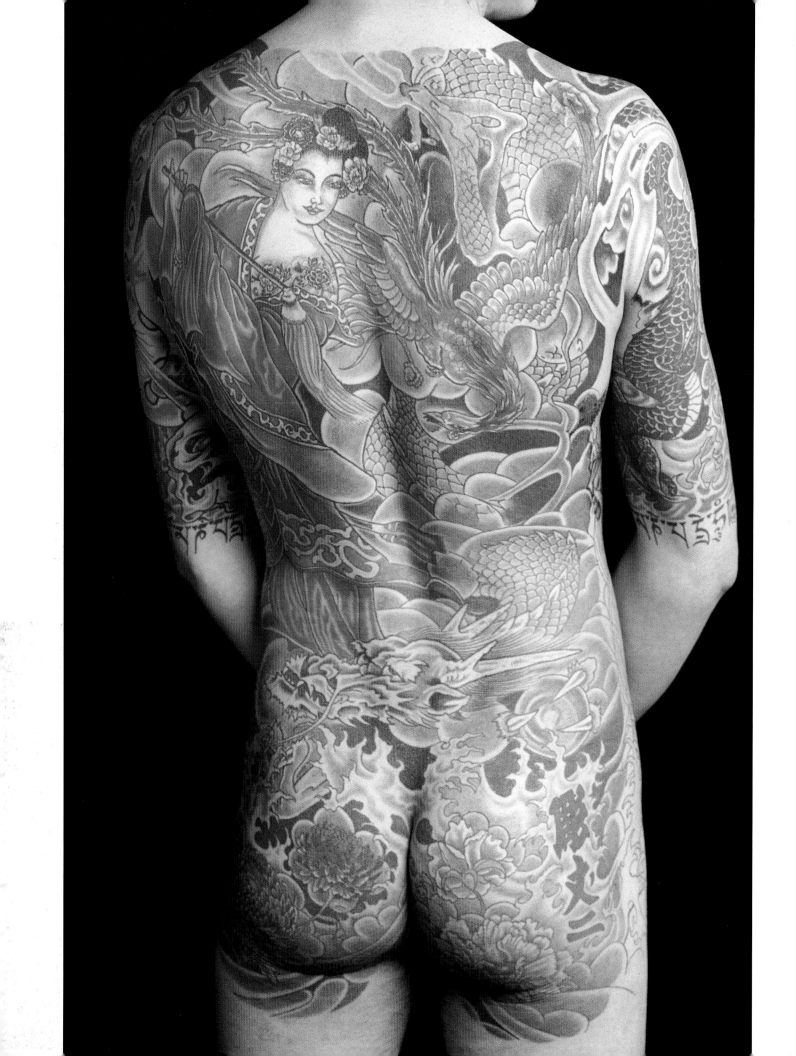

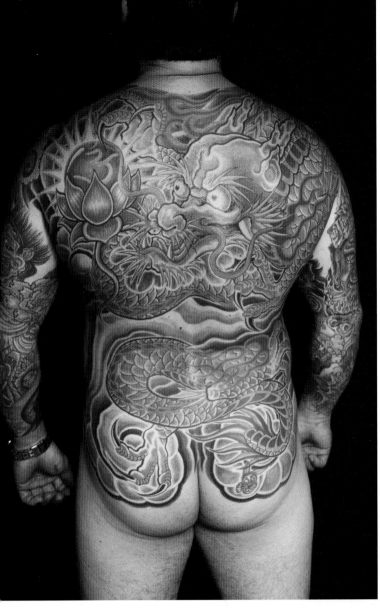

The symbolism of the pearl

Dragons are often depicted holding or chasing a luminous pearl, which is invested with yang energy and known as the pearl of wisdom. These are benevolent dragons in the Buddhist tradition, representing feminine yin energy and chasing the yang of truth and knowledge within the pearl.

The sacred pearl lends itself to various interpretations. Its symbolism stems from Taoist thought and it represents truth as well as primordial energy. It often has an irregular mark on it, taken by many to signify the yin in the pearl's yang, or even a fertilized ovum. In Buddhism the pearl is said to be born out of a lotus flower (also often depicted with dragons); its powers allegedly enable it to grant all desires. In ancient China, black pearls were said to originate from the brains of dragons and were only released when the dragons fought, hence the popular imagery of the dragon holding on to a pearl.

The pearl is often shown ablaze as it moves across the ether, with the dragon in hot pursuit or clutching it in its claws or mouth. The moon, the pearl and the dragon are closely linked: according to some scholars, pearls are formed from drops the moon releases into oysters. The moon also exerts control over the Earth's waters and is reborn every month, a symbol of immortality and regeneration. The dragon is also closely connected to water and has the power to release it to irrigate the land for growth, or ravage it with floods. Some dragons are shown living in the depths of the sea or other water dwellings.

OPPOSITE: A geisha, a phoenix and a dragon clutching a pearl of wisdom are among the elements which animate this large and colourful piece by George Bone, London, UK

ABOVE: A pearl is born out of a lotus flower as the dragon approaches to grasp it. Tattoo by Greg Orie, Dragon Tattoo, Eindhoven, The Netherlands

RIGHT: An epic battle starring a warrior, a sea serpent and a dragon. Back piece by Tacomachi Tattoo, Monfalcone, Italy

FAR RIGHT: In a striking and beautifully composed back piece, this dragon emerges from stylized red flames. Tattoo by Elisa Tattoo, Scandiano, Italy

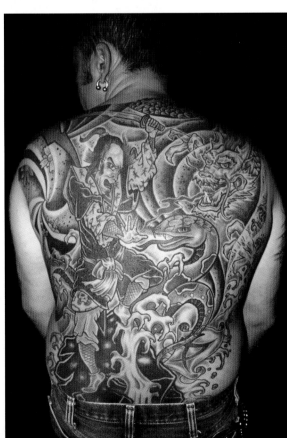

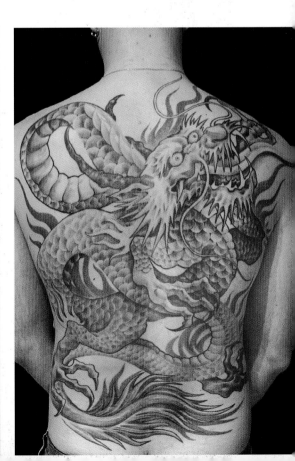

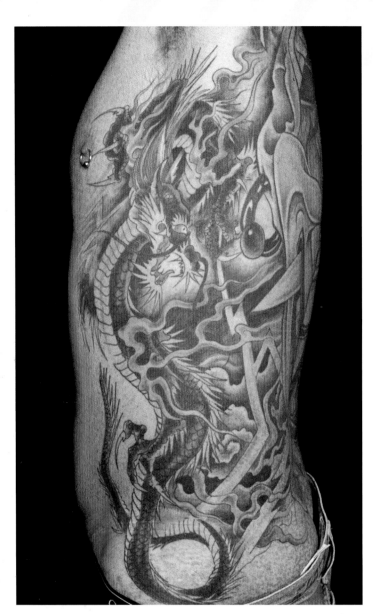

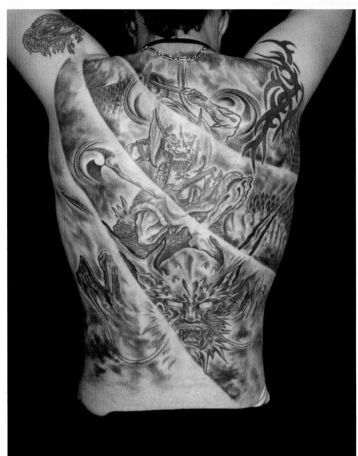

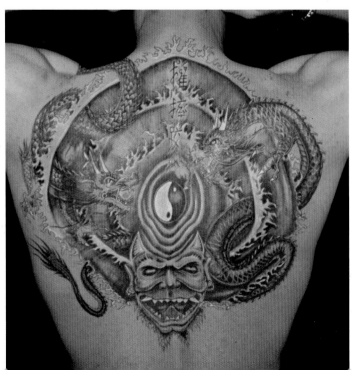

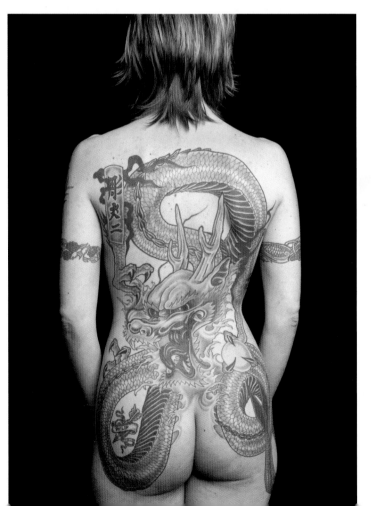

From kings to criminals

Japanese-style tattoos are very popular in the West. This is by no means a recent phenomenon – as early as 1882 the future King George V of England received a dragon tattoo on his arm from tattoo master Hori Chiyo during a visit to Japan. However, for many years tattooing was associated with the criminal underworld and carried a considerable stigma. The popularity of Japanese-style tattooing and the admiration extended to Japanese artists has done much to elevate it to a more respected figurative art form, although in Japan large tattoos and body suits are still strongly associated with affiliation to the Yakuza crime organization, the tattoos being a symbol of the members' commitment and a reflection of their inner strength.

The subject matter of Japanese-style tattooing varies, but it is inextricably tied to native folklore and dragons are a favourite motif. Honour, power, wisdom and perseverance are all qualities that are associated with the Eastern dragon and those who wear it on their skin seek to assimilate those attributes.

Japan's visual output has been highly influential in other ways, especially in popular culture in the form of cartoons or anime. These are usually derived from manga comics, whose characters are influenced by aspects of Japanese life such as religion, mythology, history and so on. No topic is off-limits for anime film-makers and dragons are a big part of the fantasy strand. One of the most successful series ever made was *Dragon Ball*; the books alone have sold more than 200 million copies worldwide. Dragon characters also populate the numerous anime TV series produced in Japan: *Blue Dragon*, *Yu-Gi-Oh!*, *Dragon Drive* and *Dragon Crisis!* are just a few of the stories to delve into Japan's rich mystical heritage.

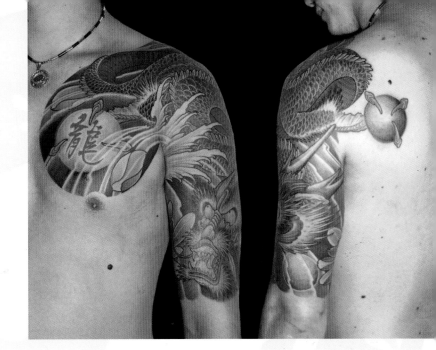

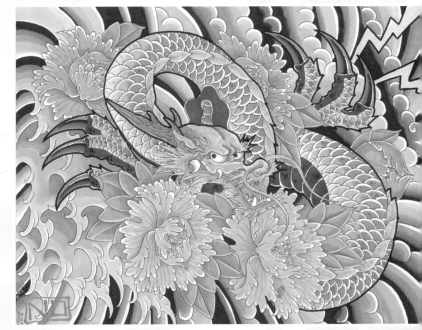

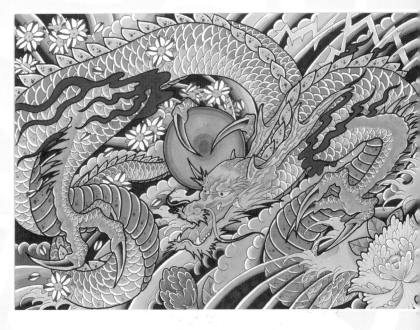

OPPOSITE TOP LEFT: A red dragon faces a large adversary (just out of our view). Tattoo by Troy Bond, Phill Bonds Tattoo Studio, Torquay, UK

OPPOSITE TOP RIGHT: A dragon ridden by a demon is very dynamically represented with design elements suggesting air movements. It is a striking back tattoo by Niko, Custom Tattoo, Paris, France

OPPOSITE BOTTOM LEFT: An unusual circular composition where two dragons oppose each other across a yin and yang symbol. Tattoo by Evil Tattoo, Spain

OPPOSITE BOTTOM RIGHT: A beautiful piece with a dragon holding a pearl dominating the whole back and with only a hint of red to break the black and grey dominance. Tattoo by George Bone, London, UK

TOP RIGHT: Japanese characters and a dragon clutching a pearl of wisdom in its three claws make up this chest and shoulder piece. Tattoo by Noi Siamese 3, 1969 Tattoo, Oslo, Norway

RIGHT: Both illustrations by Pete Oz, Seven Star Tattooing, Bexleyheath, UK

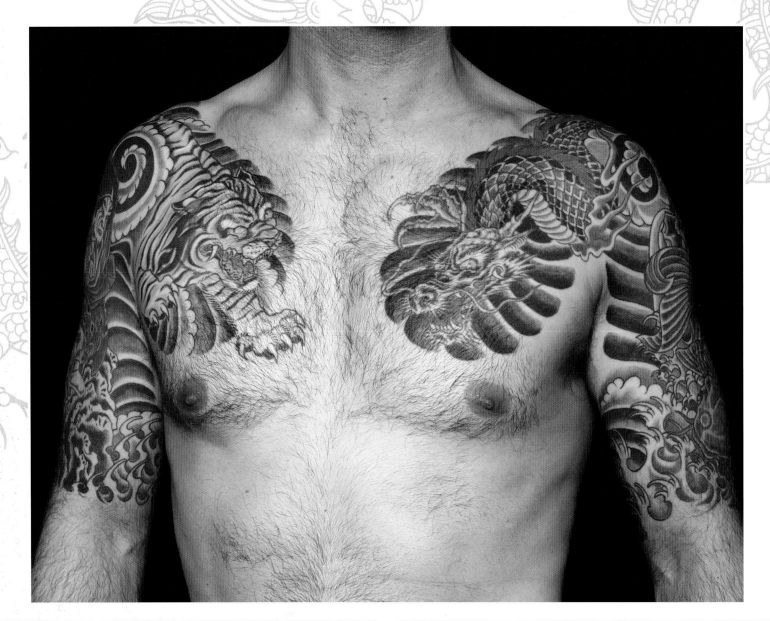

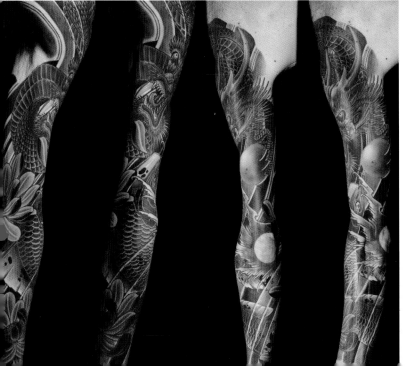

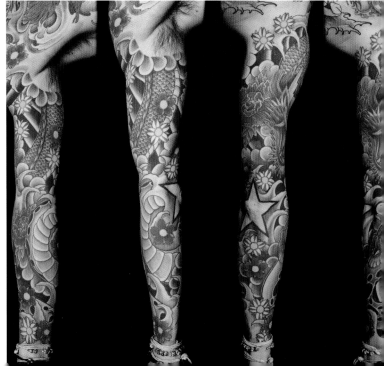

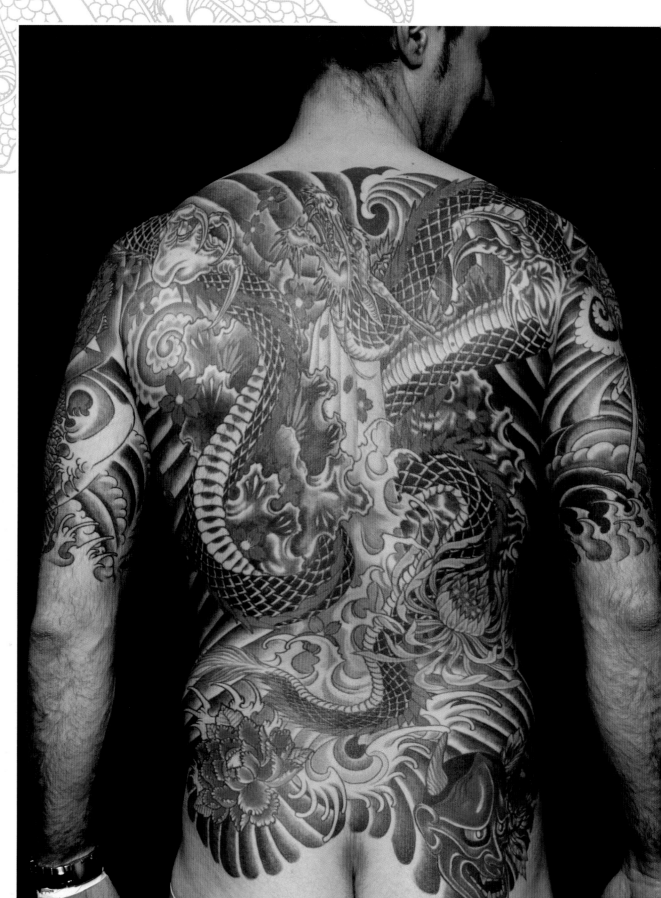

OPPOSITE TOP AND THIS PAGE: Spilling over from a back tattoo, the two opposing symbols of the tiger and the dragon face each other. Tattoo by Lynn Akura, Magnum Opus, Brighton, UK

OPPOSITE BOTTOM LEFT: A very colourful piece full of different elements and patterns, where a koi swims towards a dragon clutching a blue pearl. Tattoo by Noi Siamese 3, 1969 Tattoo, Oslo, Norway

OPPOSITE BOTTOM RIGHT: The flowers provide the colour in this black and grey dragon sleeve also featuring a snake. Tattoo by Arran Burton, Cosmic Tattoo, Colchester, UK

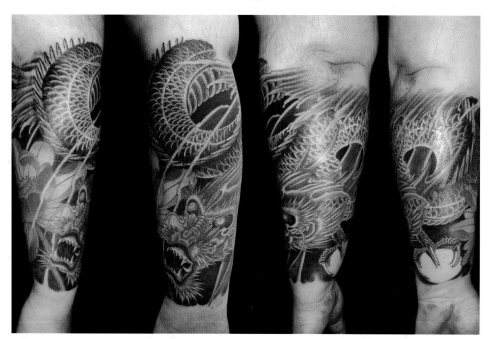

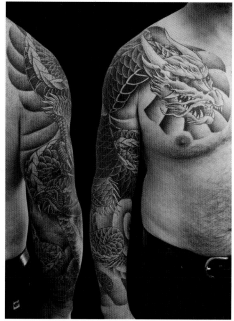

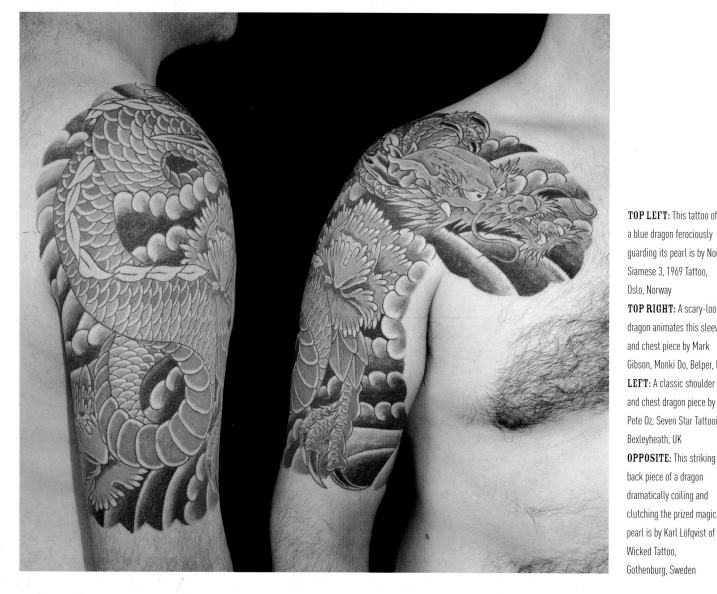

TOP LEFT: This tattoo of a blue dragon ferociously guarding its pearl is by Noi Siamese 3, 1969 Tattoo, Oslo, Norway

TOP RIGHT: A scary-looking dragon animates this sleeve and chest piece by Mark Gibson, Monki Do, Belper, UK

LEFT: A classic shoulder and chest dragon piece by Pete Oz, Seven Star Tattooing, Bexleyheath, UK

OPPOSITE: This striking back piece of a dragon dramatically coiling and clutching the prized magic pearl is by Karl Löfqvist of Wicked Tattoo, Gothenburg, Sweden

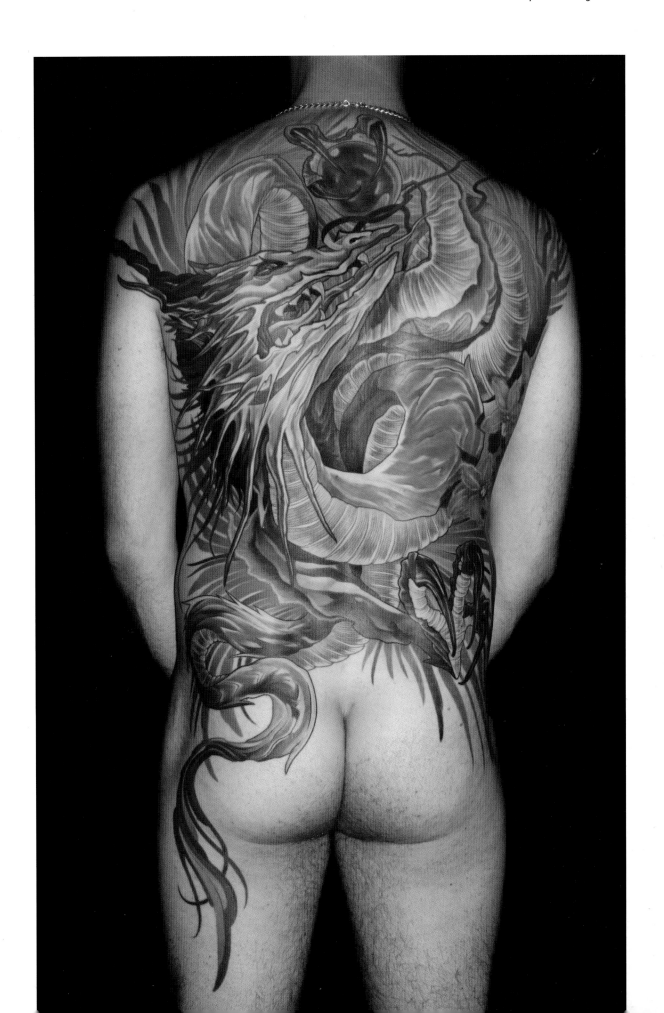

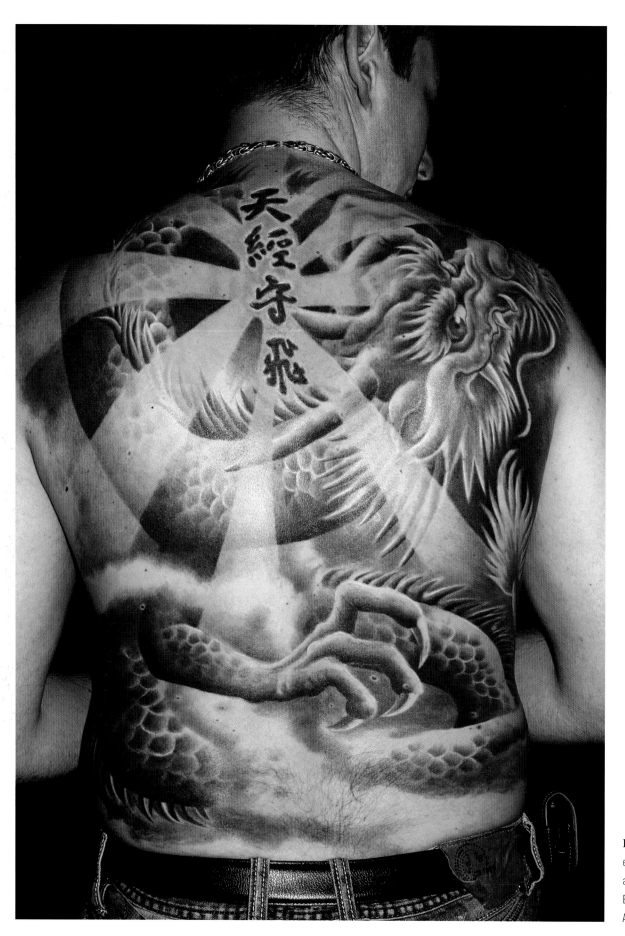

天經守飛

LEFT: A green-eyed dragon ethereally enveloped by clouds and light radiating from Eastern characters. Tattoo by Anabi Tattoo, Szczecin, Poland

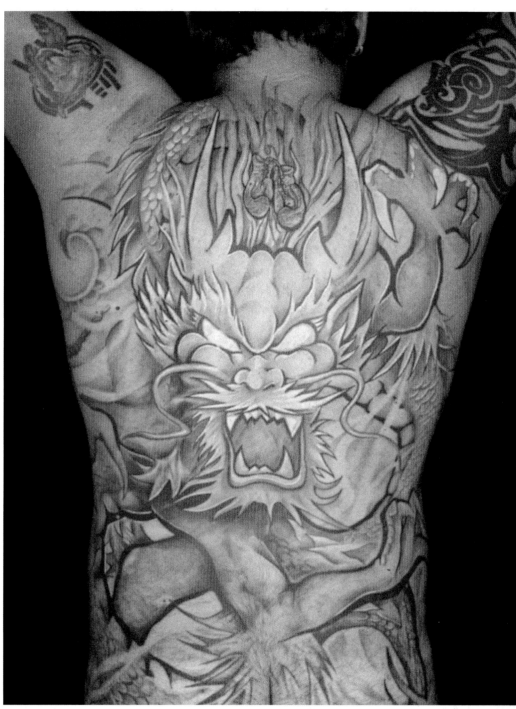

TOP LEFT: Illustration by Sakrosankt, London, UK

BOTTOM LEFT: Illustration by Elisa Tattoo, Scandiano, Italy

ABOVE: An aggressive-looking and muscular dragon dominates this back piece by Yiyi, Yiyi Tattoo Studio, Palma de Mallorca, Spain

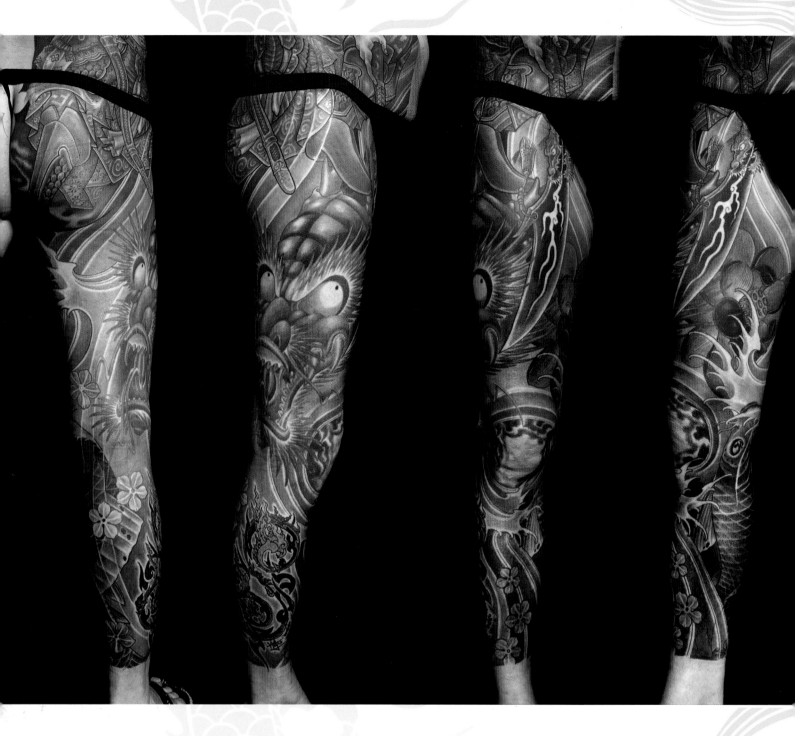

ABOVE: Fearsome and very detailed, this dragon leg (with carp) is part of a larger bodysuit. Tattoo by Noi Siamese 3, 1969 Tattoo, Oslo, Norway

OPPOSITE TOP LEFT: An unusual scene, as Eastern dragons traditionally do not breathe fire. A carp and a red demon are also part of this large-scale colour piece. Tattoo by Frank, Frank's Tattoo World, Le Havre, France

OPPOSITE TOP RIGHT: Bright colours and a dynamic composition are used in this piece where a dragon and traditional Eastern motifs are mixed with Western elements (see the heart and the swallows at the top of the shoulders). Tattoo by Ben Morris, Tattoo UK, Harrow, UK

OPPOSITE BOTTOM: A male dragon, characterized by the war club held in its tail. Tattoo by Takami at Knock Over Decorate Tattoo in Yonago, Japan

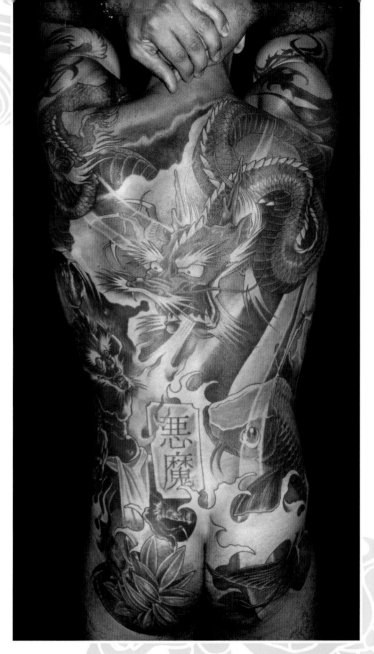

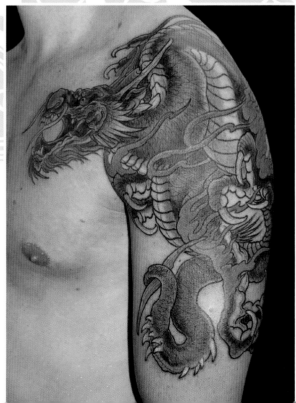

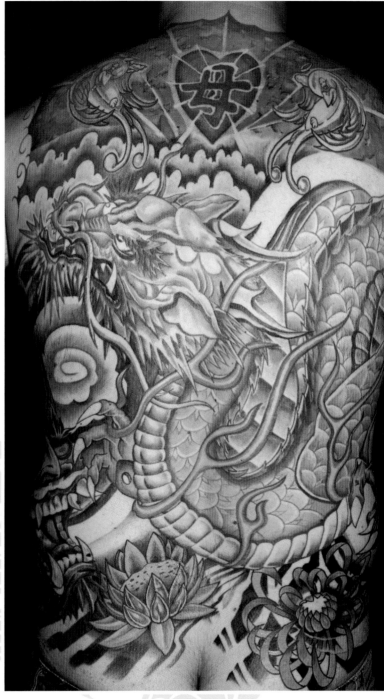

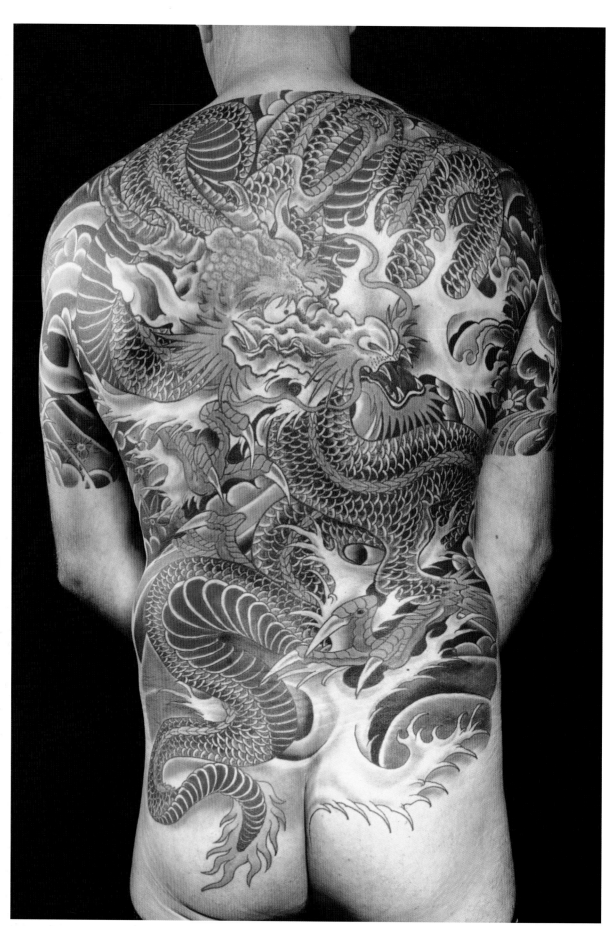

RIGHT: With gold whiskers and a long coiled body emerging from big waves, this striking dragon is by George Bone, London, UK

OPPOSITE TOP: Elegantly swimming through black waters, this dragon stands out well. Tattoo by Heiko Fähndrich, Germany

OPPOSITE BOTTOM LEFT: A Buddhist feel pervades this black and grey dragon piece by Jess Yen, My Tattoo, Alhambra, California, USA

OPPOSITE BOTTOM RIGHT: A long-whiskered, horned old dragon coils dramatically in this back piece. Tattoo by Doddo, The Pleasure of Pain, Ostia Lido, Italy

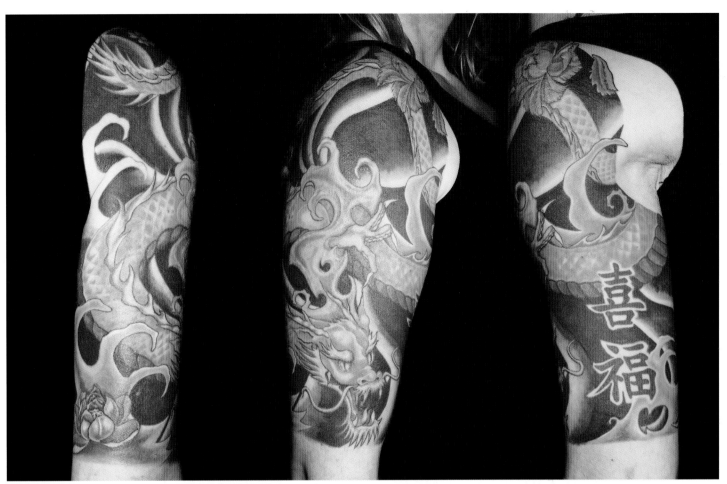

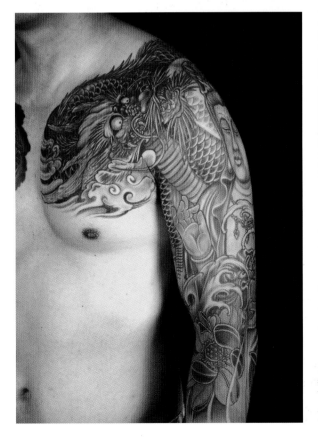

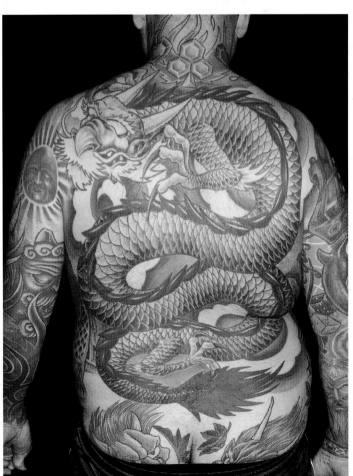

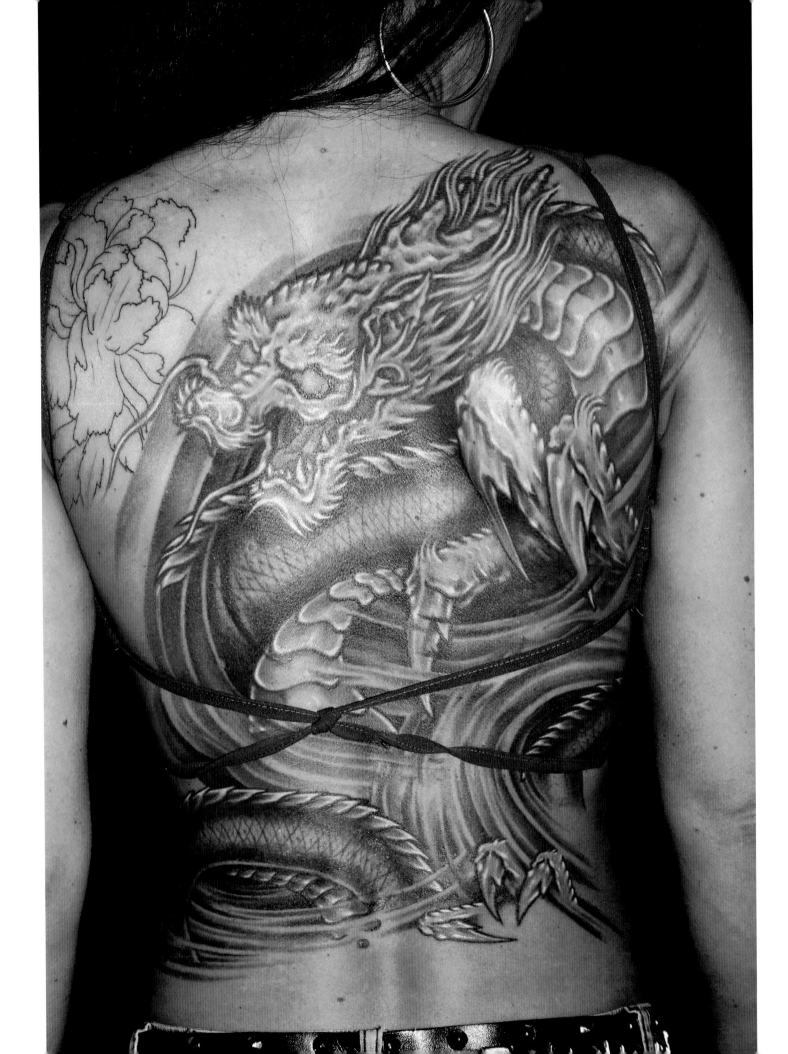

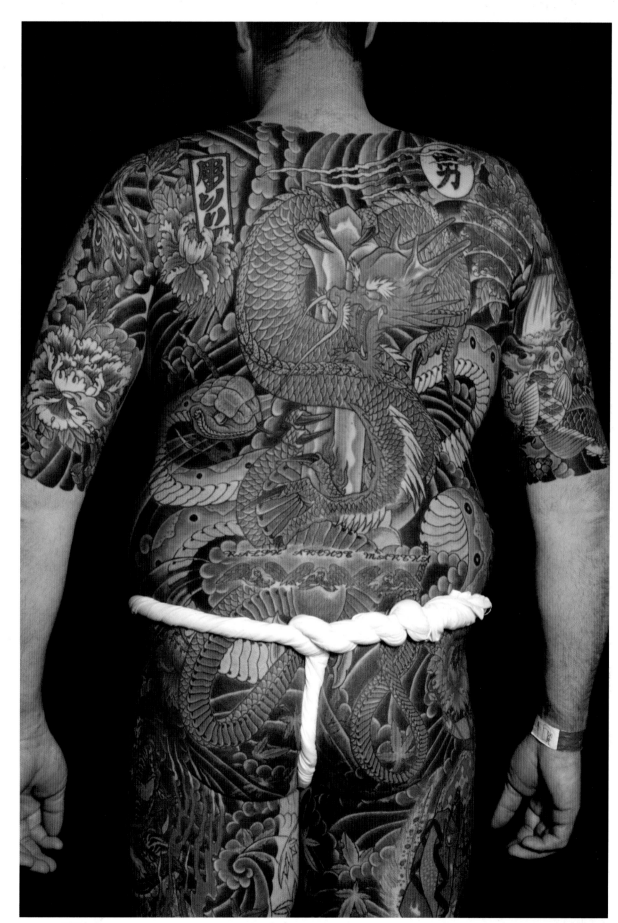

OPPOSITE: A swirling dragon is beautifully rendered in black and grey with white highlights. Tattoo by Tom, Perfect Ink, Berlin

RIGHT: A dragon coiled around a Kurikara sword, which is also known to be a manifestation of Fudou Myou-ou in esoteric Buddhism. The presence of a large snake reinforces this link to the mythology and imagery connected to Fudou. Tattoo by Chic Child, Seven Sins Tattoo, Horley, UK

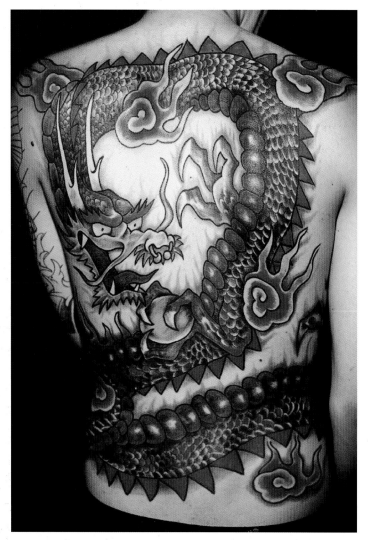

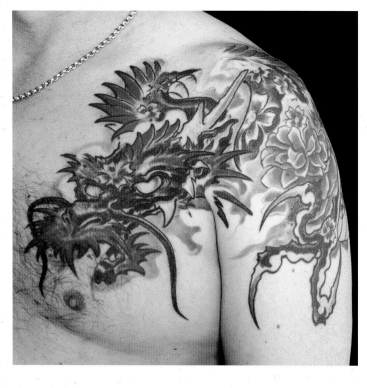

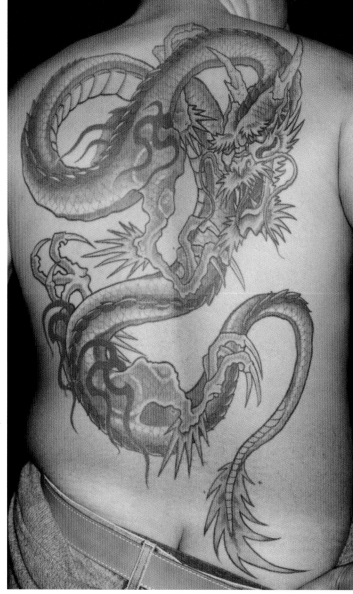

TOP LEFT: In this striking red tattoo a dragon clutches the pearl of wisdom among balls of fire. Tattoo by Sacha, Primitive Abstract, Oslo, Norway

TOP RIGHT: Full of movement and curves, this green dragon fills the back very organically. Tattoo by Vladi Tattoo, Lecce, Italy

LEFT: A dramatic and colourful appearance characterizes this dragon by Julien, Tattoo Styl, Fréjus, France

OPPOSITE: An ascending dragon in this back piece. Tattoo by Apocalipsis Tattoo, Cadiz, Spain

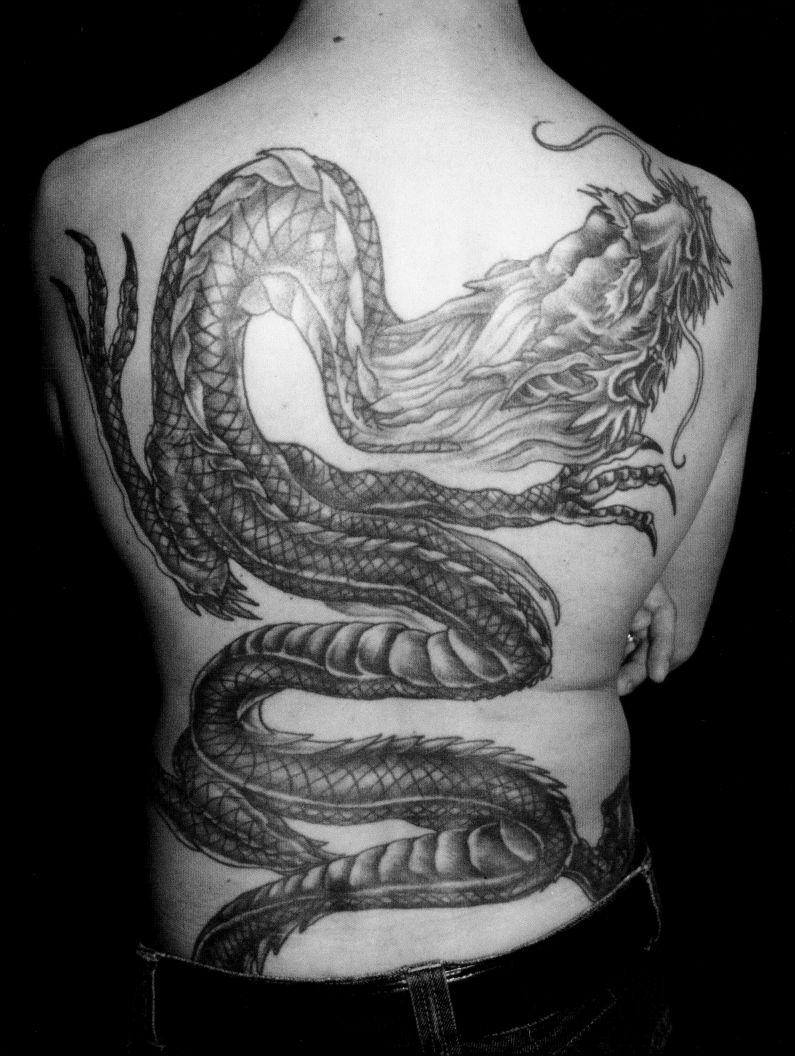

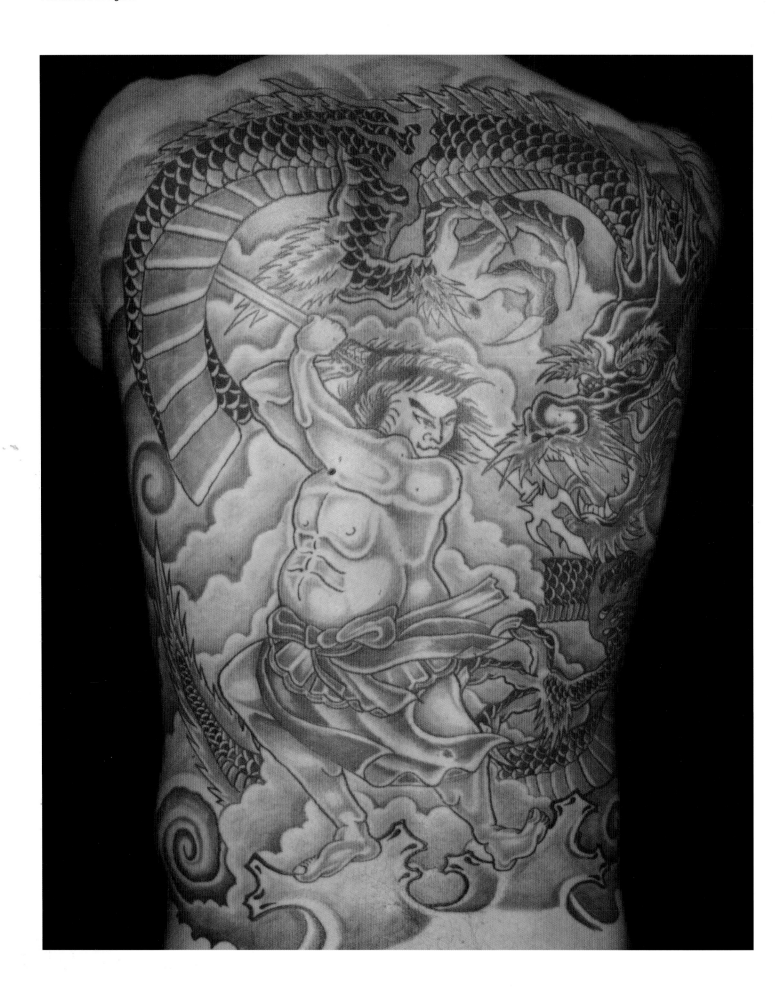

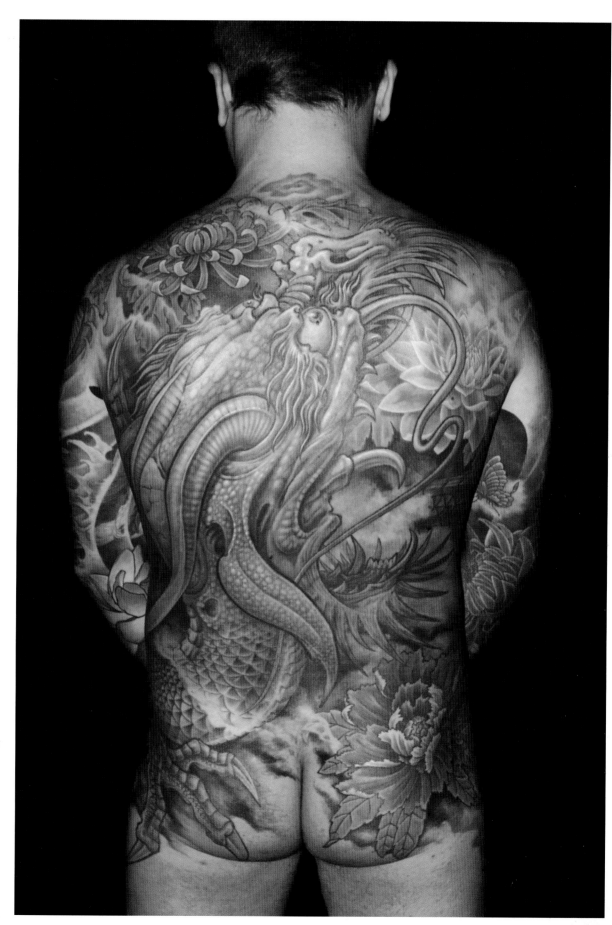

OPPOSITE: A samurai warrior fights against a red and grey dragon. Tattoo by Nicola, on the road

RIGHT: A large black and grey dragon's head emerges from colourful Eastern flowers with its mouth wide open. Tattoo by George Barbadim, St Petersburg, Russia

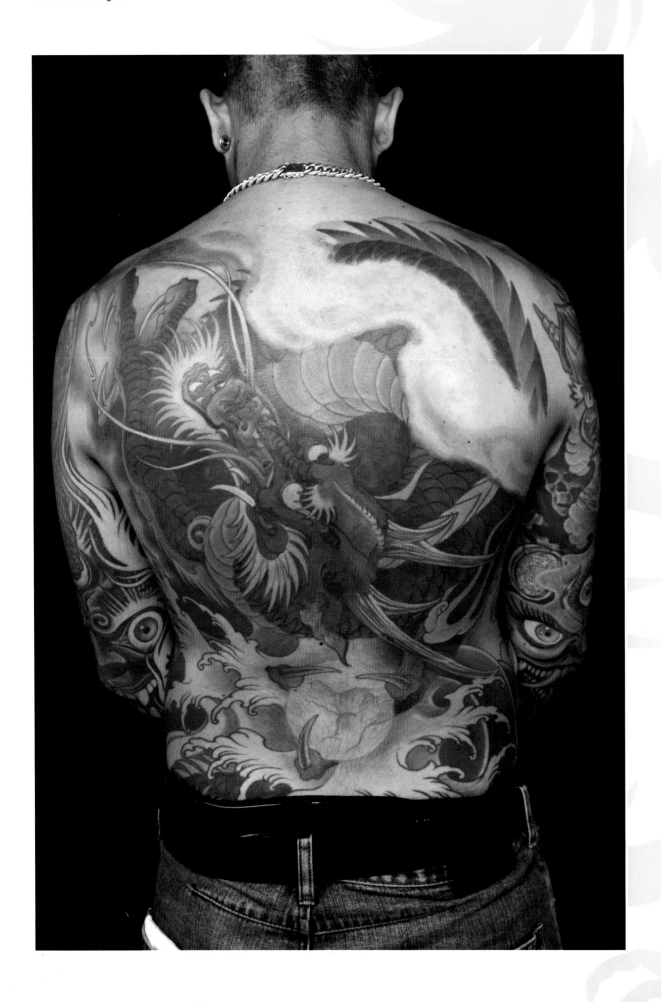

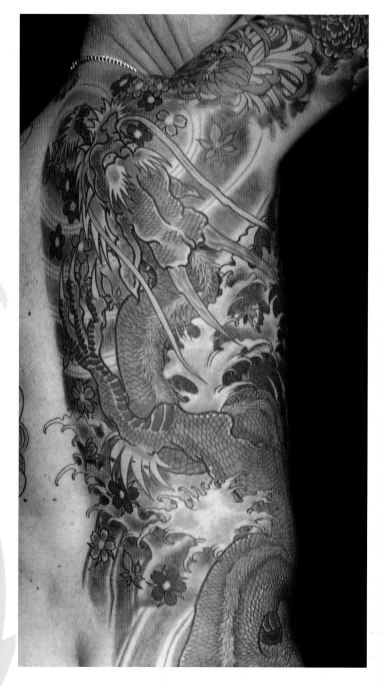

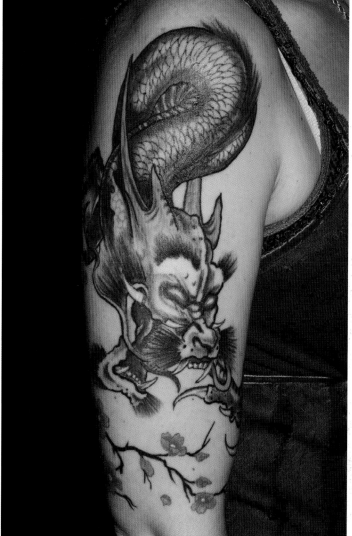

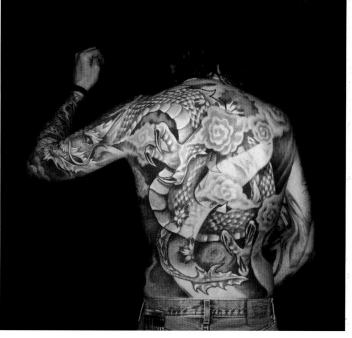

OPPOSITE: A red dragon ascends to the skies clutching a transparent pearl as it rises from the water. Tattoo by Filip Leu, Sainte-Croix, Switzerland

ABOVE: This blue dragon with touches of bright red and orange ascends through splashes of water to the heavens. Tattoo by Darren Hubbard, UK

TOP RIGHT: A delicate flower branch and an aggressive-looking dragon form this half sleeve. Tattoo by Dragon Art Tattoo Studio, Gainsborough, UK

RIGHT: Interspersed with a few flowers, this dragon occupies a full back piece and its head covers the left arm. Tattoo by Derek Young, Yankee Tattoos, Dundee, UK

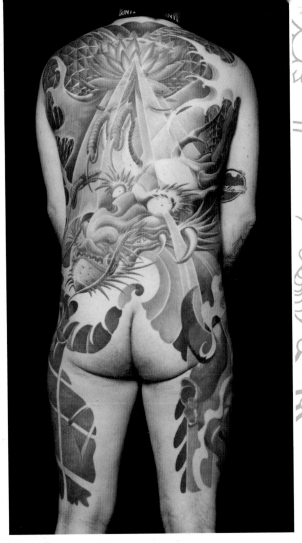

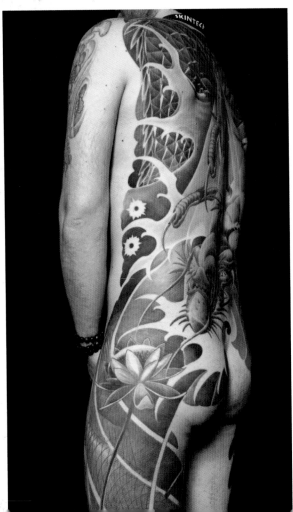

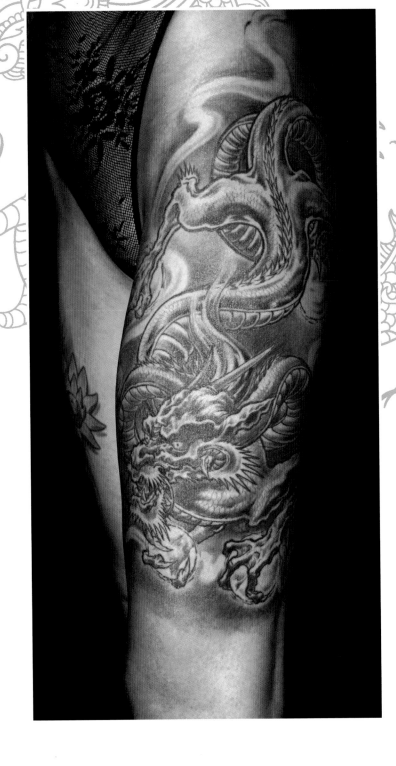

LEFT TOP AND BOTTOM: Light radiates from the large lotus flower onto the dragon's head in this large yet delicately shaded back piece by Sid Siamese I, Karlstad, Sweden

ABOVE: Clutching two pearls of wisdom, the dragon flies through the skies. Tattoo by Romy, Bulgaria

OPPOSITE: Dramatically lit, these three dragons meet in a piece encompassing Eastern flowers and swirls of air. Tattoo by Kerri, Fallen Angels, Fife, UK

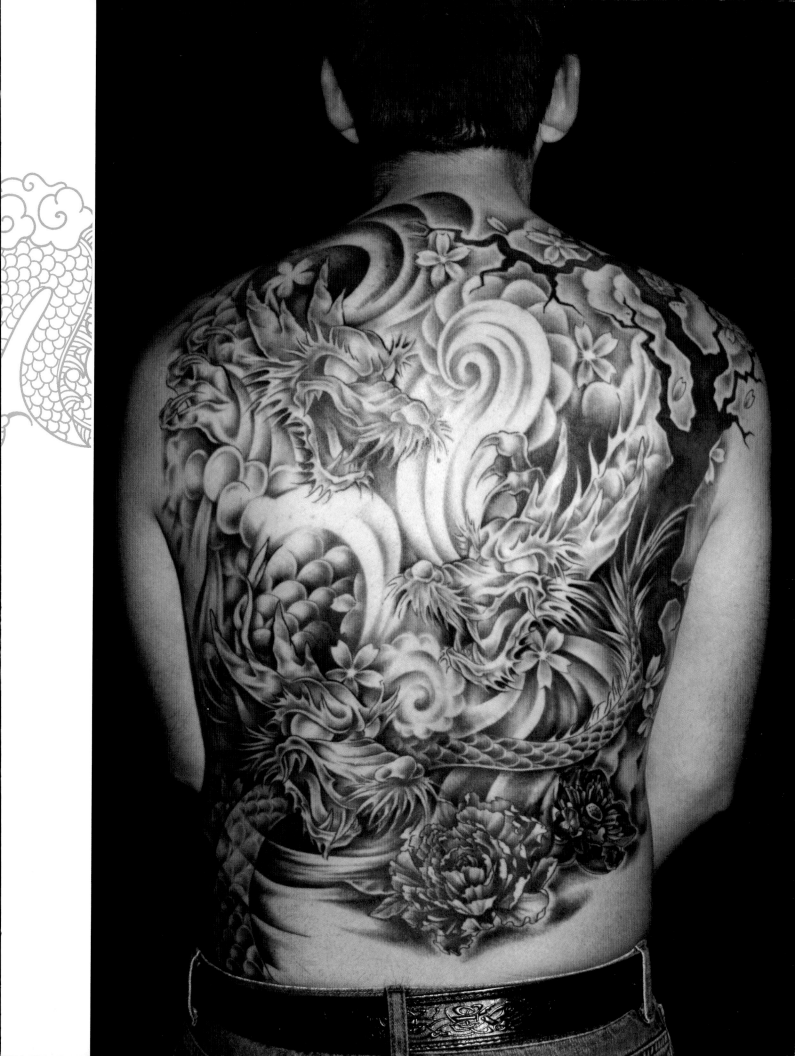

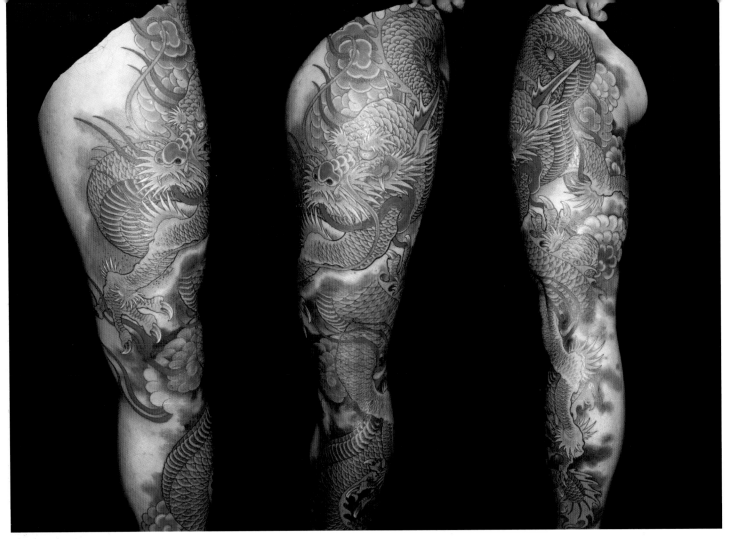

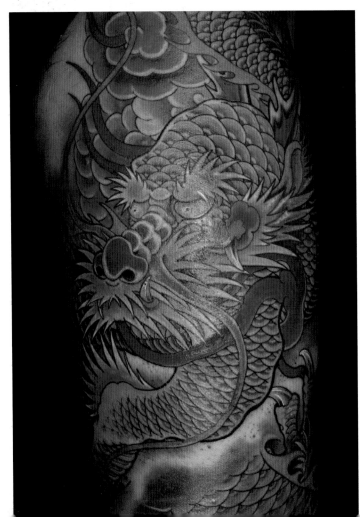

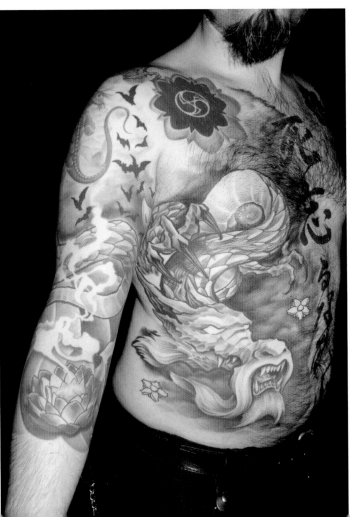

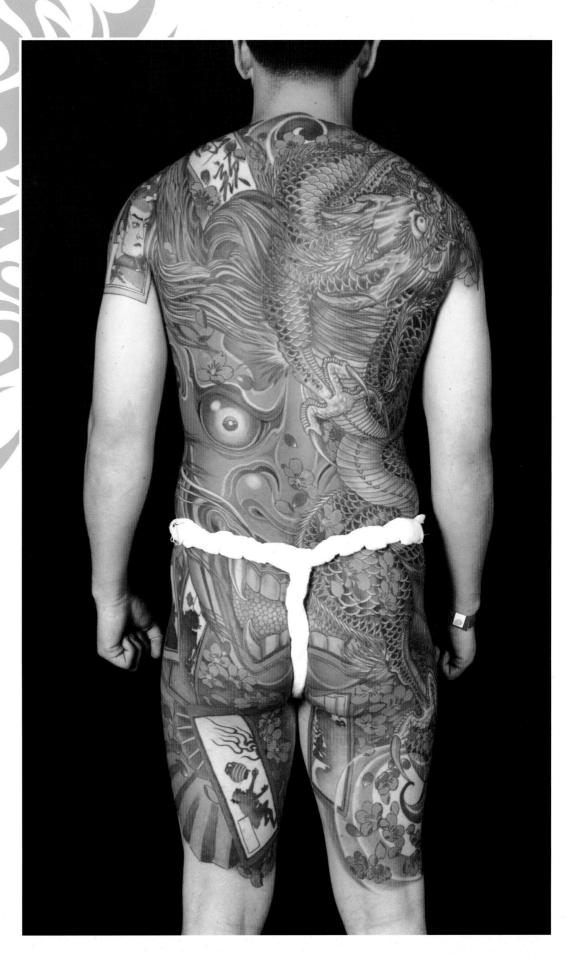

OPPOSITE LEFT TOP AND BOTTOM:
A dragon rises through clouds of vapour in this striking leg piece. Tattoo by Chang-Un, Korea
OPPOSITE RIGHT: Plenty of Eastern symbols (a lotus flower and a Borneo rosette, as well as lettering in the middle of the chest) accompany this old dragon. Tattoo by Marcuse, Smilin' Demons, Mannheim, Germany
RIGHT: A dramatic composition for this demon's face partly covered by an ascending dragon. Tattoo by Jess Yen, My Tattoo, Alhambra, California, USA

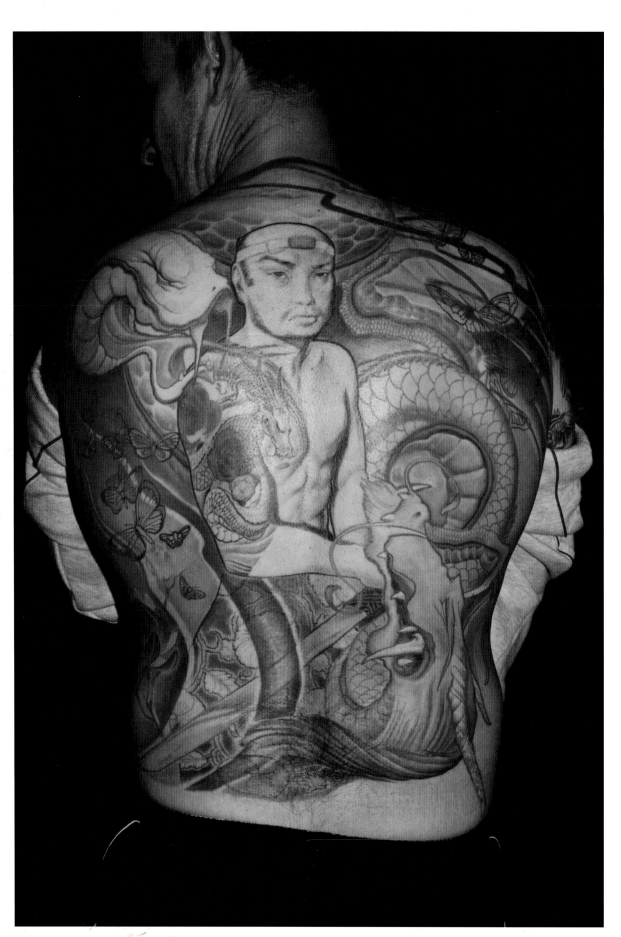

LEFT: Visually inventive and dazzling in colour, a dragon and a snake are entwined around a tattooed man. Tattoo by Levi, Evil from the Needle, London, UK

OPPOSITE TOP LEFT: Close-up of a black and grey dragon's head. Tattoo by Tattoo's Rolf, Wächtersbach, Germany

OPPOSITE TOP RIGHT: A dragon rises from the water amid lotus flowers and cherry blossoms. Tattoo by Andy Bowler, Monki Do, Belper, UK

OPPOSITE BOTTOM LEFT: An ascending dragon in a tattoo by Takami at Knock Over Decorate Tattoo, Yonago, Japan

OPPOSITE BOTTOM RIGHT: A bold black and grey design of a dragon. Tattoo by Terry Fuller, Full on Ink, Evesham, UK

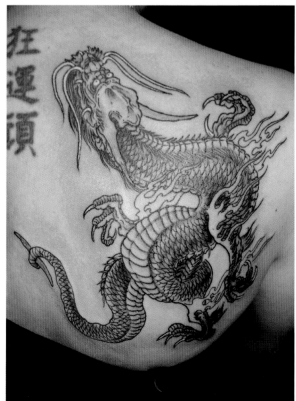
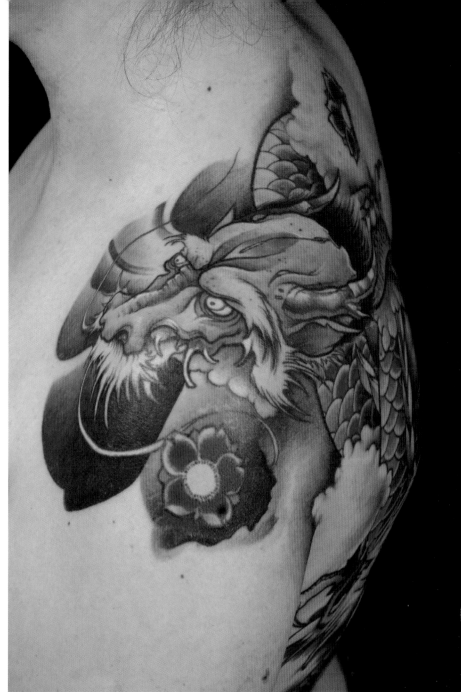
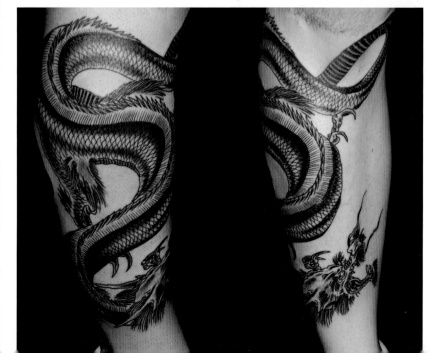
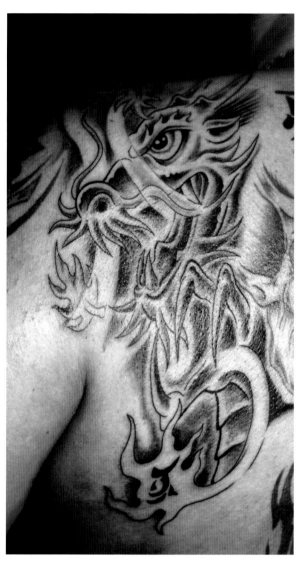

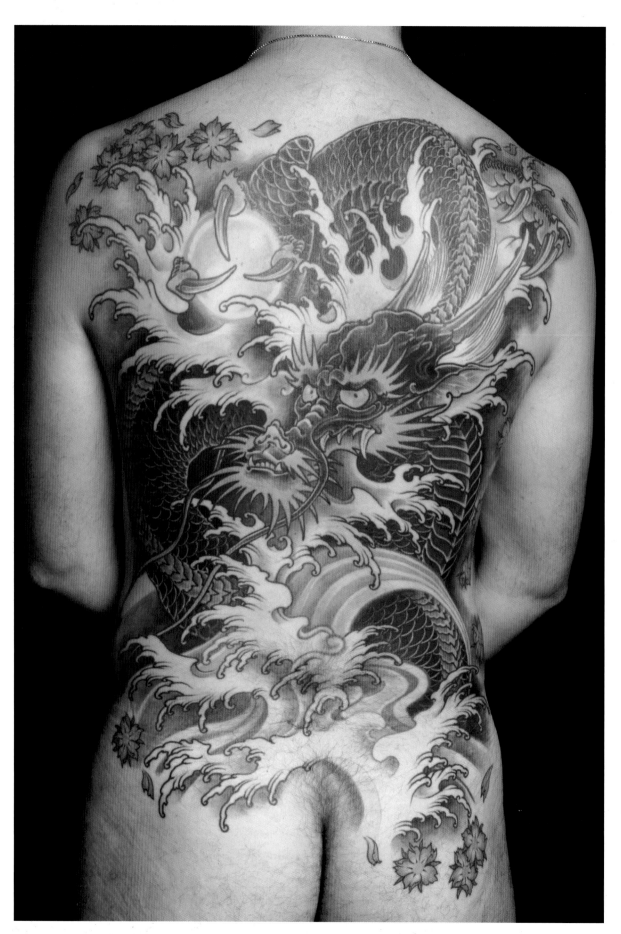

LEFT: A mighty dragon emerges from the water clutching a magic pearl of wisdom. Tattoo by Filip Leu, Sainte-Croix, Switzerland

OPPOSITE: Rising fast through the skies holding a man's head in its claws, this striking dragon is by Niccku Hori, Galaxy Tattoo, Singapore

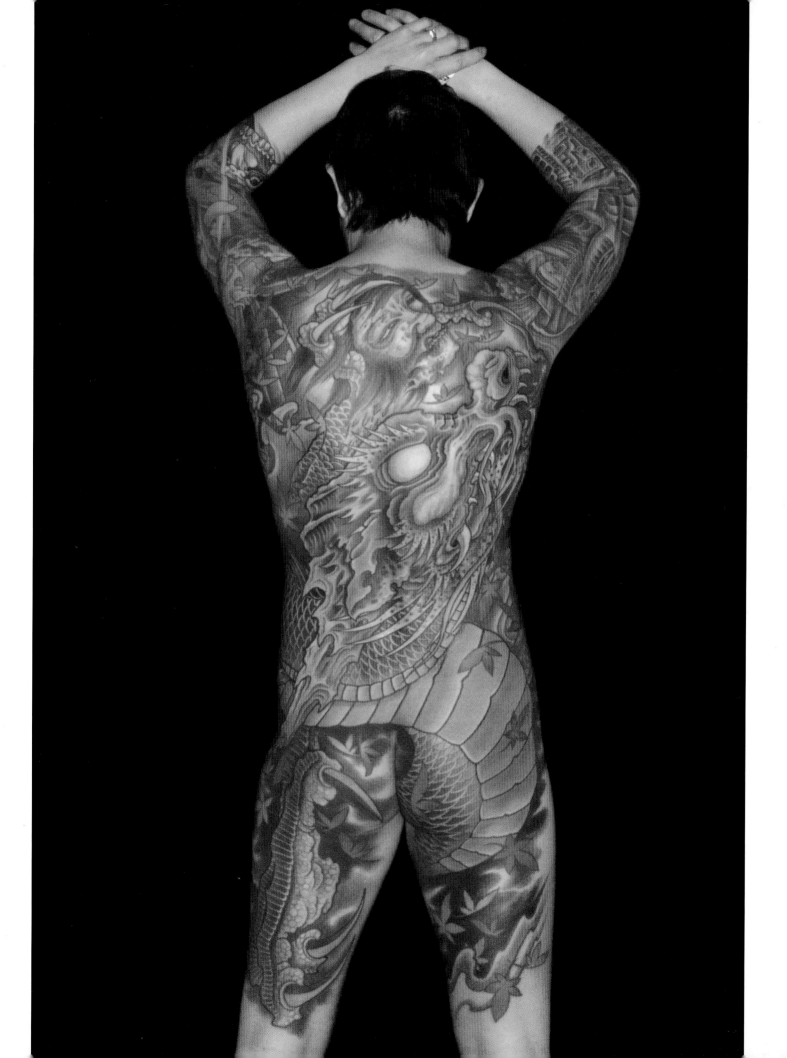

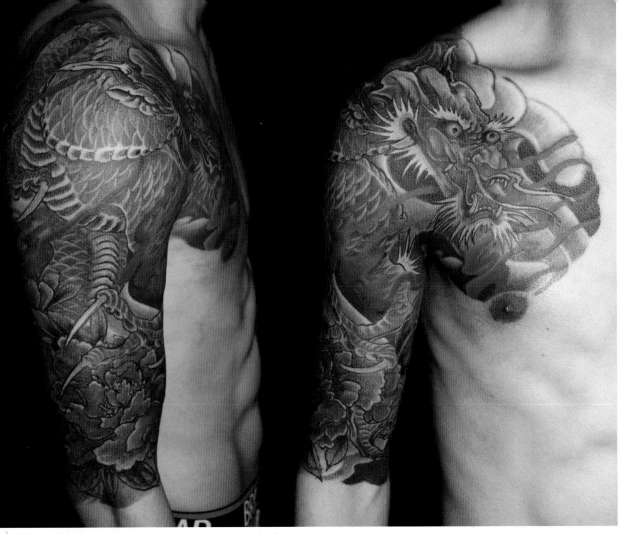

LEFT: An arm and shoulder piece with a green dragon coiled around the arm. Tattoo by Takami at Knock Over Decorate Tattoo in Yonago, Japan

BELOW: A red dragon's head, by Jack Mosher, Body Armor Tattoo Kalamazoo, Michigan, USA

OPPOSITE: A black and grey dragon pursuing the prized pearl of wisdom and holding another pearl in its coils. Tattoo by Noi Siamese 3, 1969 Tattoo, Oslo, Norway

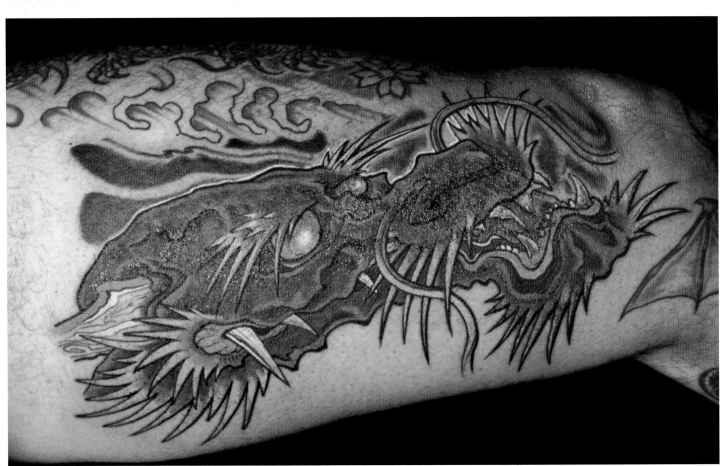

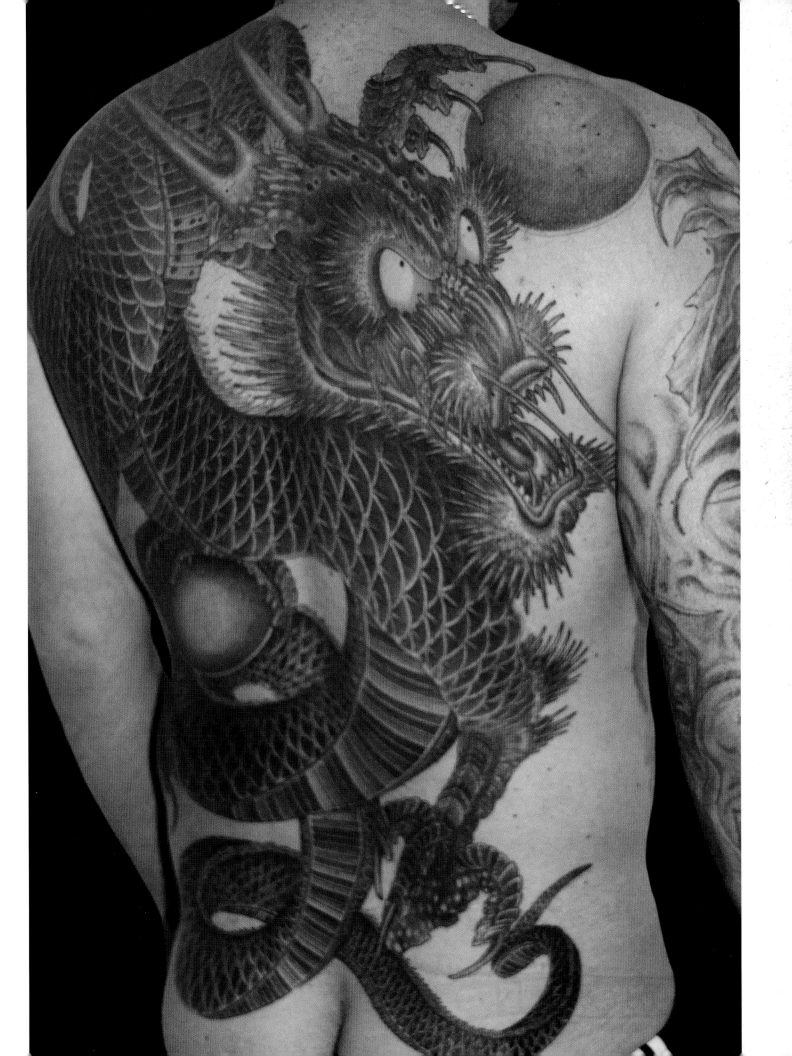

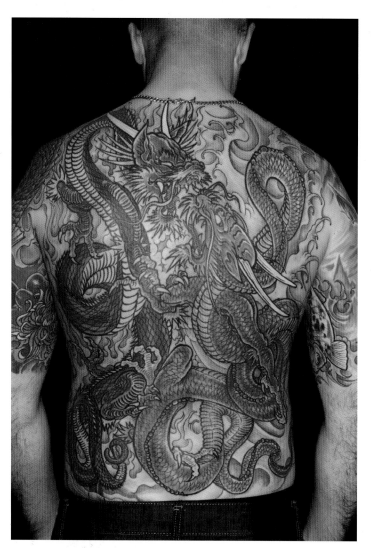

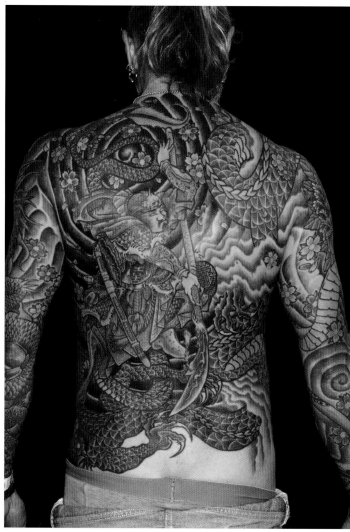

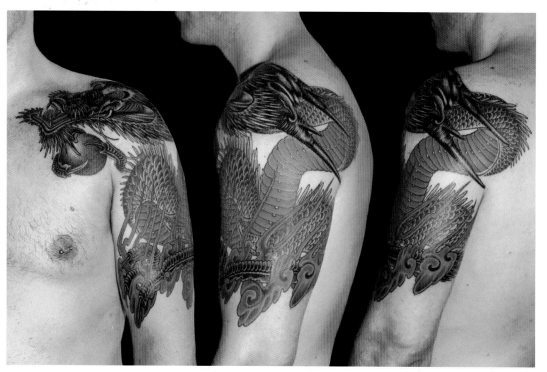

ABOVE LEFT: A red and a blue dragon fight with each other on a background of monochrome sea waves. Tattoo by Derek Campbell, Bournemouth, UK

ABOVE RIGHT: With swirls of air behind him, a warrior attacks a dragon with his mighty sword. Tattoo by Neil Bass, Tattoo FX, Burgess Hill, UK

LEFT: Black, red and grey are the dramatic hues for this dragon holding a magic pearl. Tattoo by Noi Siamese 3, 1969 Tattoo, Oslo, Norway

OPPOSITE: A carp, a lotus flower and a dragon curl around an Om (or Aum) sign, a sacred Hindu symbol. Tattoo by Katana Tattoo, Milan, Italy

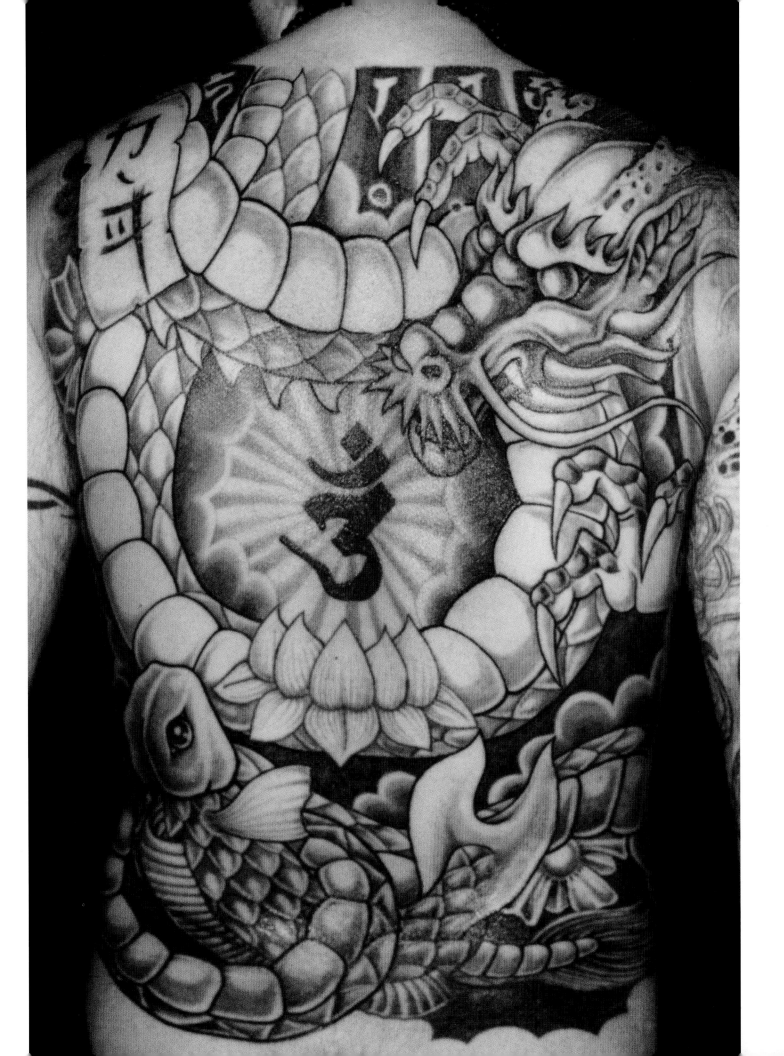

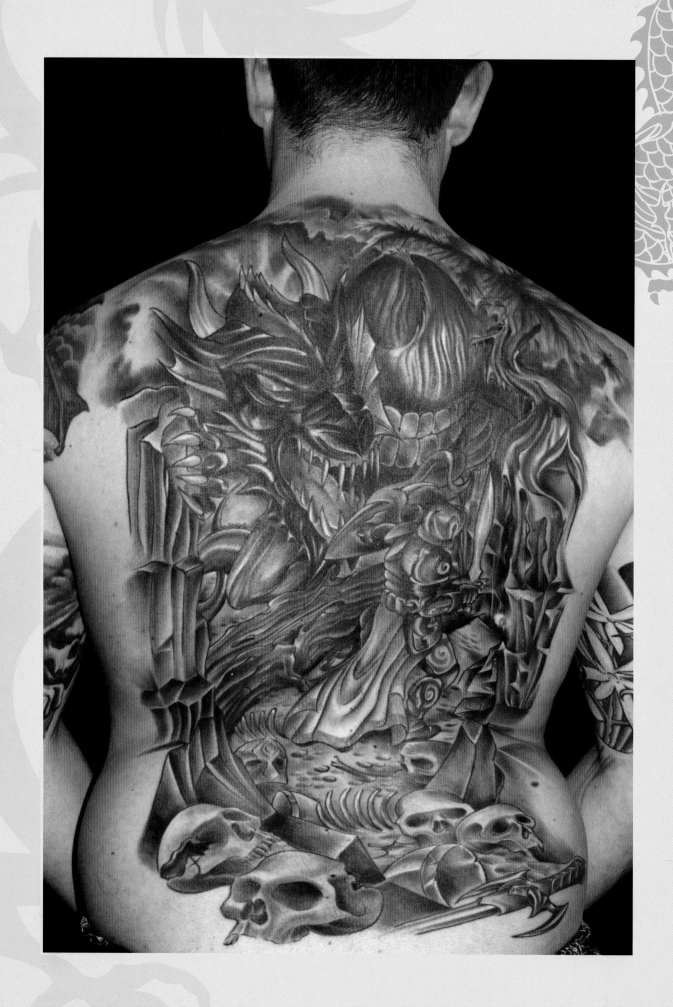

EUROPEAN DRAGONS

Although the iconography of Eastern dragons dominates modern fashion and skin art, Europe also has its own strong dragon tradition. Dragons have populated European fairytales for centuries, as part of a rich heritage which includes myths such as that of the nine-headed hydra. Many of these legends predate Christian literature.

In early Christian texts, creatures resembling dragons are used to represent Satan. The dragon's negative and destructive connotations in folk tales and myths from the Dark Ages is undoubtedly the result of its Christian demonic heritage.

The European dragon differs significantly from its Eastern counterpart. It appears as a huge lizard with bat-like wings and horns; and it breathes fire, which it often uses as a weapon to devastating effect. Another recurring image is that of the Ouroboros (literally meaning 'eating its own tail'), a dragon deity first found around 1600BCE in ancient Egypt. This alchemical motif of the snake/dragon in a circle symbolizes the life cycle of death and rebirth.

OPPOSITE: A knight confronts a terrifying dragon. The remains of earlier challengers litter the foreground. Tattoo by Stewart, Angelic Hell, Brighton, UK

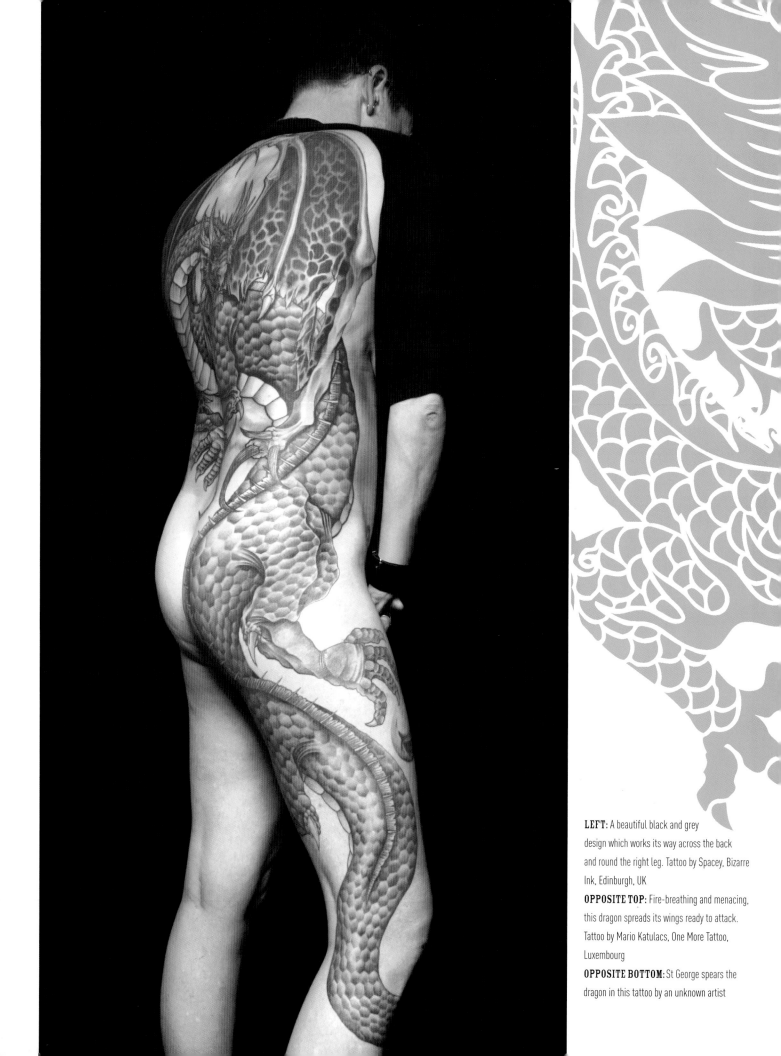

LEFT: A beautiful black and grey design which works its way across the back and round the right leg. Tattoo by Spacey, Bizarre Ink, Edinburgh, UK

OPPOSITE TOP: Fire-breathing and menacing, this dragon spreads its wings ready to attack. Tattoo by Mario Katulacs, One More Tattoo, Luxembourg

OPPOSITE BOTTOM: St George spears the dragon in this tattoo by an unknown artist

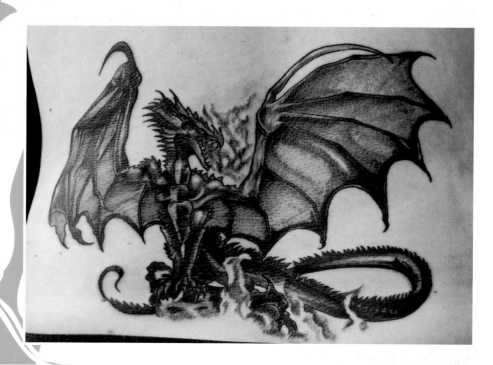

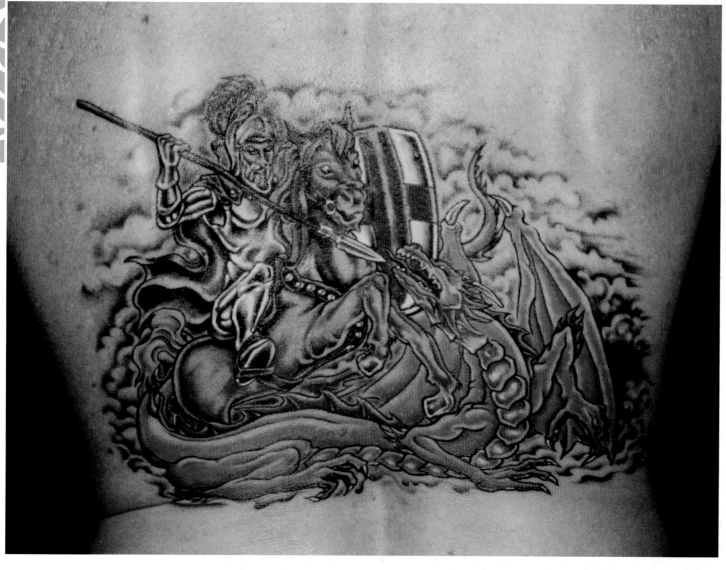

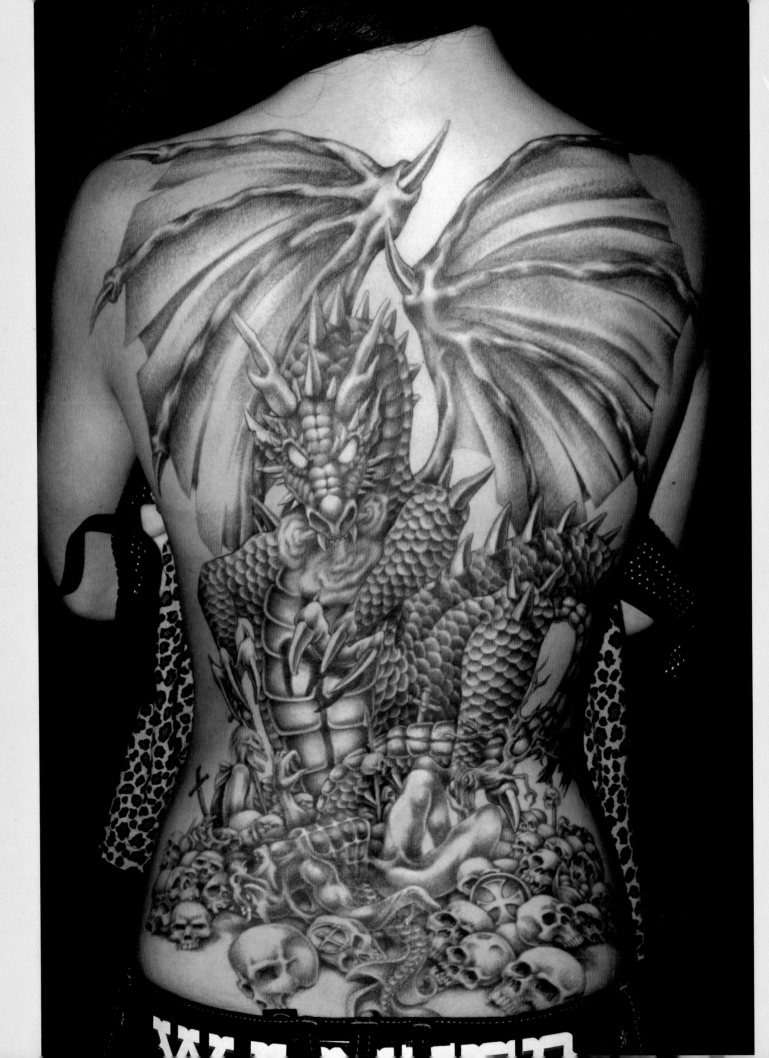

The majority of mythological and pictorial references to dragons date back to the Middle Ages, an era of unrest, war and disease. During this period, dragons allegedly became extinct; they were all slain by courageous knights intent on proving their worth and making a name for themselves. The most famous of these legends sees St George slay a malevolent dragon. This story was probably adapted from ancient Greek myth or even from a popular Middle Eastern tale brought back by the Crusaders. The story seems to have more than a passing resemblance to folk legends, which were later elaborated upon in fairytales: a princess is offered to a dragon to appease its rage, St George intervenes and rescues the maiden in distress by killing the dragon. During the Middle Ages, it appears that every period of deep misery and famine was attributed to the malign influence of a dragon – an early example of the way in which rulers and feudal landowners used false propaganda to escape accusations of negligence.

The role of dragon-vanquisher did not belong solely to intrepid knights: St Martha, for example, earned her sainthood by tackling the dragon that was afflicting the French town of Tarascon. In the Bible, Martha, sister of Lazarus, left her village after Jesus' death and settled in Provence. Legend has it that she travelled further and in the year 48CE reached a village where the Tarasque, a dragon-like creature related to the Leviathan, was terrorizing the locals. However, she did not kill it, but charmed and tamed it, in a manner reminiscent of the Beauty and the Beast story. Despite her efforts, the Tarasque was unfortunately killed by the inhabitants of the town, who, in repentance after being converted by Martha, honoured the beast by naming their town after it.

OPPOSITE: A dragon with giant wings, spikes and fangs glowers from this menacing black and grey back piece. Tattoo by Miss Nico, All Style Tattoo, Berlin, Germany

BELOW LEFT: A dragon hatches from an egg, already in fighting form. Tattoo by Dave Wiper, Modern Savage, Wakefield, UK

BELOW RIGHT: In the depths of its lair, a dragon holds the precious pearl of wisdom. Back tattoo by Andy, Mystery Touch, Gleisdorf, Austria

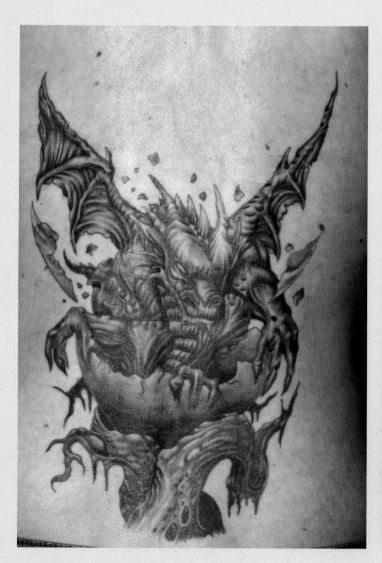

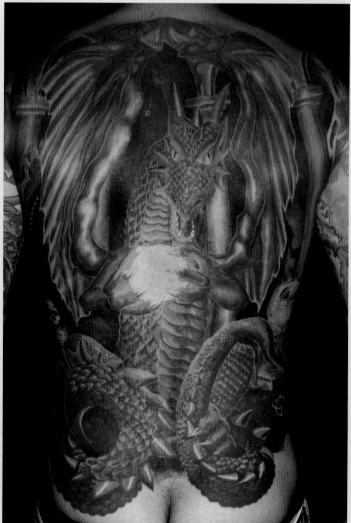

he popular medieval text the *Bestiarium* (or *Bestiary*) is a compendium of natural history in which each creature was seen to be in this world for a special reason and, as such, had symbolic meaning. The first bestiaries appeared in ancient Greece, based loosely on stories of Eastern provenance. These allegorical texts gained extraordinary popularity in Europe in the 12th and 13th centuries. They held that dragons could make the air shine just by moving; this ability was one of several dragon powers that aligned them with Satan, who could appear luminous and deceive humans into believing in his goodness. However, in spite of their bad press, dragons were used in a Christian context when Pope Paul V (1550–1621) incorporated a dragon taken from the heraldic design belonging to his aristocratic family into his papal coat-of-arms.

Eastern Europe has been a fertile ground for dragon stories for centuries. The Slavic words *smok*, *lamya* and zmiy (also *zmey* or *zmaj*) describe dragons, and variations of these nouns are used throughout the Baltic states and Russia to indicate dragon-like creatures. A particular three-headed, fire-breathing variation is well known in Russia as the Zmey Gorynych. In Ljubljana, the capital of Slovenia, the dragon is believed to be the protector of the city. A dragon features in the city coat-of-arms as a benevolent creature in much the same way that some dragons are used in the UK as mascots, in logos and on crests and flags.

Dragons are closely associated with Celtic myth, and Wales famously uses one – Y Ddraig Goch (meaning 'the red dragon') – on its national flag. This dragon symbolizes the Welsh victory over the Saxons: according to myth, a red dragon fought a white one representing the Saxon invaders. The white dragon came to be adopted by the English, and it was used on the flag of the ancient kingdom of Wessex. The only other country still to feature a dragon as the main motif on its flag is Bhutan: the creature portrayed is the Druk, the Thunder Dragon from Bhutanese mythology, and Bhutan itself is often referred to as Druk Yul, meaning 'Land of the Thunder Dragon'.

According to psychoanalytic thinking, monstrous hybrids such as dragons are born out of several feared creatures which represent incestuous desire. Fighting (and defeating) the dragon symbolizes a victory over a matriarchal power: a battle against emotional problems that hold us back from the ultimate prize of achieving our true potential – emotional maturity and freedom of the soul. In that, the dragon is a universal figure.

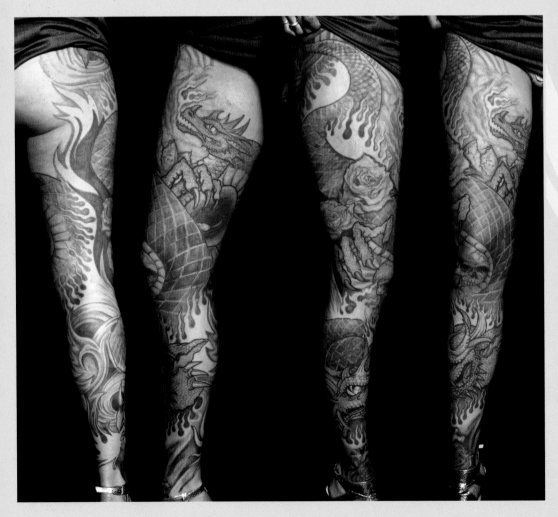

LEFT: A scene of dragons, fire, destruction and rebirth in this fine black and grey tattoo by Brendon Roberts, Think Tattoo, Bolton, UK
OPPOSITE: Dragons, pterosaurs and other dinosaurs take over the Earth! Gore and mayhem in this tattoo by Rabbit, Grin 'n' Wear It Tattoos, Lakenheath, Brandon, UK

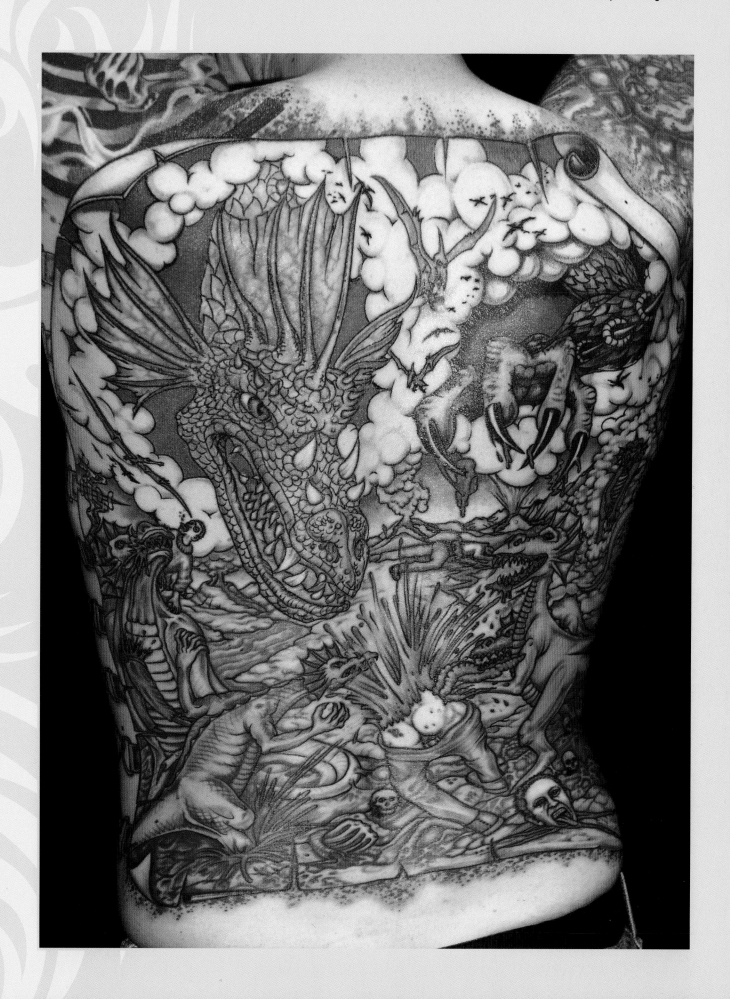

RIGHT: Elegant and beautifully poised, this magical creature is carefully balanced on a magical symbol, the pentacle. Tattoo by Mario Katulacs, One More Tattoo, Luxembourg

BELOW LEFT: An ornate frame surrounds this infernal dragon. Tattoo by Lal Hardy, New Wave Tattoo, London, UK

BELOW RIGHT: A warrior on horseback is attacked by an enormous dragon. Tattoo by Güldner, Germany

OPPOSITE: Very snake-like, but with huge claws, this dragon is represented with delicate details in grey ink (note the skulls in the rising smoke). Tattoo by Steve, Joker's Tattoo, Norwich, UK

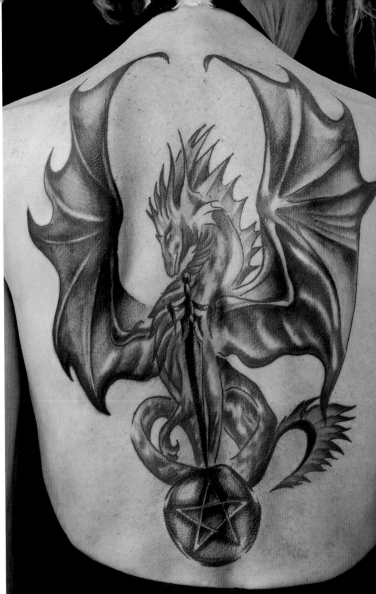

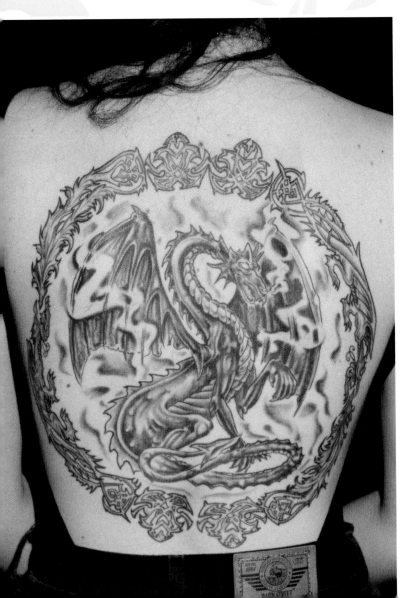

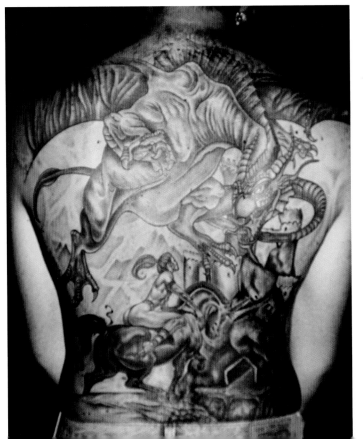

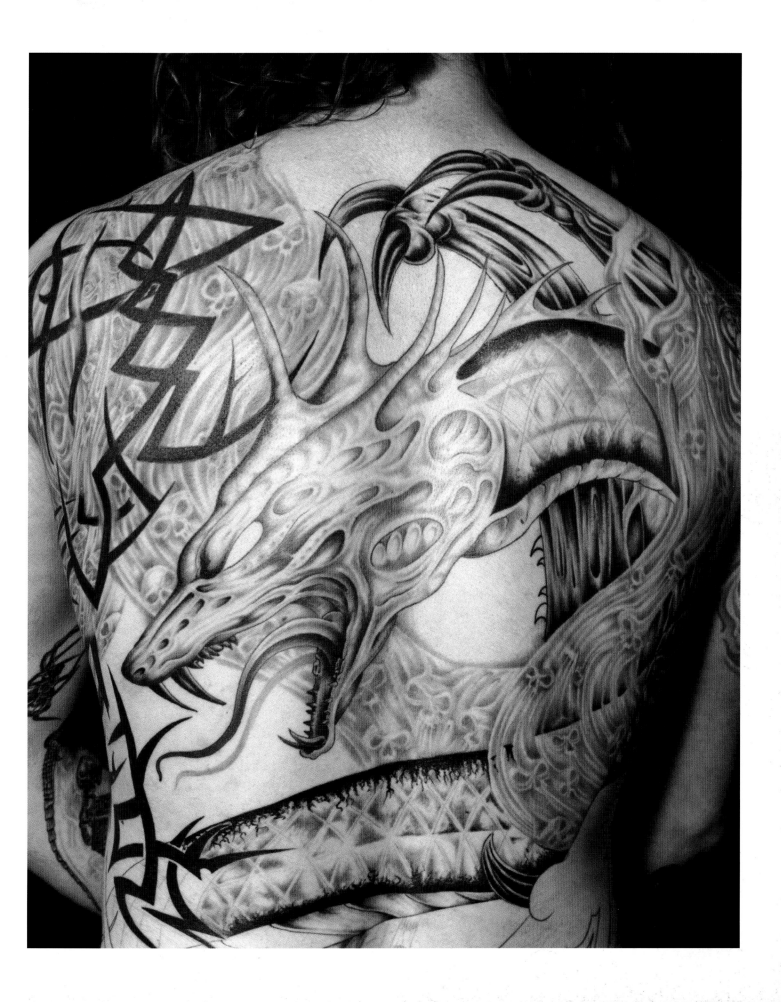

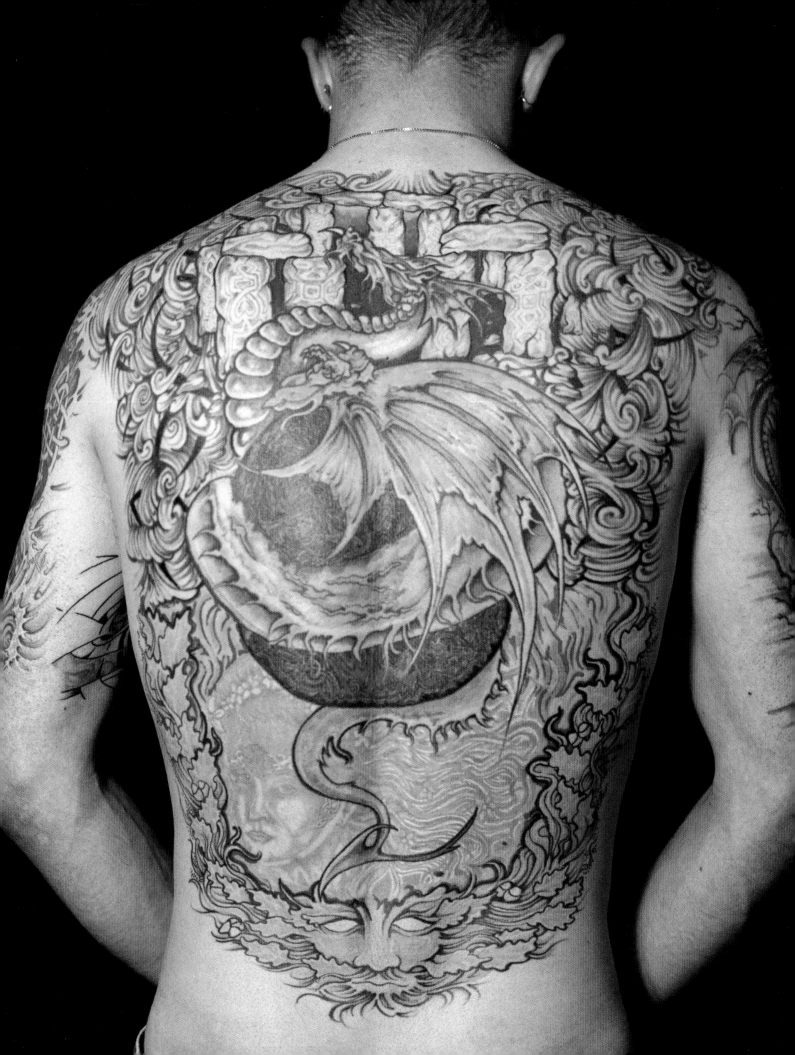

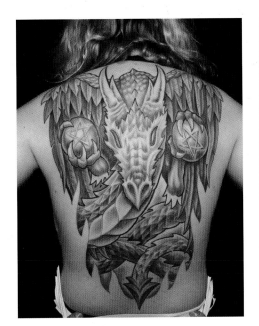

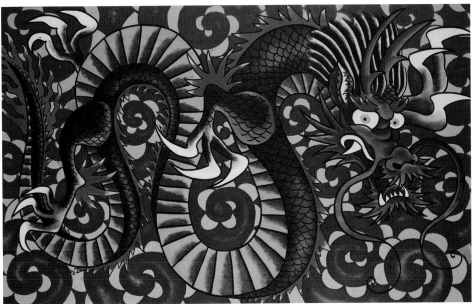

OPPOSITE: Beautifully ornate and with a touch of Celtic sensitivity (note the Green Man framing the bottom part of the tattoo), the dragon in the middle creates a powerful image. Tattoo by Bob Hoyle, Garghoyle Tattoo Studio, Elland, UK

TOP LEFT: Symmetrical and striking, this dragon holds two magic stones carved with pentacles. Tattoo by Marcus, All Style Tattoo, Berlin, Germany

TOP RIGHT AND BOTTOM: All illustrations by Sacha, Primitive Abstract, Oslo, Norway

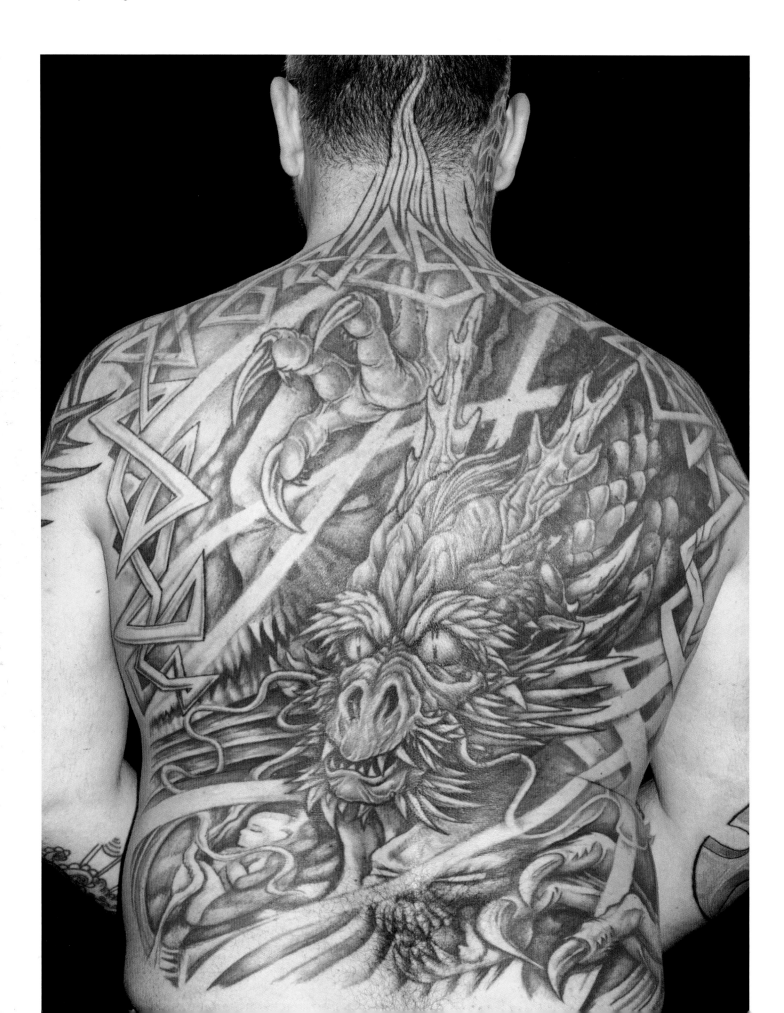

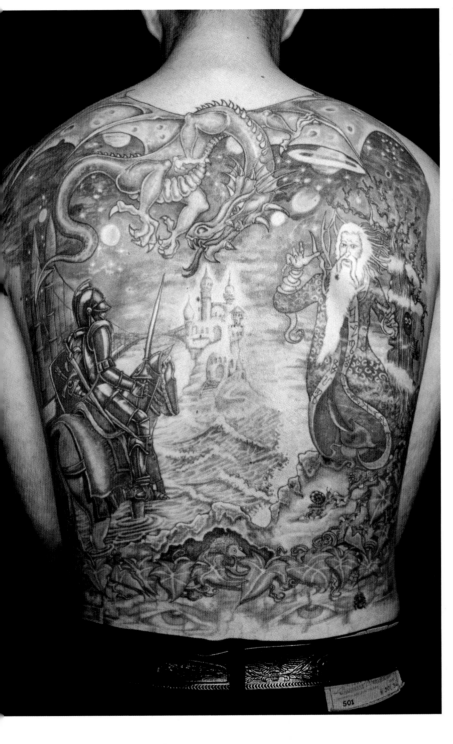

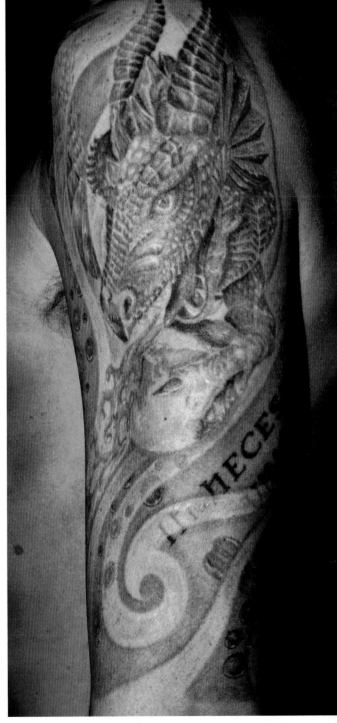

OPPOSITE: A very demonic dragon, surrounded by abstract shapes and patterns, hovers over a sleeping boy. Tattoo by Vas, Skin Shot Studio

ABOVE LEFT: A mythological scene with a knight, a castle and a wise warlock, all framed by the hovering dragon at the top. Tattoo by Beth Smith

ABOVE RIGHT: Scaly and horned, this dragon is by Gerhard, Art Factory, Echsenbach, Austria

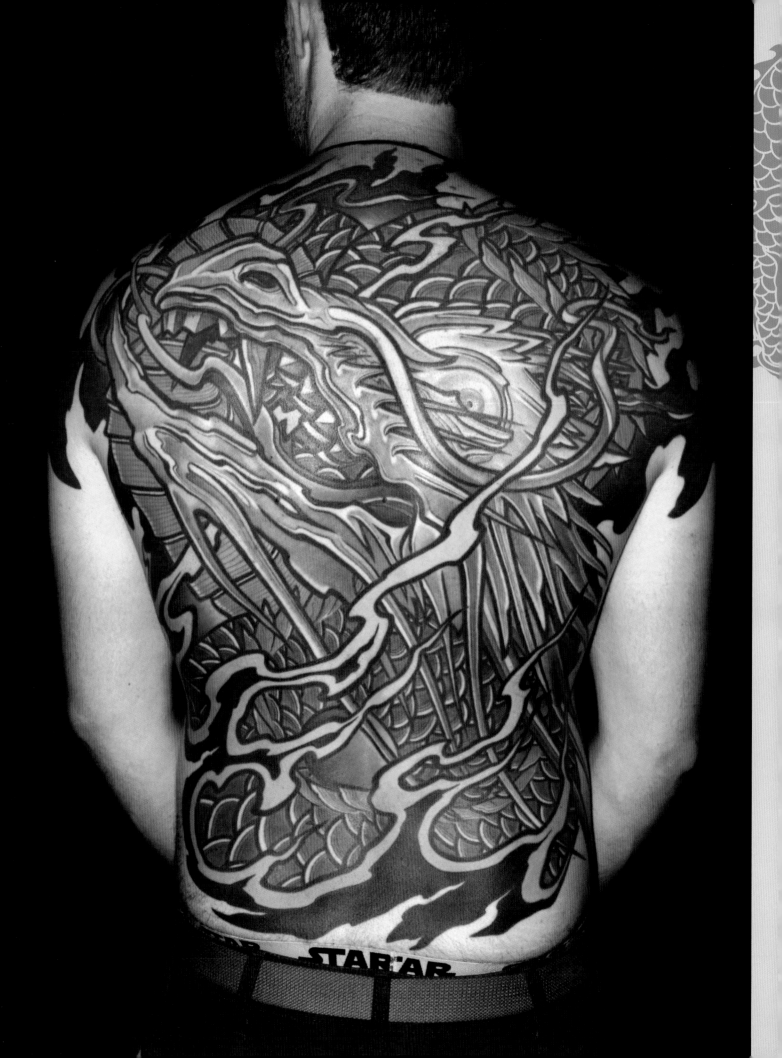

DRAGON
VARIATIONS

The dragon's ancient association with power and magic means that it is closely linked to medicine and healing. It has been suggested that the dragon's coil motif was an early DNA double helix symbol used by pre-Christian civilizations to signify a return to order after chaos. In ancient Egypt in the year 2170BCE, the Royal Court of the Dragon was established to conduct extensive study into the work of the Dragon of Al-Khem (from which the word alchemy evolved), who later came to be known as Thoth, or Hermes. In sculptures dating back to 4000BCE, the caduceus, a staff carried by Hermes – or Mercury, as he was known by the Romans – was shown entwined with two snakes and flanked by dragons. Hermes himself brought medicine, commerce, measures, the alphabet and fire to humans, and he was the protector of inventions and literature, among other things. A coiled snake is often represented on the staff of Aesculapius (or Asklepios), Greek god of healing, and it is used as a symbol of the medical profession the world over.

OPPOSITE: Flames, bold colours and a striking close-up of a dragon fill this back piece. Tattoo by Karl Löfqvist, Wicked Tattoo, Gothenburg, Sweden

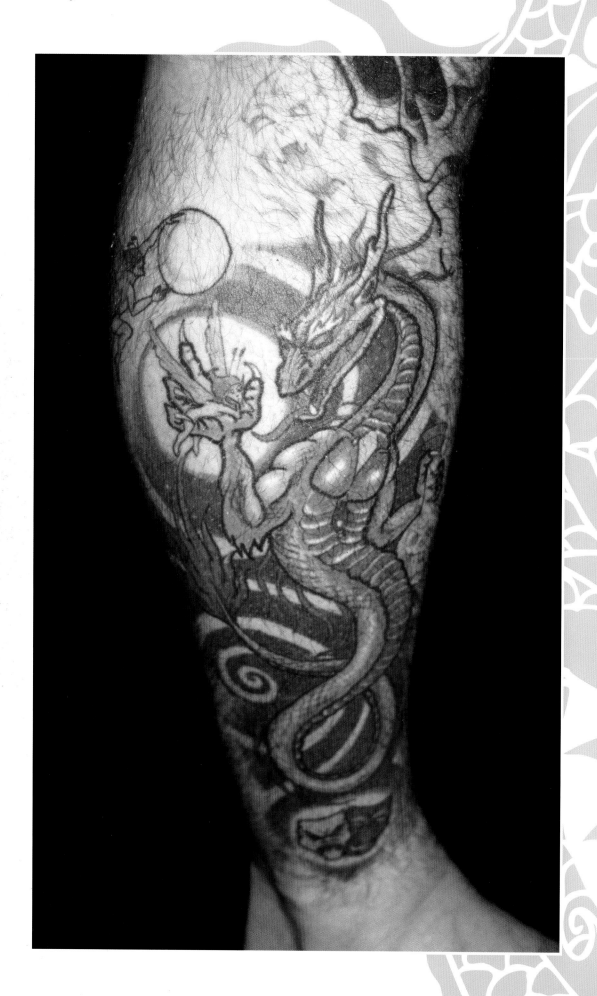

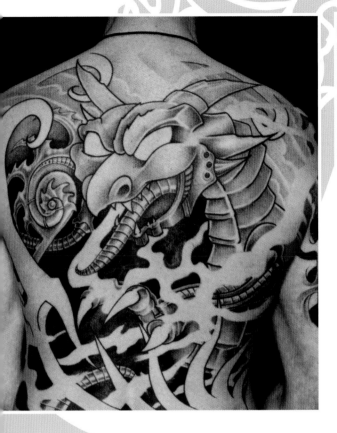

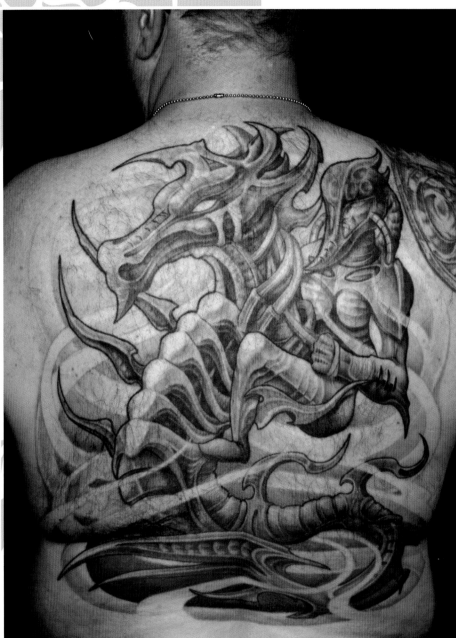

OPPOSITE: In spite of the malevolent look in its eyes, this lindworm is small, colourful and not too scary. Tattoo by Pert, Ink Castle, Belfast, Ireland

ABOVE LEFT: A robotic interpretation of the organic dragon theme, this works very well, especially in black and grey. Tattoo by Sean Zeek, Kongsvinger Tattoo Studio, Kongsvinger, Norway

ABOVE RIGHT: Skeletal, ornate and ridden by an alien-looking creature, this dragon is very striking. Tattoo by Jason Butcher, Immortal Ink, Chelmsford, UK

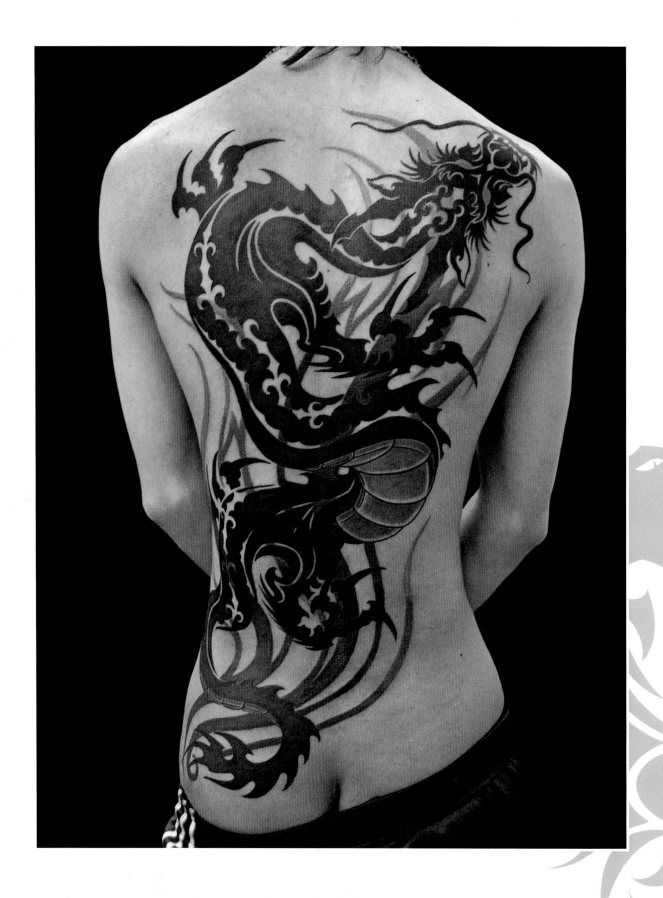

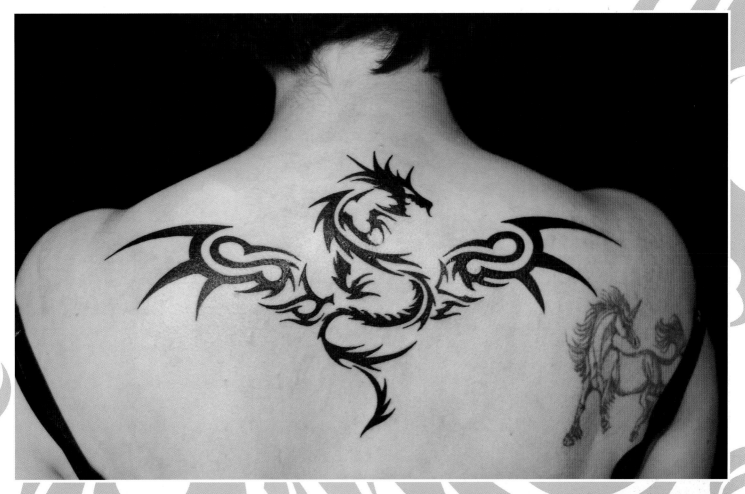

OPPOSITE: A beautiful design in block colours, this ascending tribal ryu is given depth by the stylized red motif and the grey underbelly. Tattoo by Cova at Knock Over Decorate Tattoo in Yonago, Japan

ABOVE: An elegant, abstract design of a dragon reduced to its essential elements. Tattoo by Mario Katulacs, One More Tattoo, Luxembourg

RIGHT: A dragon hybrid fused with a rearing horse. Tattoo by Bob Eagle, Bob Eagle's Tattoo Parlour, Oxford, UK

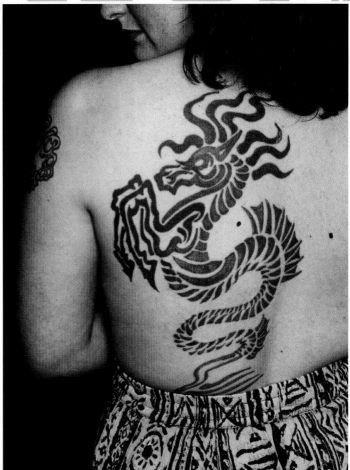

The Aztec god Quetzalcoatl (meaning feathered serpent) was the Mesoamerican equivalent of the Greek god Hermes. Both deities could cure ailments and both were linked to winged serpents or amphitheres (South American winged serpent gods). Quetzalcoatl was an amphithere, while Hermes wore a winged hat and shoes and carried the snake-entwined caduceus. Quetzalcoatl was worshipped by the Aztecs, the Toltecs, the Mayans and other Mesoamerican cultures, who believed he was one of the original creators of the universe. He was credited with creating humankind and introducing civilization, culture and knowledge.

Quetzalcoatl was born of a virgin goddess and his appearance very closely resembled that of Eastern dragons. After his death the Aztec people expected his return 52 years later. Unfortunately, it was the Spanish conquistador Cortés who actually arrived on Mexico's shores and was welcomed by the native people in the mistaken belief that he was the reincarnation of their beloved god.

According to evidence found near the Mississippi River in the USA, another dragon-like creature was the Piasa bird. A limestone mural depicting the bird, possibly dating from about 1200CE, was found by a traveller in 1673. Said to be a carnivorous creature with a scaly body, four legs and large wings, it co-existed happily with the local Native American tribe, the Illini. However, after a war with another tribe left bloody remains strewn around its habitat, the Piasa developed a taste for human flesh and started to terrorize the Illini. It was eventually killed by a local hero.

The Hydra, which appears in Greek mythology, was another feared creature. It was born from the Greek deity Echidna and was sibling to the pernicious Chimera (see page 121). A monstrous creature with the body of a serpent and nine heads, the Hydra lived in a swamp at the entrance to the Underworld, which it guarded. Accounts of the number of heads the Hydra possessed vary from five to a hundred, but nine seems to be the generally accepted figure. The Hydra was armed with poisonous breath and when one head was severed another grew, making it virtually invincible. The Greek hero Heracles defeated it by cutting off its heads and getting his helper Iolaus to cauterize the necks so they could not grow back. The last head resisted Heracles' attacks until he buried it under a mighty rock.

BELOW: The two-headed serpent, a popular icon in Aztec culture, was one of the symbols of Tlaloc the rain god. Serpent and dragon gods were present in various incarnations in Aztec mythology. Tattoo by Art Tattoo, Rome, Italy
OPPOSITE: An Aztec totem representing Mesoamerican deities. At the top and bottom we can see a serpent-like head, possibly that of Quetzalcoatl, the main Aztec god. Tattoo by Chelo, Mandinga Tattoo, Buenos Aires, Argentina

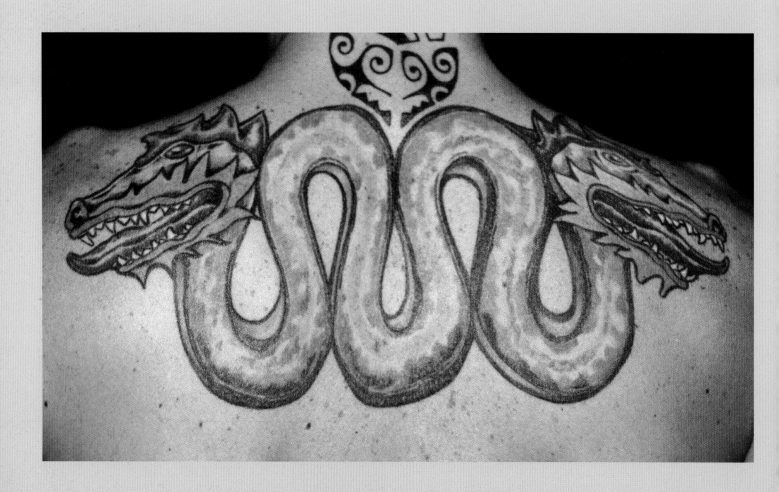

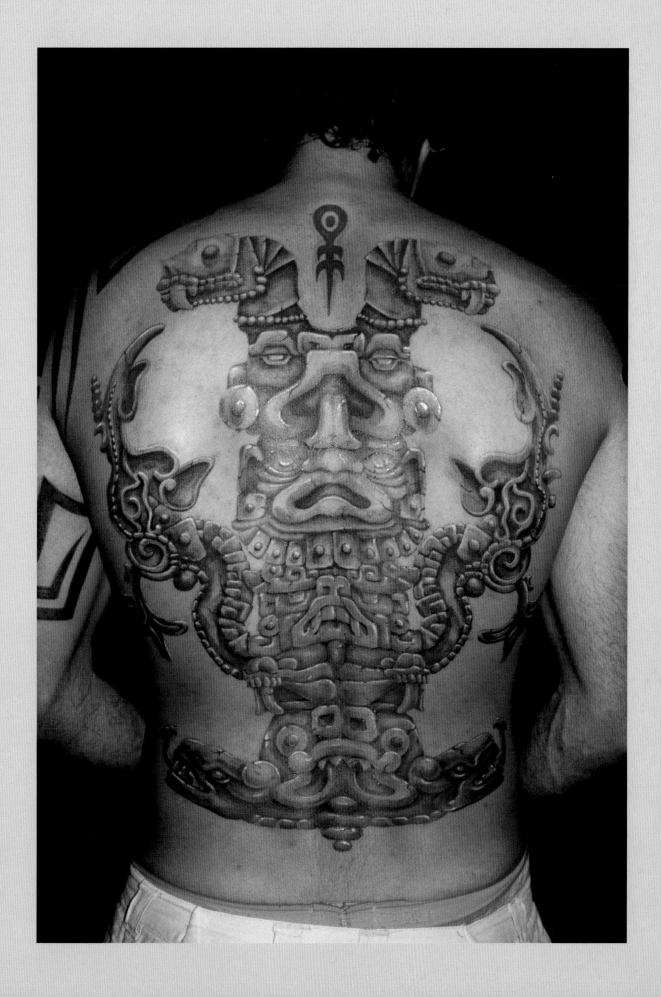

The heraldic dragon

In spite of the monsters of legend, the dragon is generally a positive symbol when used in heraldry across Europe. A recurring creature is the wyvern, a winged serpent with a forked tongue that was often used to signify military valour, courage, vigilance and loyalty. The European lindworm (or lyndworm) had similar characteristics to the wyvern, although it was depicted without wings.

Some armed forces use the dragon as their emblem. In this context, it is usually winged and with its mouth open, sometimes breathing fire. Originally the use of the dragon as an emblem would have been granted to the families of heroic soldiers, though some popular myths describe the tales of courageous knights who fought dragons or wyverns and earned the right to use the monsters' likeness on their coat-of-arms after slaying them. Figures in coats-of-arms have different meanings depending on their positioning within the design; their colour, the use of objects and other figures, the patterns of the lines employed and the background colour are also part of the message. The meaning of the figures is always benevolent, though: the plants, animals or objects depicted, including dragons, demonstrate a positive symbolism and represent the valour and good qualities of a particular family.

BELOW: A somewhat humorous interpretation of a dragon, traditionally represented but brandishing tools and soldering metal. Tattoo by Leo, Naked Trust, Salzburg, Austria

OPPOSITE: This dragon in swirling waters has a touch of the biomechanical about it. Tattoo by Urban Cowboy, Verona, Italy

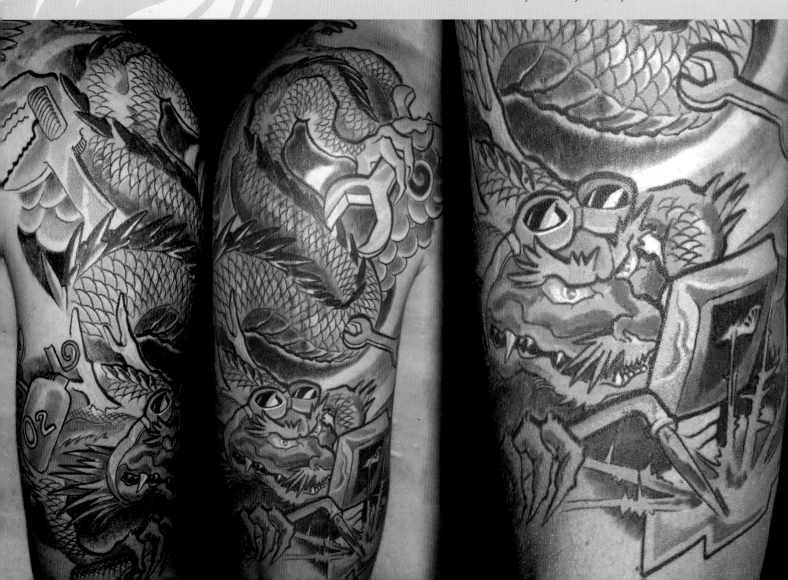

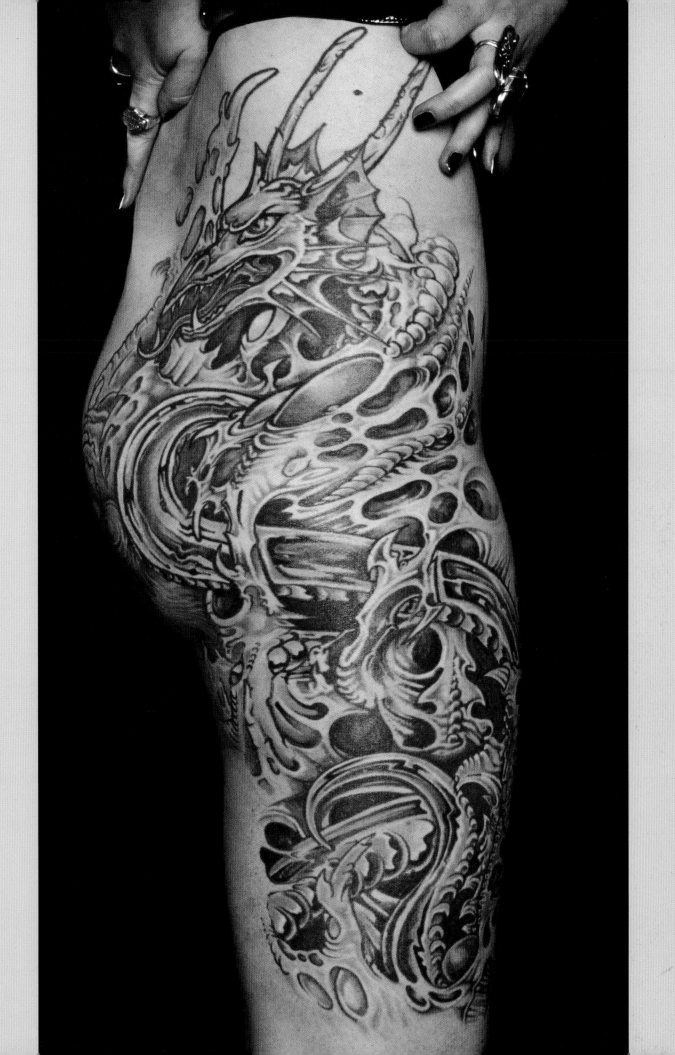

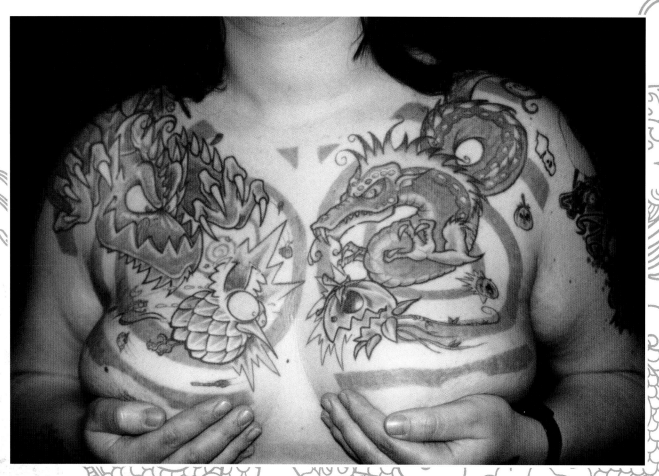

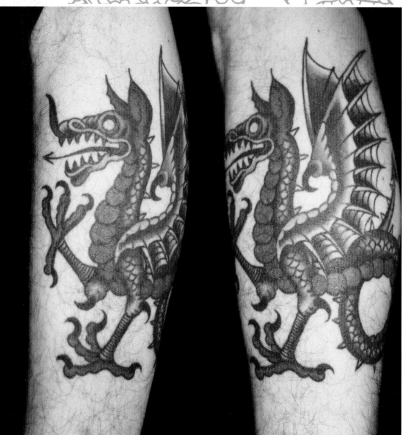

ABOVE: A fun tattoo with playful manga dragons. Tattoo by Doc Denti, La Caverna delle Torture, Arezzo, Italy

LEFT: A wyvern which has the characteristics of a heraldic dragon. Tattoo by Tomás García, Keepsake Tattoo, Arlington, VA, USA

OPPOSITE LEFT: Dynamic and colourful, this wyvern is by Mario Katulacs, One More Tattoo, Luxembourg

OPPOSITE RIGHT: Fire-breathing and meaning business, this dragon is represented with three skulls and is brandishing a magic stone. Tattoo by Pert, Ink Castle, Belfast, Ireland

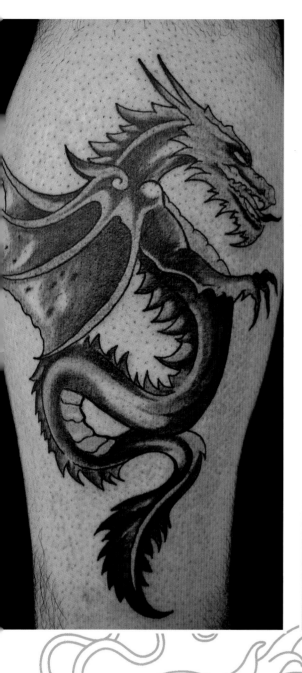

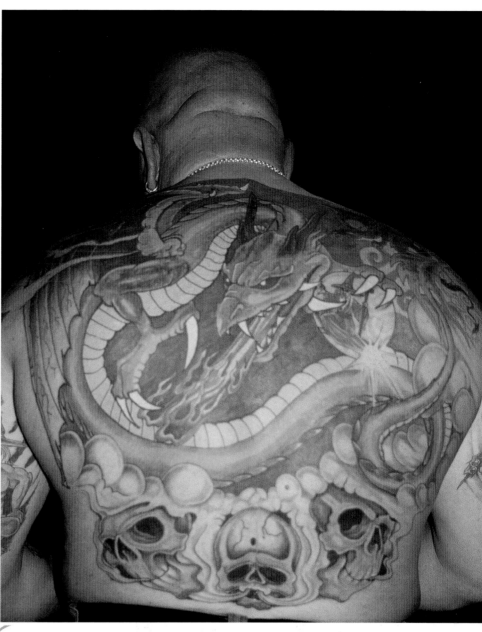

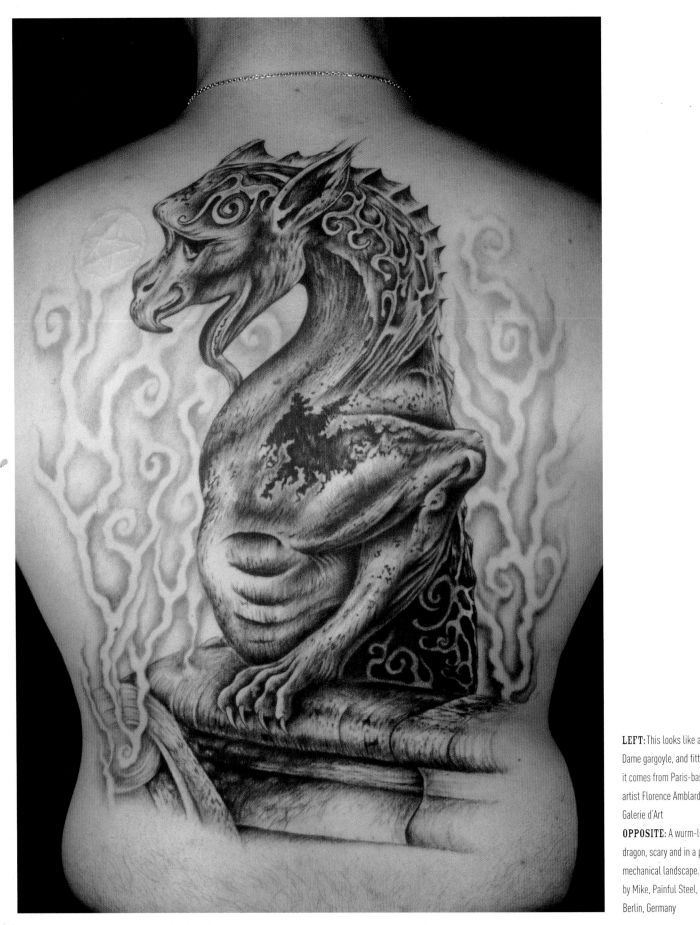

LEFT: This looks like a Nôtre Dame gargoyle, and fittingly it comes from Paris-based artist Florence Amblard, Galerie d'Art

OPPOSITE: A wurm-like dragon, scary and in a proto-mechanical landscape. Tattoo by Mike, Painful Steel, Berlin, Germany

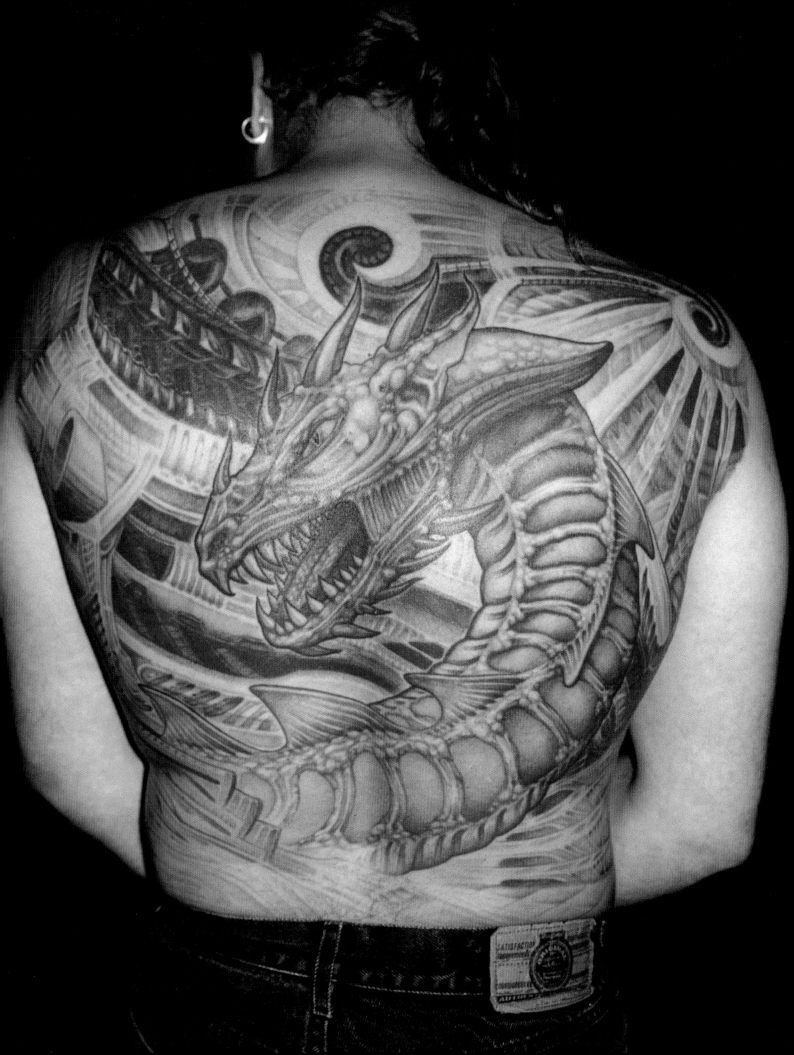

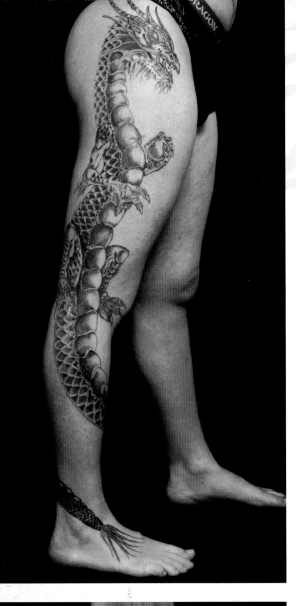

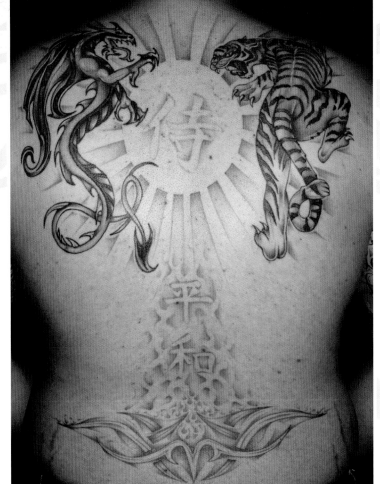

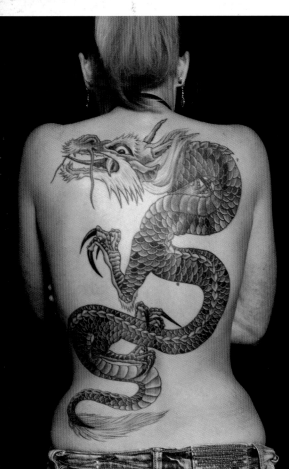

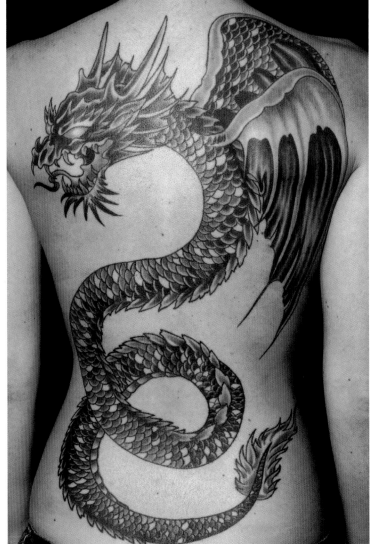

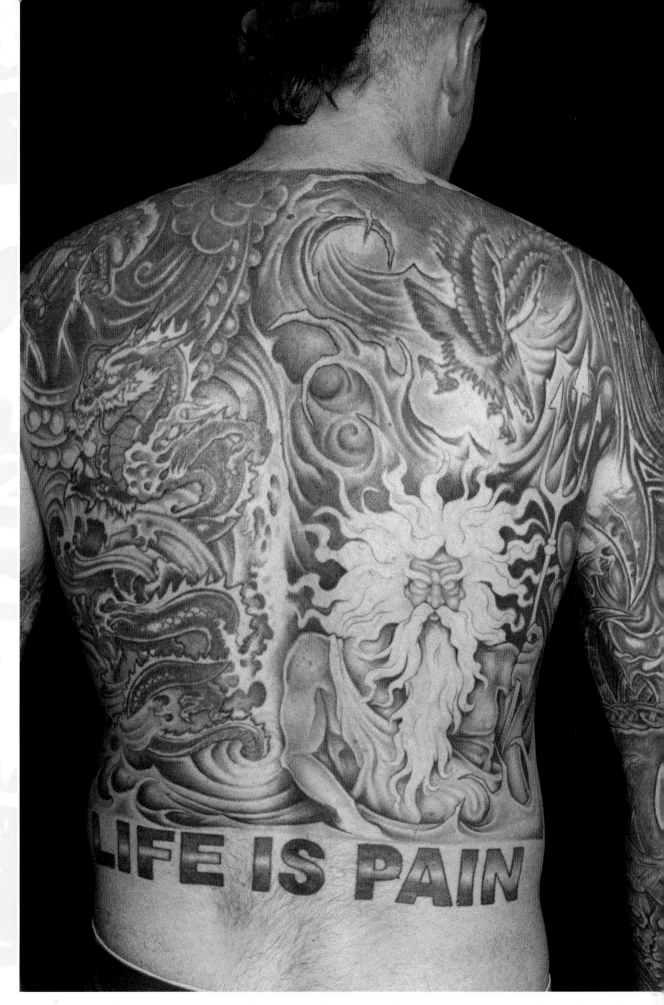

OPPOSITE PAGE

ABOVE LEFT: Very crocodile-looking and holding a sacred pearl, this dragon wraps itself around a leg. Tattoo by Marco, Samsara Tattoo, Italy

ABOVE RIGHT: A wyvern dragon faces a tiger across delicately tattooed spiritual symbols in grey. Tattoo by Paul Owen, Naughty Needles, Bolton, UK

BELOW LEFT: A coiled black and grey dragon with a feathery tail. Tattoo by Andy, Mystery Touch, Gleisdorf, Austria

BELOW RIGHT: By Drew Horner, Living Art Tattoo, Lidköping, Sweden

RIGHT: A back piece with epic storytelling, this tattoo pictures a dragon on one side and Poseidon/Neptune on the other, both sea lords. Tattoo by Sean Wood, Woody's Tattoo Studio, High Wycombe, and Ian of Reading, UK

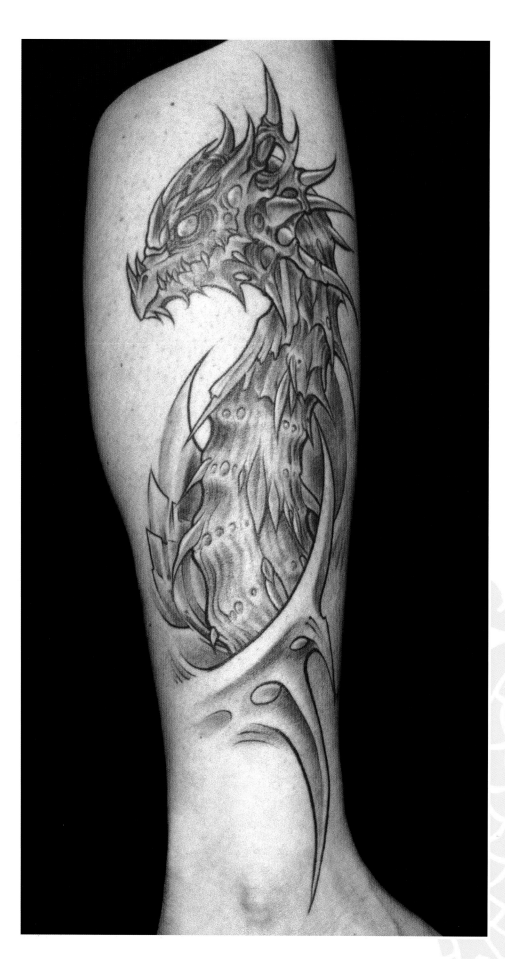

Fire and flood

The wyvern originated from a type of French dragon called the guivre, popular in stories from the Middle Ages. The guivre (or vouivre, its equivalent in modern French) also appears in German mythology as the wurm. It was a little different from known representations of the wyvern, having a serpentine body, the head of a dragon and, occasionally, wings. It was a fearsome creature with foul and fiery breath that spread disease and terrorized the European countryside. The North American amphithere appears to have had more than a passing resemblance to the European wurm.

The story of the famous Lambton worm inspired the Irish author Bram Stoker to write *The Lair of the White Worm*. Dating back to the time of the Crusades, according to some accounts, the tale is about a giant wurm-like creature that terrorized a village in County Durham for seven years. When young, it was taken from its hiding place and incarcerated at the bottom of a well, where it grew for many years before escaping and terrifying the locals. The boy who had first found the Worm, now a grown man and crusader returned from the Holy Land, took it upon himself to rid the land of the monster and succeeded in slaying it by following the advice of a witch. However, because he did not follow the witch's advice to the letter, he had a curse visited upon him which plagued his family for generations.

Another mythological creature originating in France was the gargouille, or gargoyle. With the traditional winged appearance of a dragon, the gargouille lived in the Seine River and caused floods, for it spouted water instead of fire. Stone effigies of gargoyles were later used on churches around the world to decorate water drains; they were superstitiously believed to preserve the longevity of these sacred buildings.

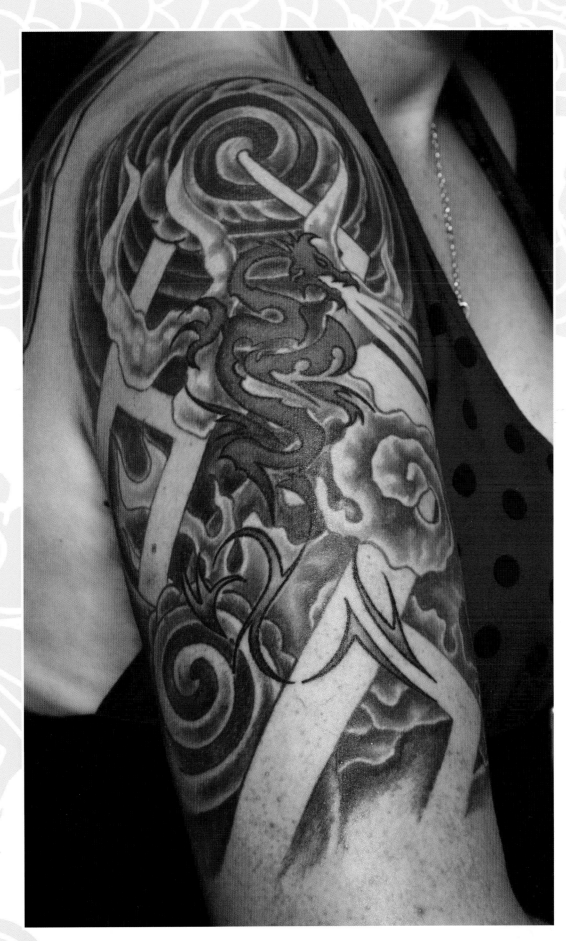

OPPOSITE: Spiky and with tribal elements, this reptilian creature looks like a baby dragon. Tattoo by Gato, Galien Tattoo, Cadiz, Spain

RIGHT: A small tribal dragon amid swirls of water and fiery spirals. Tattoo by Andy Bowler, Monki Do, Belper, UK

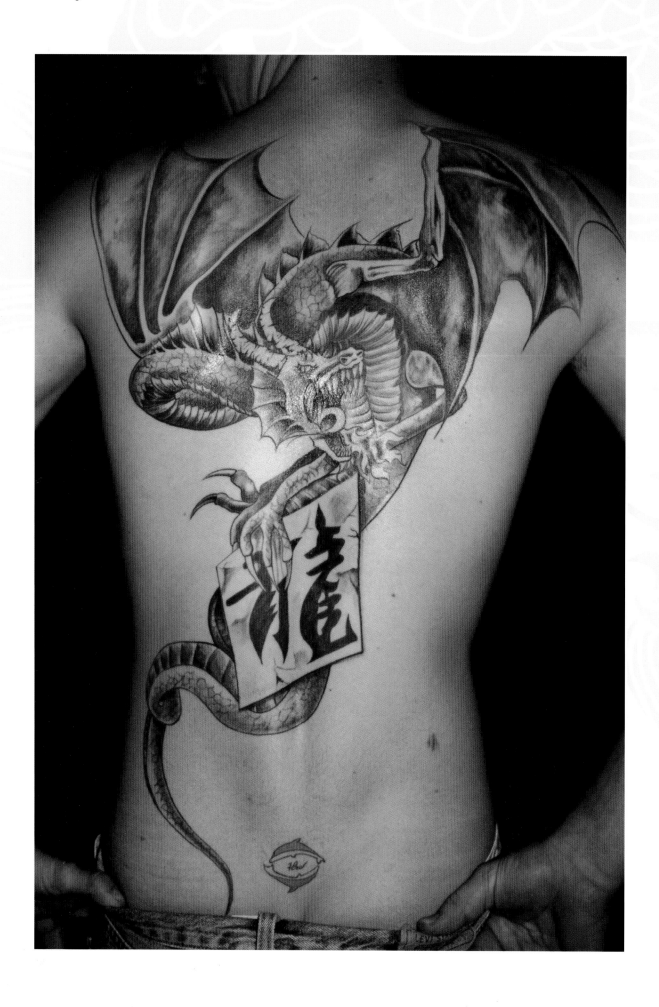

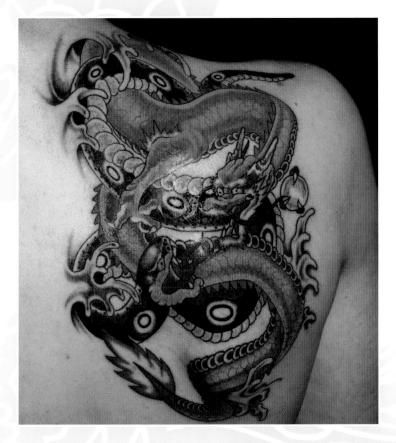

LEFT: A green dragon defends a magic pearl from the attack of a large serpent. Tattoo by Marc, Skin Sorcerer, Maldon, UK

BELOW: Conjoined and facing each other, these two delicately executed dragons are in pursuit of the two magic pearls. Tattoo by Robert Kornajzel, One More Tattoo, Luxembourg

OPPOSITE: With its large wings spread out, this dragon rises high, holding Eastern symbols. Tattoo by David Tattoo, Pertuis, France

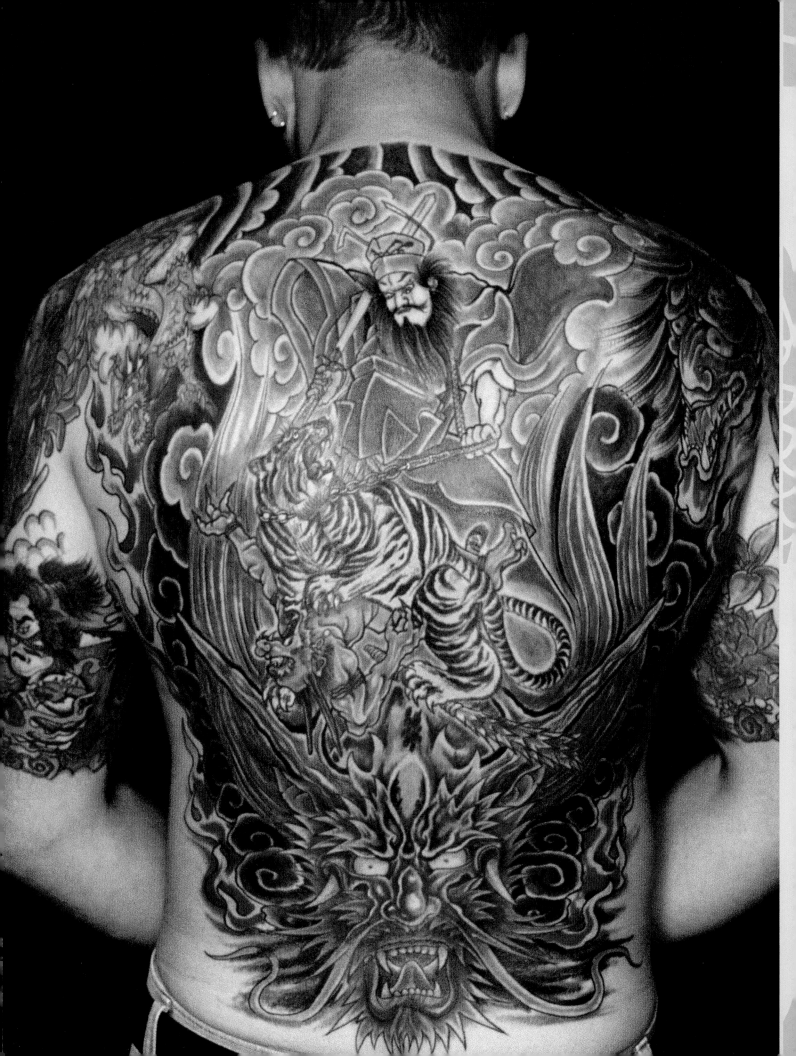

DRAGONS AND OTHER ANIMALS

The mythology and iconography of the Eastern dragon is hugely varied and made up of cultural, historical, mythical and religious components from Indian, Chinese, Japanese, Tibetan, Korean and Vietnamese sources. As these cultures share many legends, generally the stories have been assimilated and represented in ways that complement regional and national sensitivities. This is why we find recurring themes and myths in which only the names of the characters are different.

OPPOSITE: An intricate and very detailed Japanese mythological scene with several participants: a dragon, a tiger and a samurai warrior, all framed with black smoke. Tattoo by Derek Campbell, Bournemouth, UK

A story that originates in China describes the journey of the koi carp which turns into a dragon. This symbolizes overcoming life's hardships and challenges and a rebirth or a new beginning. The koi swims up a waterfall on the Yellow River and over the Dragon's Gate at the top, where it transforms into a dragon itself, acquiring more powers and strength and realizing its life's ambitions.

The koi is a symbol of perseverance and willpower to fulfil one's destiny against the odds, and the Yellow River represents the difficulties the koi has to overcome. Legend has it that 360 carp attempted the journey and gave up; but one kept trying until it succeeded, whereupon the gods rewarded it by transforming it into a higher being. In tattoos, the koi dragon, a hybrid creature with the head of a dragon and the body of a carp, is a variant on the dragon theme.

The symbols of opposites

Another recurring motif is dragons and tigers together, often engaged in an epic struggle. Both are Buddhist symbols: their fight underlines their different approaches and they represent opposite ends of the spectrum, namely yin and yang. The tiger's approach is more forceful and direct, using physical strength in battle, while the dragon internalizes and reflects more, deploying tactics and wisdom. As we already know, the dragon is a yang symbol par excellence; here the tiger, despite an outward display of physical strength, is considered a yin symbol, probably because of the stealth it displays when stalking a victim. The dragon and the tiger also represent opposite ends of the compass, the tiger West and the Dragon East. They are creatures of equal strength but pulling in opposite directions.

Often the dragon is shown with a phoenix. In Eastern mythology the two are closely connected and in Chinese culture the phoenix (or Fenghuang) is a good omen. Its representation with the dragon shows them in conflict sometimes, as they symbolize opposite elements – fire (phoenix) and water (dragon). They are also depicted as partners, with the male dragon complementing the female phoenix. This is a metaphor for the emperor and empress, a successful union of yin and yang in an example of the attraction of opposites.

BELOW: A carp is depicted swimming upstream and turning into a dragon (a reward for its bravery), while a blue dragon occupies the other half of this striking piece. Tattoo by Richard Pinch, Richard's Tattoo Studio, Aberdeen, UK

OPPOSITE TOP LEFT: Plenty of Japanese symbols are present in this piece by Louis Molloy, Middleton Tattoo Studio, Manchester, UK

OPPOSITE BOTTOM LEFT: The carp and the dragon are represented together, with accents of the same colours present in both creatures. Tattoo by Leo, Naked Trust, Salzburg, Austria

OPPOSITE RIGHT: A very bold piece showing the carp in mid-transformation, its face already turned into a dragon as it swims over Dragon's Gate. Tattoo by Lars, Art of Paint, Oranienburg, Germany

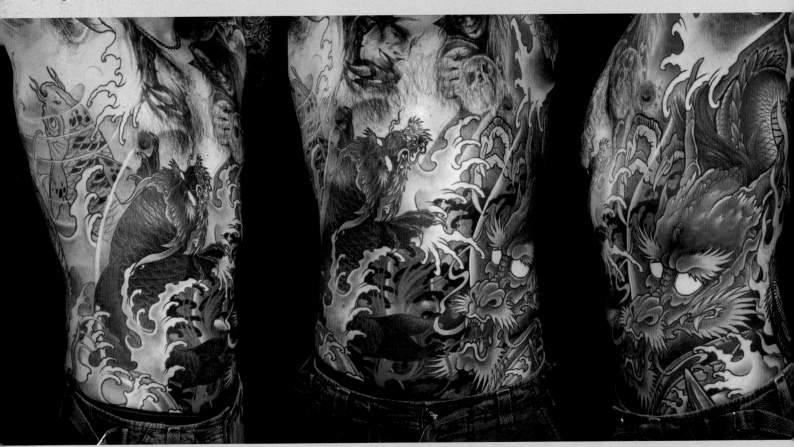

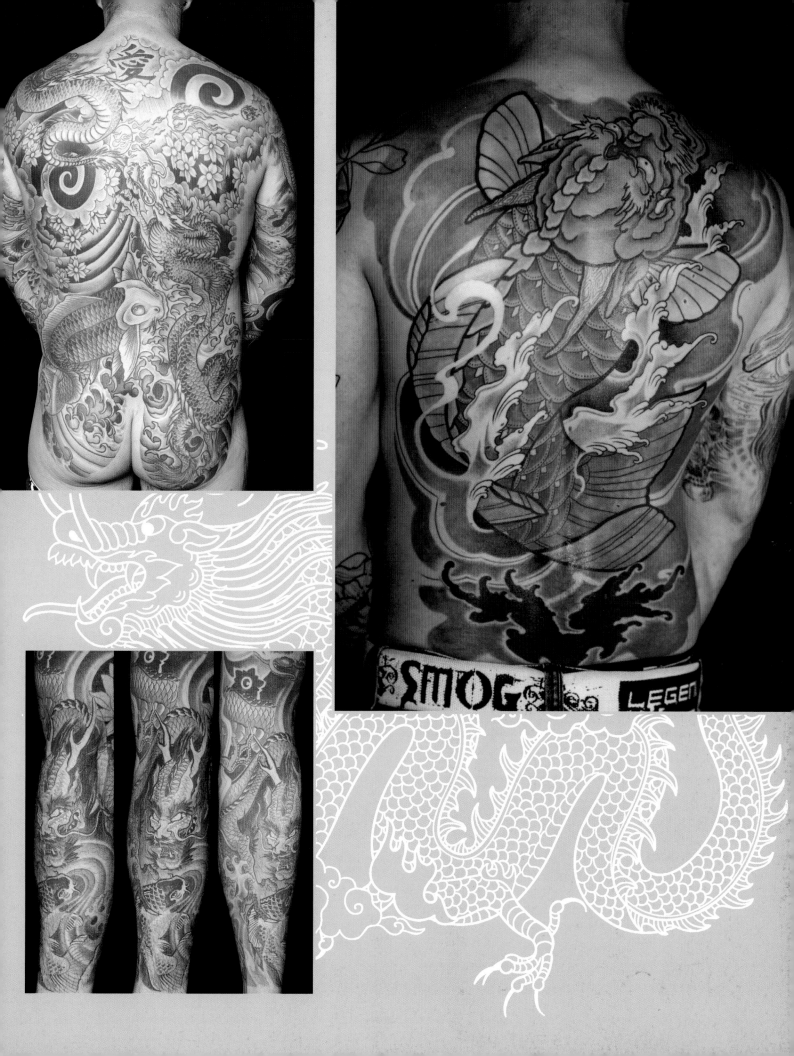

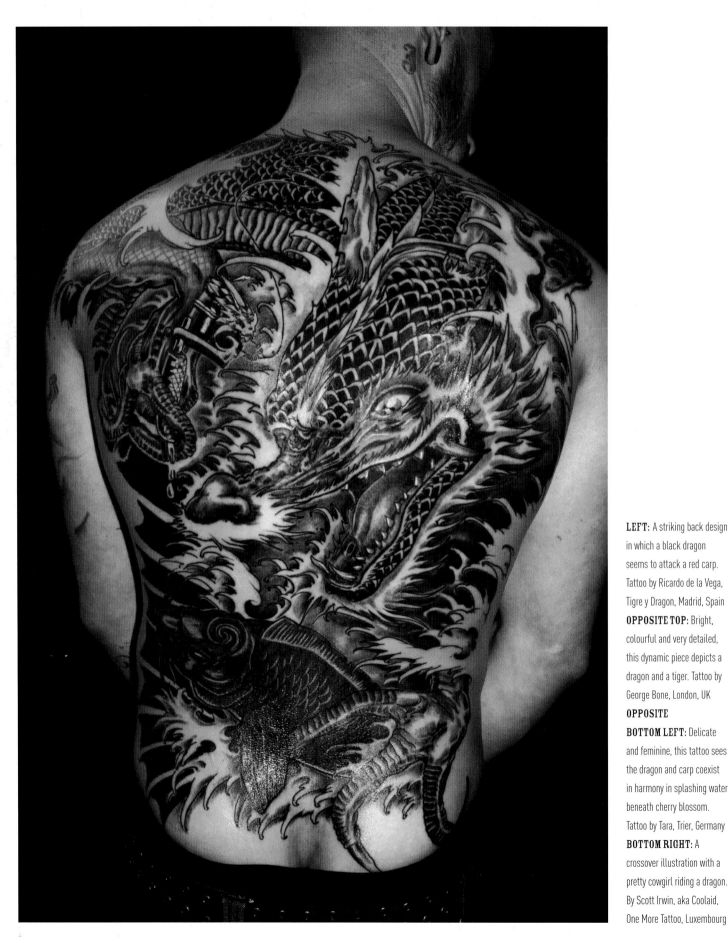

LEFT: A striking back design in which a black dragon seems to attack a red carp. Tattoo by Ricardo de la Vega, Tigre y Dragon, Madrid, Spain

OPPOSITE TOP: Bright, colourful and very detailed, this dynamic piece depicts a dragon and a tiger. Tattoo by George Bone, London, UK

OPPOSITE BOTTOM LEFT: Delicate and feminine, this tattoo sees the dragon and carp coexist in harmony in splashing water beneath cherry blossom. Tattoo by Tara, Trier, Germany

BOTTOM RIGHT: A crossover illustration with a pretty cowgirl riding a dragon. By Scott Irwin, aka Coolaid, One More Tattoo, Luxembourg

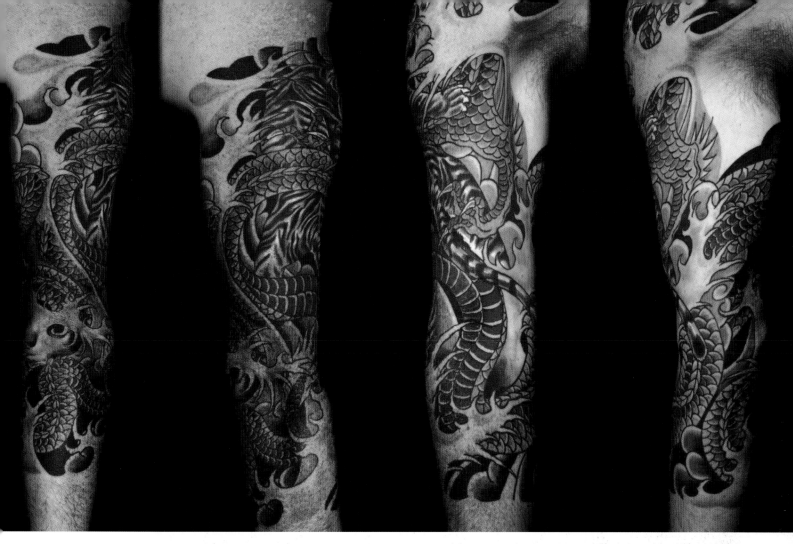

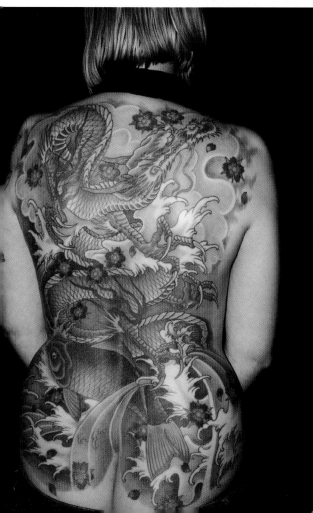

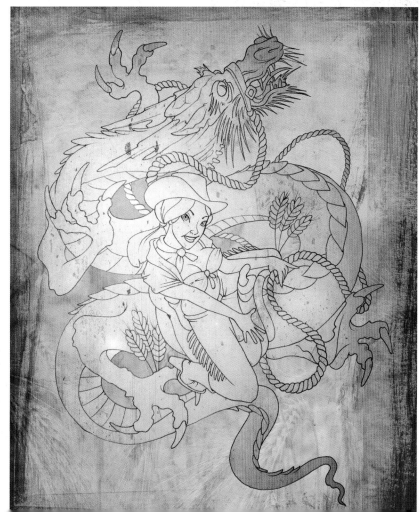

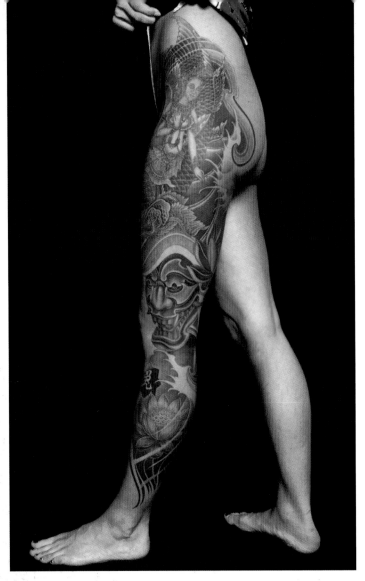
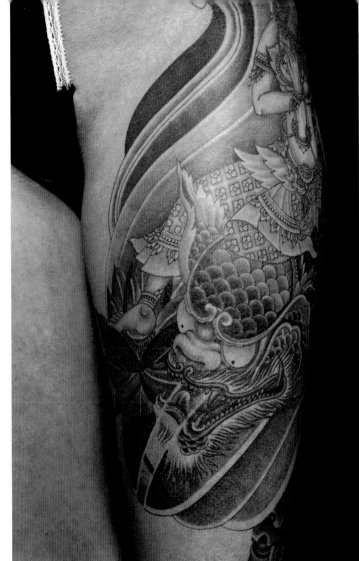
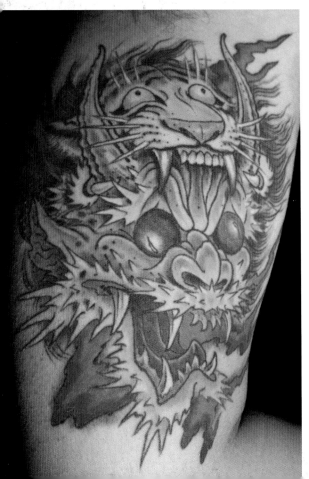
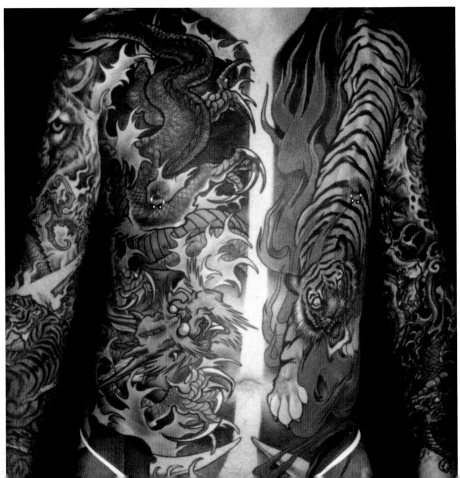

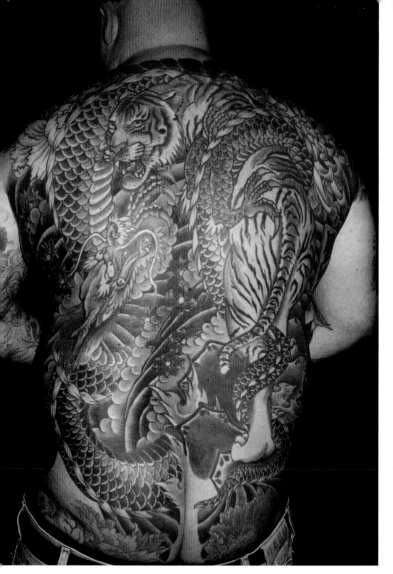

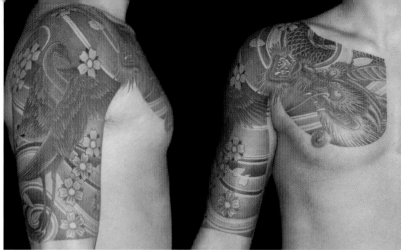

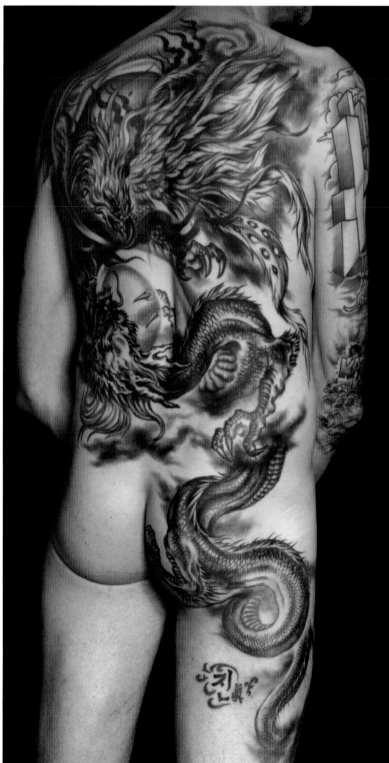

OPPOSITE

TOP RIGHT AND LEFT: This tattoo wraps itself around a leg and tells a story with several mythological elements, including a dragon carp. Tattoo by Noi Siamese, 1969 Tattoo, Oslo, Norway

BOTTOM LEFT: A dragon's head wearing a tiger's head, perhaps as a cunning disguise? Tattoo by Thymlhi, Tattoo City

BOTTOM RIGHT: A mighty dragon on one side, a tiger on the other, beautifully balancing each other. Tattoo by Tin Tin, Tin Tin Tatouages, Paris, France

ABOVE: Two powerful symbols of Eastern mythology together in one epic struggle: the yang dragon and the yin tiger. Tattoo by Lee Symonds, Cherry Blossom Tattoo, Essex, UK

TOP RIGHT: A black bird and dragon, all in black and grey with bold splashes of red. Tattoo by Noi Siamese, 1969 Tattoo, Oslo, Norway

RIGHT: A phoenix and a dragon fighting, the two elements of yin and yang confronting each other. Tattoo by Jin, Middleton Tattoo Studio, Manchester, UK

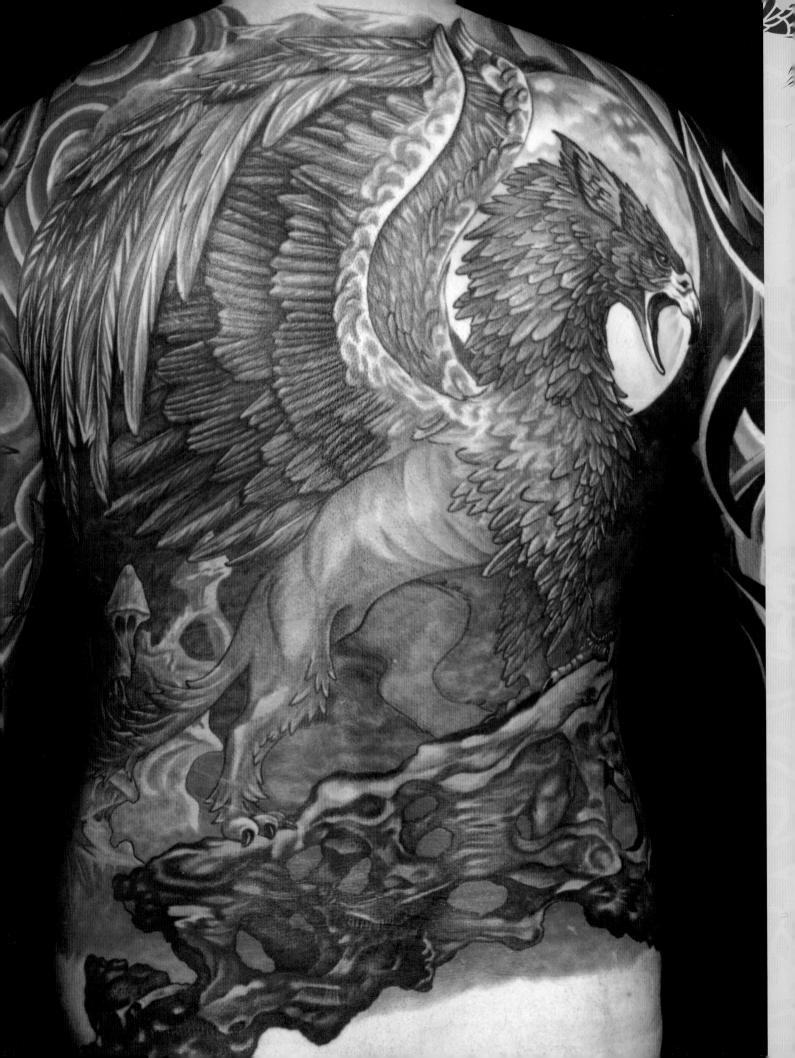

CHIMERAS

According to Greek mythology, the Chimera (or Chimæra) was a monstrous hybrid creature made from the body of a lioness with a goat's head on its back and a tail that ended as a serpent's head – a fire-breathing genetic nightmare! The Chimera was a one-of-a-kind creature, a unique oddity which spread fear and destruction in the region of Lycia in modern-day Turkey. Of divine origin, she was the offspring of Echidna, a part-woman, part-snake deity who also generated Cerberus and the Hydra, among others. The Chimera herself was believed to have given birth to the Sphinx after copulating with her own monstrous brother Orthus. It is widely thought that the Greek representation of the Chimera came to be the blueprint for medieval dragon imagery.

OPPOSITE: A proud griffin dominates this detailed and colourful back piece. Tattoo by Fiona Long, Feline Tattoo Studio, Sheffield, UK

The phoenix

The best-known chimera is the phoenix, also a very popular tattoo motif. Like the dragon, the phoenix represents eternal life by means of regeneration. According to different versions of the story, at the end of its lifespan of 500 years the phoenix was said to self-immolate on a pyre, facing the sun, after loading its wings with frankincense. It was then reborn in glory from its ashes. Another legend has it that the day after burning a worm was found in the phoenix's ashes, and the worm turned into a phoenix on the third day.

The phoenix was thought to live in India or Arabia, though the myth is rooted in ancient Egypt. The Chinese phoenix is a similar-looking bird which is often called a Fènghuáng (August Rooster). In Chinese mythology the phoenix is considered the counterpart of the dragon: yang 'masculine' essence resides in the dragon, while the phoenix is the receptacle of yin 'female' energy. They are occasionally represented together and may symbolize the imperial couple.

The Feng Bird in Japan is the equivalent of the Western phoenix and the Chinese Fènghuáng. Represented as a red bird – 'suzaku' in Japanese – it is one of the Shishin celestial guardians.

Legend has it that sightings of the phoenix are rare and when they occur they herald the beginning of a new era or a major positive change. Its appearance varies depending on the country of origin: it is perceived to have the characteristics of different animals and dazzling feathers of various colours according to different mythologies (black, white, red, green and yellow in Imperial China, a vibrant multi-coloured peacock's tail in ancient Greece). It is often represented in red, because of its inextricable links with fire (it is also known as the firebird). In ancient Egypt, the phoenix represented the setting sun and its rebirth in the morning, while Christians saw the death and rebirth of the phoenix as a metaphor for the resurrection of Christ. In modern times, it still has a positive connotation. It is considered a symbol of feminine qualities and female energy, indicating kindness and devotion, and regeneration through the purification of fire.

In Native American cultures, the phoenix was referred to as the 'thunderbird'. It was a symbol of prosperity, bringing fertility to the land; its beak was supposed to spark lightning and it caused thunder and winds by beating its wings. The thunderbird is still often represented on Native American totem poles.

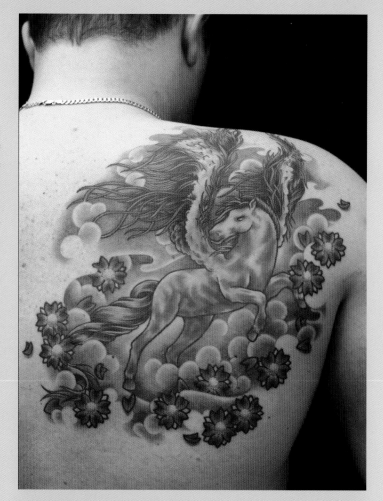

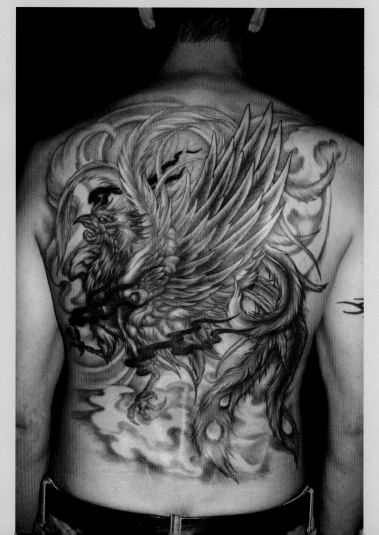

ABOVE RIGHT: Pure and ethereal, the winged horse Pegasus symbolized knowledge, wisdom and glory in Greek mythology, although its meaning changed through the ages. Tattoo by Avishai Tene, Ink Junkies, Luxembourg

RIGHT: Full of movement and delicate subtleties, this phoenix is beautifully rendered in black and grey with some sharp red flames still showing through its feathers. Tattoo by Jin, Middleton Tattoo Studio, Manchester, UK

OPPOSITE: A red phoenix rising, an auspicious symbol. Tattoo by unknown artist

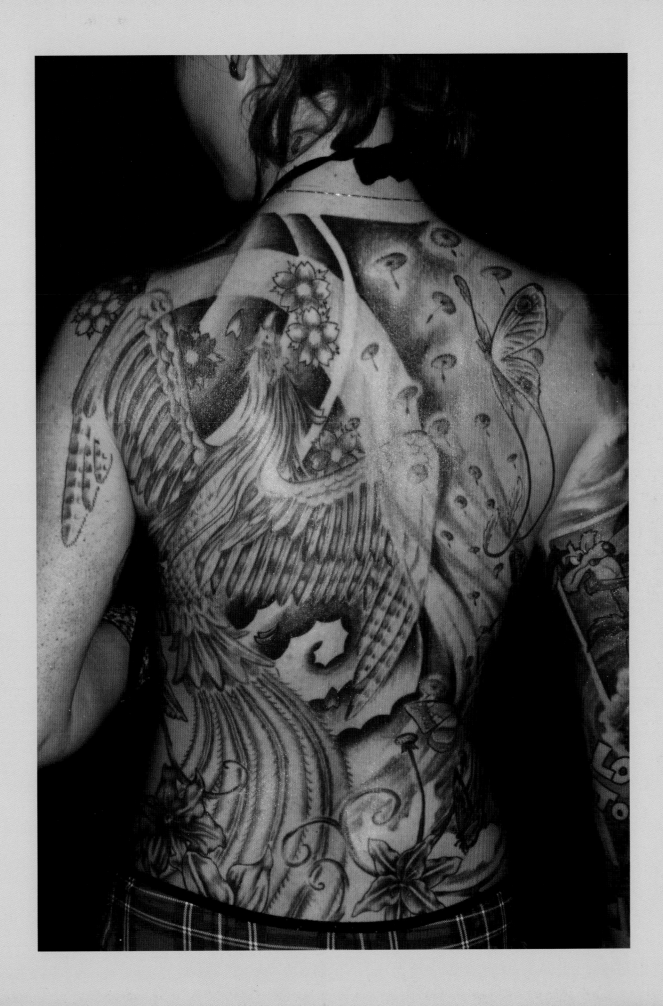

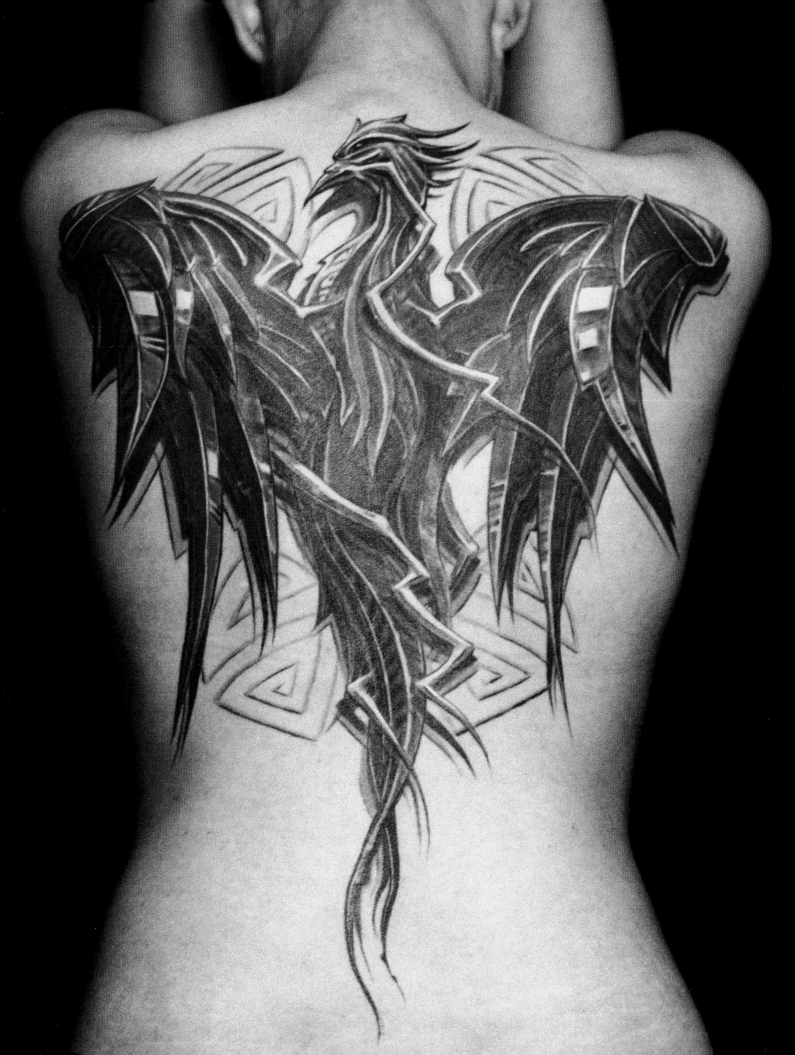

The unicorn and other chimeras

Another mythological creature invested with positive magical powers is the unicorn. A European legendary being, it has the appearance of a white horse with a long pointed horn protruding from its forehead. The beauty and colour of the unicorn signified the creature's attributes of purity and innocence. Unicorns were wild animals that lived in the woods and could only be tamed by a virgin; their horns and blood were said to hold magical healing properties.

Other well-known chimeras include the griffin (a lion's body with the wings of an eagle), the basilisk (the body of a rooster with a reptilian tail), and Pegasus, the winged horse. Mermaids and centaurs are human/animal chimeras, as are the Minotaur (a bull's head and the body of a man), harpies (a woman's head and a bird's body), the Sphinx (a woman's head and the body of a lioness), Ganesh (a boy's body and elephant's head) and several ancient Egyptian deities.

The basilisk, also known as the 'king of snakes' appeared to have a snake's tail, a rooster's head (the crest looking like a crown, hence its regal name) and a bird-like body. Once considered the most poisonous animal on Earth, which could kill by just looking at another creature, it is said to have evolved into the cockatrice, a creature made up of a two-legged dragon with a rooster's head and bat-like wings. Its blood, like that of a dragon, was said to have therapeutic properties. By all accounts, the basilisk was a fearsome creature, which explains its evil incarnation in popular culture today – for example, in *Dungeons and Dragons* and the *Harry Potter* series.

Depictions of the griffin predate 3000BCE. Its appearance dictated its moral qualities: the courage of the eagle and the strength of the lion co-existed in the same majestic creature. Its role in mythology was to guard a treasure. It always appears alert and is often used to portray military valour and power.

OPPOSITE: Stylized and full of geometric patterns, this is a different but equally powerful phoenix. Tattoo by Sven, SW Design, Worbis, Germany

ABOVE RIGHT: A glorious Japanese-style phoenix in flight, the red plumage symbolizing the fire from which it was reborn. Tattoo by Miss Nico, All Style Tattoo, Berlin, Germany

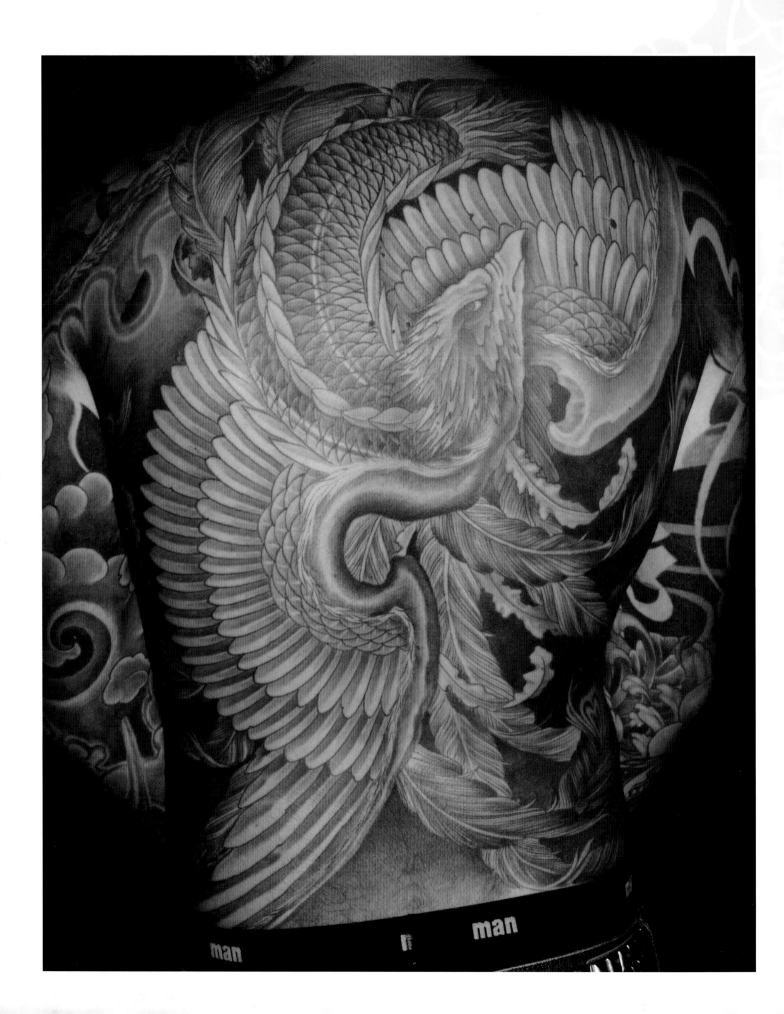

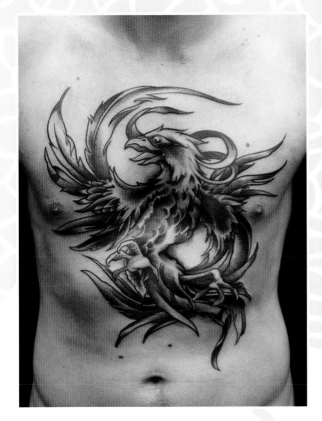

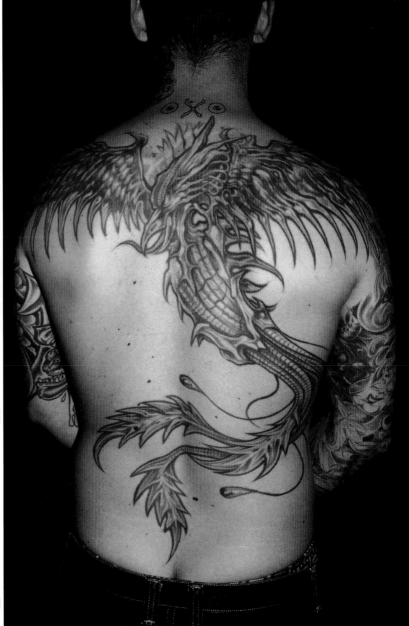

OPPOSITE PAGE: Elaborate and delicately nuanced, this phoenix in mid-flight fills the back with its open wings. Tattoo by Stigma, Norway

ABOVE LEFT: A phoenix chest piece in black and grey with just a hint of red in its plumage. Tattoo by Andy Bowler, Monki-Do, Belper, UK

BELOW LEFT: A rare example of a Russian phoenix, reminiscent of the iconic matrioska dolls. Tattoo by Alex Mad Crow, Proky Royale Tattoo, Stockholm, Sweden

ABOVE RIGHT: Wings spread across the shoulders and plumage decorating the rest of the back, this phoenix rising is by Bongio, Bongio Tattoo Studio, Maserà di Padova, Italy

PICTURE ACKNOWLEDGEMENTS

All photography © Doralba Picerno, except:

Getty Images: 8

Title page tattoo by Noi Siamese 3, 1969 Tattoo, Oslo, Norway

CREDITS

Thanks to:

Aaron Hewitt, Andy Bowler, Emma Griffin, Eun Sen Sin, Florence Amblard, Garry Hunter, George Bone, Leo, Lepa Dinis, Luca Ortis, Mario Katulacs, Marion Thill, Masuimi Max, Miss Nico, Noi Siamese, Pete Oz, Robert Kornaijser, Sacha Lehne, Takami

Links:

Aaron Hewitt **http://www.cultclassictattoo.co.uk/**
All Style Tattoo **http://www.allstyle-tattoo.de/**
Anabi Tattoo **http://www.anabi-tattoo.com/**
Florence Amblard **http://www.tatouage-art-paris.fr/**
George Bone **http://www.georgebonetattoos.co.uk/**
Ink Junkies **http://www.inkjunkies.com/**
Knock Over Decorate Tattoo **http://www.knockover.net/**
Luca Ortis **www.lucaortis.com**
Monki-Do **http://www.monkido.net/**
Naked Trust **http://www.nakedtrust.com/**
1969 Tattoo **http://www.1969tattoo.no/1969_Tattoo_Oslo/Welcome.html**
One More Tattoo **http://www.tattoo.lu/**
Primitive Abstract **http://www.primitive-abstract.com/**
7 Star Tattooing **http://www.sevenstartattooing.com/**
Tattoo FX **http://www.tattoo-fx.co.uk/**